THE TRAPROCK LANDSCAPES

OF NEW ENGLAND

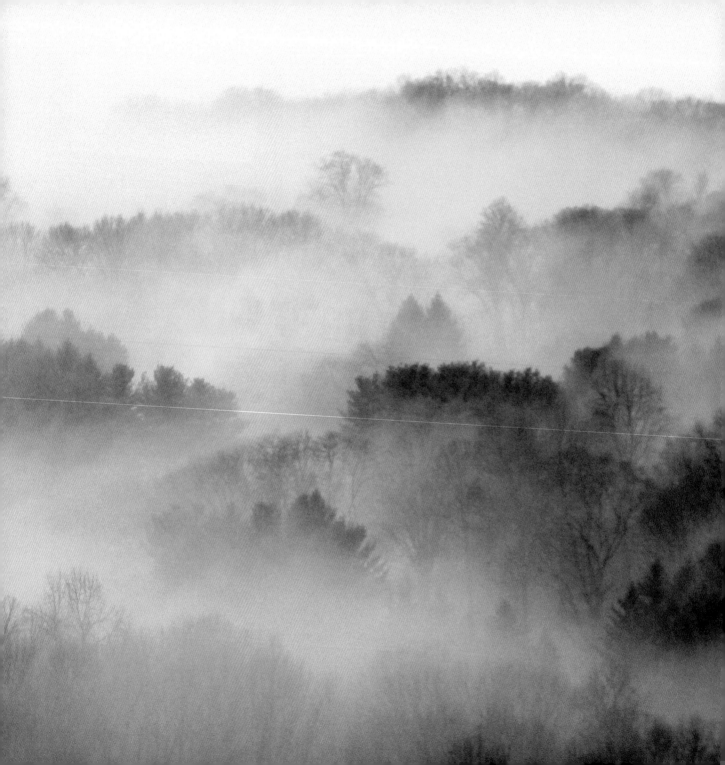

A DRIFTLESS CONNECTICUT SERIES BOOK

This book is a 2016 selection in the Driftless Connecticut Series, for an

outstanding book in any field on a Connecticut topic or written by a

Connecticut author.

Peter M. LeTourneau PHOTOGRAPHS BY ROBERT PAGINI

The Traprock Landscapes
of New England

ENVIRONMENT, HISTORY,
AND CULTURE

Wesleyan University Press Middletown, Connecticut

Wesleyan University Press
Middletown CT 06459
www.wesleyan.edu/wespress
Text © 2017 Peter M. LeTourneau
Photographs © Robert Pagini
Manufactured in the United States of America
Designed by Mindy Basinger Hill
Typeset in Electra LT Standard

The Driftless Connecticut Series is funded by the
Beatrice Fox Auerbach Foundation Fund
at the Hartford Foundation for Public Giving.

Images available from Robert Pagini Photography.
Contact rpagini@snet.net.

Library of Congress Cataloging-in-Publication Data

NAMES: LeTourneau, Peter M. | Pagini, Robert.

TITLE: The traprock landscapes of New England: environment,
history, and culture / Peter M. LeTourneau and Robert Pagini.

DESCRIPTION: Middletown, Connecticut: Wesleyan University Press,
2016. | Series: Driftless Connecticut series | Includes bibliographical
references and index.

IDENTIFIERS: LCCN 2016032965 (print) | LCCN 2016044992 (ebook) |
ISBN 9780819576828 (pbk.: alk. paper) | ISBN 9780819576835 (ebook)

SUBJECTS: LCSH: Landscapes—Connecticut River Valley. |
Natural history—Connecticut River Valley. | Connecticut River
Valley—History.

CLASSIFICATION: LCC QH76.5.C8 L38 2016 (print) |
LCC QH76.5.C8 (ebook) | DDC 333.7209746—dc23

LC record available at https://lccn.loc.gov/2016032965

5 4 3 2 1

For Jelle Zeilinga de Boer (1934–2016),

Harold T. Stearns Professor of Earth Science, Wesleyan University,

BELOVED TEACHER, MENTOR, AND FRIEND

and to our children and grandchildren,

who will inherit the earth we leave behind:

ANNIE, JEFFREY, KEVIN, EMMA, AND KAITLYN

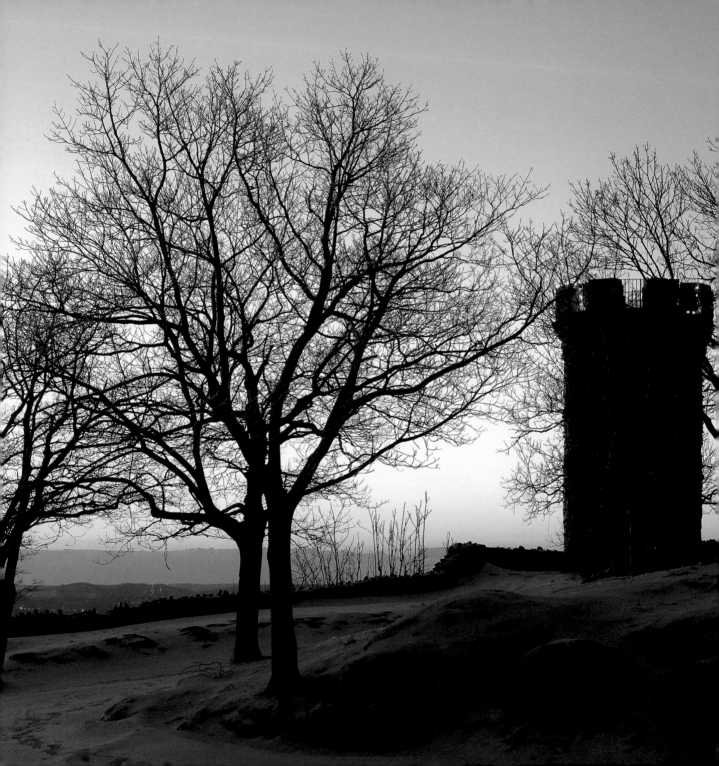

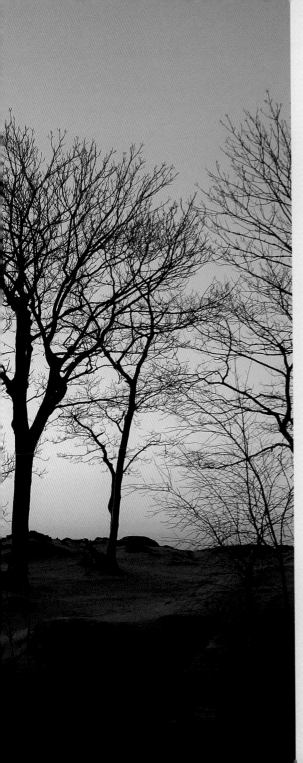

CONTENTS

Preface xi

Note on Terminology and Usage xiii

1 Welcome to Traprock Country 1

2 Rising in Shapes of Endless Variety 17
Geography of the Traprock Highlands

3 Born of Fire *Traprock Geology* 43

4 Sky Islands *Ecology and Water Resources* 71

5 A Valley of Extreme Beauty and Great Extent 121
Traprock Landscapes and Legacy

6 These Mural Cliffs 157
Sculpted by Nature, Painted by Time

7 So Fine a Prospect 197
Landscapes of National Significance

Appendix Places to Visit in Traprock Country 211

Notes 219

References 221

Index 229

Sunset lights up the cliffs of Beseck Mountain at Black Pond State Fishing Area, Middlefield, Connecticut.

PREFACE

This book is our love letter to a landscape and a call for action. We were both born in Meriden, Connecticut, and have lived all, or most, of our lives surrounded by the magnificent traprock crags of the central Connecticut Valley. The Hanging Hills, Mount Lamentation, Chauncey Peak, Mount Higby, and Beseck Mountain—dominating the local skyline—enticed us into countless youthful adventures among their peaks and ledges. These formative experiences motivated us to pursue separate careers in environmental science and the fine arts, following in the footsteps of scientists and artists who had studied and painted the traprock hills for more than one hundred years. As we practiced our respective crafts, the traprock ridges continued to whisper, speak, and sometimes shout: "Remember, respect, and protect us." So we returned—countless times spanning decades—to photograph, paint, research, write, lead tours, and lecture on the most stunning landscapes in southern New England.

After half a lifetime exploring, studying, and photographing the traprock highlands, we finally paused long enough to assemble our pictures and thoughts into this celebration. We hope that this book will inspire you to visit these landscapes of national significance for the first time, or return after a long absence.

Thank you for joining us on our tour through the traprock hills. Please support the conservation organizations managing the parks, preserves, and trails in the traprock highlands, including the Meriden Land Trust, Berlin Land Trust, Simsbury Land Trust, Ragged Mountain Foundation, Sleeping Giant Park Association, Peter's Rock Association, Friends of East Rock Park, Friends of the Mount Holyoke Range, the Nature Conservancy, Connecticut DEEP,

xi

Massachusetts DEC, and the Trustees of Reservations; and, especially, the Connecticut Forest and Park Association.

The authors are extremely grateful to the Beatrice Fox Auerbach Foundation Fund at the Hartford Foundation for Public Giving, and to Catherine Lapollo, for their generous funding in support of publication.

The following libraries provided essential reference material: the Libraries of Columbia University; Thomas J. Watson Library and Nolan Library, Metropolitan Museum of Art; the Patricia D. Klingenstein Library, New York Historical Society; the New York Public Library, especially the East 96th Street Branch, William Siefert, Manager; Olin Library, and the Science Library, Wesleyan University; Meriden Public Library; the New Haven Museum; the New Britain Museum of Art; the National Academy of Design, New York; the Connecticut State Library.

This project was supported and encouraged by many, including: Nick McDonald, Westminster School (ret.); Jelle Zeilinga de Boer, Wesleyan University; Dr. Paul E. Olsen, Columbia University; the Connecticut Landmarks Foundation; Jim Little, Connecticut Forest and Park Association; Gini Traub, Massachusetts DEC; Deborah Woodcock, Clark University; Elizabeth Farnsworth, New England Wildflower Society; Uwe Neiring, National Park Service (ret.); and Teresa Gagnon, Connecticut DEEP.

The authors especially thank Parker Smathers, Suzanna Tamminen, Jaclyn Wilson, and Marla K. Zubel at Wesleyan University Press; Cannon Labrie; and Susan Abel and Mindy B. Hill at the University Press of New England for their efforts on behalf of this project.

The authors are grateful to Bob's wife, Marcie Pagini, for her endless support and encouragement, including many hours of stimulating discussion about local history, and exciting field walks on the traprock hills. Peter is indebted to his dad, Lawrence, for taking him on his first hike up Chauncey Peak and instilling a love of nature, science, history, and art; Bob Pagini for his outstanding efforts on this project; and Annie, Peter's shining star, for absolutely everything.

xii

NOTE ON TERMINOLOGY
AND USAGE

Nearly all the geographic locations and topographic features discussed in this work are found in Connecticut and Massachusetts. Therefore, to spare the reader the tedious repetition of the state names, the author assumes that the reader will refer to the included maps, and has, or will gain, a passing knowledge of the major towns and cities in the Connecticut Valley. Thus, it is obvious within the geographic context that Springfield refers to the city in Massachusetts, and New Haven to the coastal city in Connecticut.

The early Connecticut Valley settlers referred to the alluvial terraces bordering the major rivers as "intervales." With easily worked, fertile, and well-watered soils, the intervales were important to the agricultural success of both the Native Americans and the Euro-Americans in the Connecticut Valley. The Connecticut Valley intervales rose to prominence as the most productive soils in the nation, a reputation based on high yields of grass and grains, and, beginning in the mid-nineteenth century, shade-grown and broadleaf tobacco. The term *prospect* was used in the nineteenth century to indicate a scenic view, hence, Prospect House on Mount Holyoke, Prospect Mountain, and so on.

Colloquial terms for basalt lava include *trap, trap rock, trap-rock, greenstone, bluestone*—to name a few; following modern usage, we will use *traprock* for any igneous rock of volcanic origin in the Connecticut Valley. The word *trap* derives from the Swedish *trappa* meaning "stairs" or "steps," and refers to the blocky appearance of the lava formations. We also use *diabase* rather than the European term *dolerite* for the coarse-grained rocks of basaltic composition found as dikes and sills intruded into the sedimentary layers.

The geographic term Connecticut Valley, or, as designated by William Mor-

ris Davis in the late 1800s, the Connecticut Valley Lowland, specifically refers to the elongate lowland underlain by sedimentary and volcanic rocks of Late Triassic and Early Jurassic age, extending from Greenfield, Massachusetts, to New Haven, Connecticut. Geologists refer to the main part of the Connecticut Valley as the Hartford basin and call the smaller northern extension the Deerfield basin, terms based on their particular rock types and geologic structures. The Connecticut River flows only through the northern and east-central part of the Connecticut Valley Lowland, from Gill, Massachusetts, to Middletown, Connecticut, where the river then cuts southeast through older Paleozoic-age crystalline rocks on its way to Long Island Sound.

Thus, the Connecticut River Valley and the Connecticut Valley, or Connecticut Valley Lowland, refer to separate but partly overlapping geographic features (see page 21). The northern part of the Connecticut Valley from Greenfield to Hatfield is known as the Deerfield Valley, a historic region of ancient towns and particularly fertile soils that support crops of high-quality tobacco. Although the Deerfield Valley shares a similar geologic origin, has a small area of traprock ridges, and is similarly rich in natural and cultural history, this work focuses on the main part of the Connecticut Valley, from Mount Holyoke in Amherst, Massachusetts, to East Rock in New Haven.

Although other traprock hills of similar geologic age and origin are found in eastern Pennsylvania, northern New Jersey and adjacent New York, the Southbury-Woodbury region of western Connecticut, and around the Bay of Fundy, none of those areas compare with the size, variety, visual interest, and cultural history of the volcanic landforms of the Connecticut Valley. Only the Palisades cliffs along the Hudson River are comparable in size and scenic qualities, but they lack the topographic complexity—the crags, promontories, notches, and mountain lakes—that make the Connecticut Valley so appealing.

Unlike the Berkshire, Green, and White Mountains, no common term was historically assigned to the chain of traprock ridges in the Connecticut Valley. Early writers including Silliman, Dana, and others, simply referred to the main

series of lava ridges as the Greenstone Range, Main Trap Range, Mount Tom Range, Blue Mountains, and other indefinite geographic terms.

The name Metacomet Ridge has been used to refer to the major chain of lava hills since it was first popularized in Bell's 1985 *The Face of Connecticut*; in 2008, the term was entered into the U.S. Board on Geographic Names database (GNIS—see http://geonames.usgs.gov). It remains a useful reference for the main trend of lava ridges, but the Metacomet Ridge does not encompass the series of diabase hills along the western side of the Connecticut Valley. In addition, the use of *ridge* causes confusion in the hierarchy of geographic names, since there are many local or subregional "ridges" in the Connecticut Valley, and the geographic term *ridge* refers to a local elevated feature of linear form. Raising its rank to "range" similarly causes problems, because there are a number of established "ranges" in the Connecticut Valley, including the Mount Tom Range and the Holyoke Range.

As the highest-rank geographic feature in the Connecticut Valley, the Metacomet Ridge, in this book is called the Metacomet Mountains, a term that respects the proper geographic hierarchy of the subordinate ranges, mountains, mounts, hills, and ridges, and more accurately reflects the rugged alpine aspect of the traprock crags. The name Western Range, first coined by William Morris Davis in 1898, is used for the chain of discontinuous diabase hills located along the western margin of the Connecticut Valley from West Rock to Manitook Mountain in Granby on the Massachusetts border.

The very definition of a mountain is also a matter of geographical debate, particularly where moderate elevations are characterized by extremely rugged terrain and sheer cliffs, as is the case with the traprock hills of the Connecticut Valley. Thus, the lava landforms have long been referred to as "mounts" and "mountains," even though they fall short of the classic geographic definition of that term—"more than 2,000 feet of complex elevated terrain."

Modern usage of the geographic term *mountain* varies widely, and, according to the U.S. Geological Survey, there are no standardized criteria for its defi-

nition, although abrupt topographic relief above the surrounding landscapes, and rugged terrain characterized by cliffs, promontories, and peaks, is implied. In the 1970s, the U.S. Board on Geographic Names abandoned its formal definition of a mountain as "1,000 feet of local relief," instead deferring to local, historical, and anecdotal usage.

Until the 1920s, the British Ordinance Survey defined a mountain as any topographic feature with an elevation of 1,000 feet or more. A 1995 movie *The Englishman Who Went up a Hill but Came down a Mountain*, humorously recounted the true story of a "hill" in Wales that was redefined as a mountain in 1917 after the locals constructed a rock cairn reaching the desired elevation. A 13-foot-high stone cairn was likewise built by hikers on Mount Katahdin in Maine, to bring its official height of 5,267 feet up to 5,280 feet, or one mile above sea level. Modern usage in Great Britain informally defines landforms with elevations of 2,000 feet or more as mountains, although there is no formal agreement or recognized standard for a minimum elevation.

That redoubtable arbiter of all things linguistic, the *Oxford English Dictionary* (1989), offers perhaps the most practical definition of the geographic term: "A natural elevation of the earth's surface rising more or less abruptly from the surrounding level, and attaining an altitude which, relatively to adjacent elevations, is impressive or notable." Further, the OED states that the difference between *hill* and *mountain* "is largely a matter of local usage, and of the more or less mountainous character of the district; heights, which in one locality are called mountains being in another reckoned merely as hills. A more rounded and less rugged outline is also usually connoted by the name [hill]."

The mountain geographer John Gerard states that "altitude alone is not sufficient to define mountains"; relative relief compared to the surrounding terrain, slope angles, and rugged or scenic aspect, are all taken into account when defining mountains and hills. A notable recent trend in Great Britain, the land of great crag walkers and peak baggers, uses "relative relief" or "topographic prominence," not only to distinguish between mountains and hills, but also to capture the effect of rugged terrain and steep slopes and cliffs in

A rugged notch invites hikers
and rock climbers into the
traprock highlands at Ragged
Mountain, Southington,
Connecticut.

the hiking experience. Therefore, a very tall rounded landform may be less of a "mountain" than smaller but more rugged crags.

Given their extreme topographic relief, nearly all the traprock ridges in the Connecticut Valley more than qualify as mountains. Robert Louis Stevenson tackled this same geographic dilemma when attempting to capture the alpine qualities of the legendary Salisbury Crags near Edinburgh. He artfully concluded that the rugged but relatively modest landform, strikingly similar to East Rock in New Haven, was "a hill for magnitude, a mountain in virtue of its bold design" (Stevenson 1879, 21).

Inasmuch as a single ridge may be referred to as Mount Higby or Higby Mountain, for example, the designations *mount, mountain, ridge,* and *hill* are used interchangeably in this book for the sake of readability, the flow of ideas, and the reader's patience.

The term *traprock highlands* (or *traprock ridgelands,* sensu LeTourneau, 2008) refers to the distinctive series of volcanic landforms in the Connecticut Valley, whether the rocks are of intrusive or extrusive origin. The traprock highlands are distinguished by their prominent elevations rising hundreds of feet above the valley floor, and by their characteristic tilted profile. According to geographic terminology, most of the Connecticut Valley traprock ridges may be classified as landforms called *cuestas*: hills formed from planiform or gently folded layers of rock that tilt, or dip, up to thirty degrees from horizontal (a *hogback* tilts more than thirty degrees). Cuestas are characterized by steep cliffs on their uphill, or upturned, edges, and may feature vast piles of broken rock, or talus, lying beneath the cliffs.

This book also designates the region from Ragged Mountain in Southington to Beseck Mountain in Middlefield as the High Peaks District because it displays the most dramatic "ridge and notch" topography in the Connecticut Valley, includes several of the highest summits, and has a striking similarity to the renowned Peak District in Derbyshire, England. In 1889, the leading American geographer of his time, William Morris Davis of Harvard, declared: "The

district of the Hanging Hills, between Meriden and Farmington, is among the most picturesque in southern New England" (Davis 1889, 78).

It is interesting to note that for centuries writers and artists have celebrated the similar rocky crags, or "fells," and sheer cliffs, or "edges," of northern England, including those in the Pennine Hills, the Yorkshire Dales, and the Peak District. Alfred Wainwright, the inveterate British fell walker, published an enormously popular series of illustrated hiking guides, still used today, featuring the crags of northern England. *Wainwright Walks*, a popular BBC television series, traced Wainwright's footsteps along landscapes remarkably similar to those of the Connecticut Valley. Had Wainwright ever traveled to Mount Holyoke, the Hanging Hills, or other traprock crags, he would have immediately felt at home.

Elevations cited in this book are measured in feet above mean sea level and were obtained mainly from the topographic maps and online databases of the U.S. Geological Survey, supplemented by trail maps from parks and preserves, and other resources. Accurate determination of the altitude of the most significant topographic elevations on the traprock summits proved to be one of the most challenging, and ultimately unsatisfying, tasks of this study. One expects that the spot elevations could easily, and consistently, be obtained from U.S. Geological Survey topographic maps, but that is not the case. In many instances, named prominences do not have accompanying spot elevations. To further compound the difficulties, the highest elevations are often not consistent with the elevations of named ledges or summits or surveying benchmarks, although they may be located nearby. For example, the highest point on West Rock Ridge is well north of the southern promontory called West Rock. In addition, many spot elevations are posted on "false summits" owing to the necessities of surveying, access, and land cover.

Comparing the USGS topographic map spot elevations with the GNIS creates additional difficulties. For example, the USGS topographic map gives a spot elevation of 1,024 feet for West Peak in the Hanging Hills; GNIS lists the elevation as 1,007. The "spot elevation" tool on the U.S. National Map Viewer

was also used to query elevations at specific locations on topographic maps or aerial photographs based on the 2010 LIDAR (laser interferometry distance and ranging), a state-of-the-art satellite-based system of determining topographic elevations. Therefore, the elevations given in this book are based on the "best available" information and may differ from elevations cited in other works or GPS measurements.

THE TRAPROCK LANDSCAPES

OF NEW ENGLAND

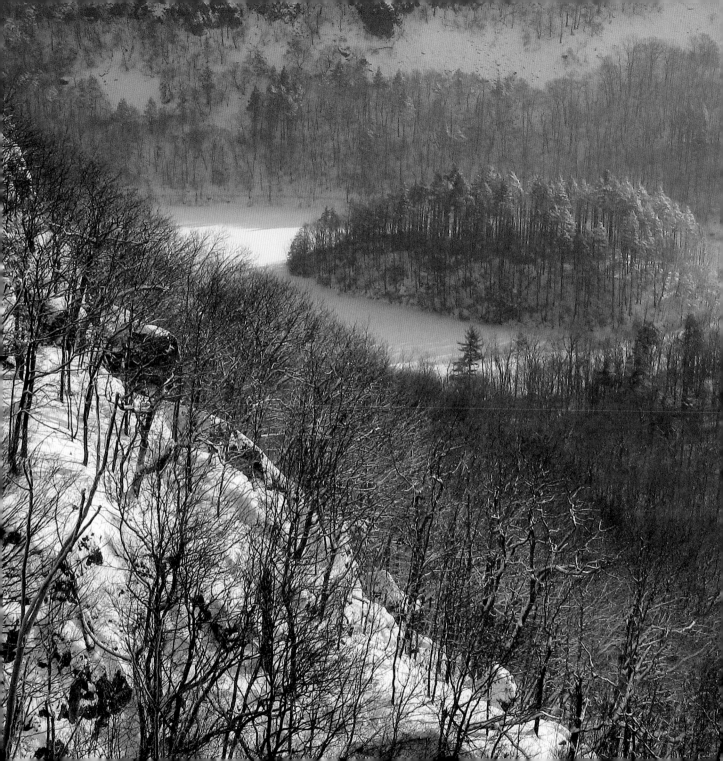

1

Welcome to
Traprock Country

The high and rocky mountains,

contrasted with the smiling

valleys altogether form . . .

one of the most magnificent

panoramas in the world.

E. T. Coke, *A Subaltern's Furlough* (1833)

Stone. Soil. Water. Forged by nature and sculpted by time, the Connecticut Valley is more clearly defined by the basic elements of the landscape than any other region in the United States. The city and culture of New Orleans may be inseparable from the Mississippi River and its delta, San Francisco owes its unique charm to its famous hills, the Bay, and the legendary Pacific fogs, but only in the Connecticut Valley are the boundaries of the cultural landscape so precisely limned by topography and geology. Travelers arriving in the Connecticut Valley realize that they have entered a landscape of special character with their first glimpses of the lofty traprock cliffs, the ledges of red-brown sandstone and shale, and the broad alluvial terraces bordering New England's largest river. There, the patterns of stone, soil, and water reveal the natural and cultural history of one of the most storied and celebrated landscapes in America.

To understand the history, culture, and character of the Connecticut Valley, we must travel through both geographic space and geologic time. Along the way, we will witness the planet-wrenching turmoil that created the bedrock foundation of the region, observe great ice-age glaciers scouring the land, watch successive waves of human occupation replace forests with fields of grass and grain, and finally arrive in a modern landscape of highways, houses, and commercial strips, bordered by rugged traprock cliffs that seem ageless in comparison.

Of all the natural features in the Connecticut Valley, none command more attention than the bold lava crags. With their barren windswept summits and deep rock-lined ravines, savanna-like meadows and cool broadleaf forests, and splashing cascades and sparkling lakes, the ancient volcanic ridges make up the most diverse and visually stunning landscapes in southern New England. Rising abruptly from the valley floor to elevations of more than 1,000 feet, the lava ridges are reminiscent of the legendary crags in northern England, including those in the Pennine Hills, the Yorkshire Dales, and the Peak District. Forming a dramatic backdrop for cities and towns from Northampton to New Haven, the traprock promontories offer expansive views that stretch to nearly one hundred miles in any direction, along with intimate maplike scenes of the

PREVIOUS PAGE The most spectacular alpine scenery in the Connecticut Valley is found at Merimere Notch in Meriden, Connecticut. Merimere Reservoir, Mine Island, and the talus slopes of South Mountain viewed from East Peak in Hubbard Park.

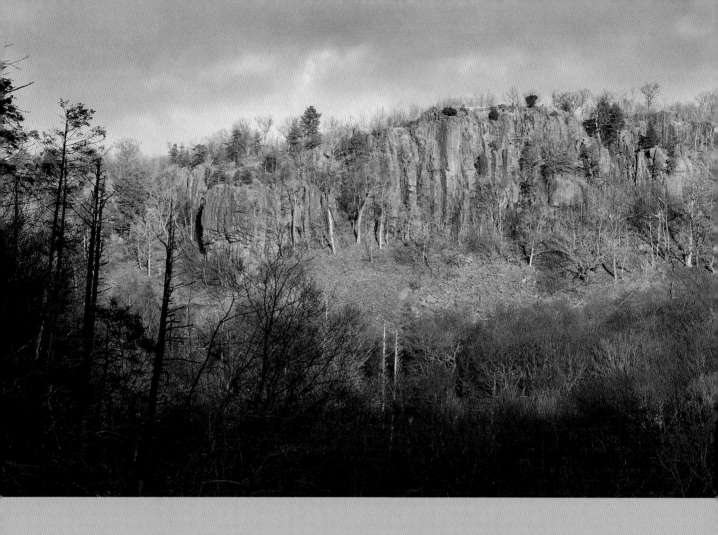

Massive walls of lava and vast talus slopes like these at South Mountain form fortresslike barriers along the length of the Connecticut Valley.

The sheer cliffs of Ragged Mountain in Southington, Connecticut, host the finest rock climbs in southern New England.

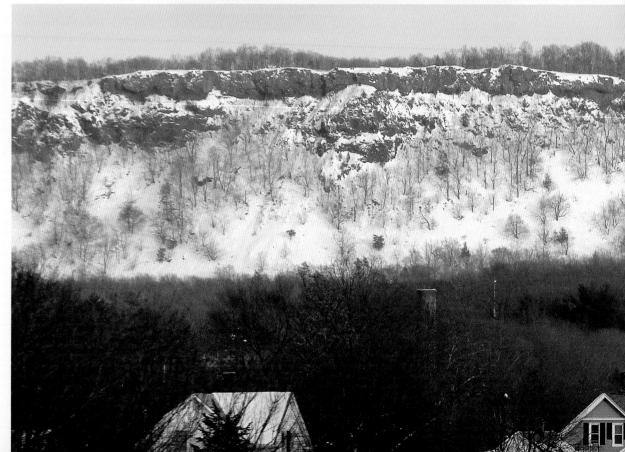

lands beneath the towering cliffs. Writing about the views from the traprock summits in 1820, the Yale professor Benjamin Silliman enthusiastically stated: "The bold scenery . . . and the rich and grand landscape, from their summits . . . can hardly be exaggerated."[1]

Influential nineteenth-century travel writers declared the Connecticut Valley traprock ridges the most beautiful landscapes in New England and world-class natural wonders. In 1821, Yale president Timothy Dwight called the view from Mount Holyoke "the richest prospect in New England, and not improbably in the United States."[2] Writing about his North American tour of 1832, the British adventurer and travel writer Lieutenant Edward T. Coke named the view from Mount Holyoke "one of the most magnificent panoramas in the world." Nathaniel Parker Willis described the same view as "the richest view in America,

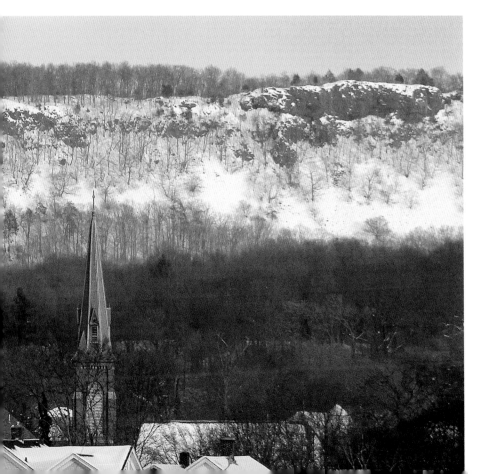

Timeless elements of the local landscape, lava crags form dramatic backdrops for towns and cities from Northampton to New Haven. Here, Higby Mountain looms over Meriden in the central Connecticut Valley lowland.

Gigantic basalt blocks form
natural monuments, such
as this trilithon reminiscent
of England's Stonehenge.
Cathole Peak, Meriden.

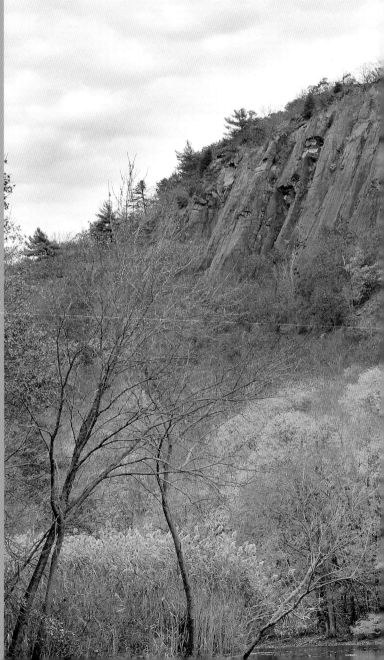

Visible for miles at sea, the
red-colored traprock cliffs
surrounding New Haven,
including East Rock, shown
here, are the most distinctive
rocky headlands on the
Atlantic coast south of Maine.
East Rock Park.

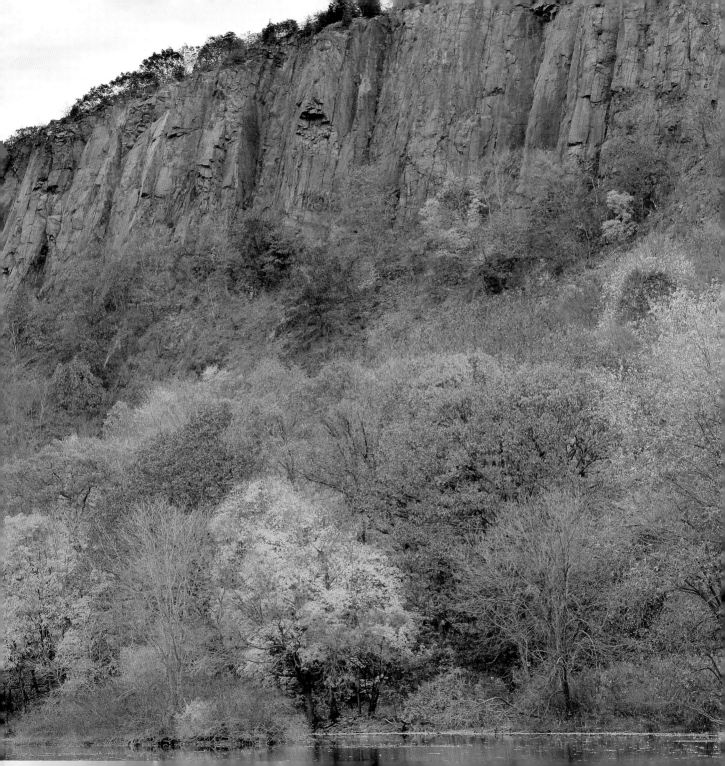

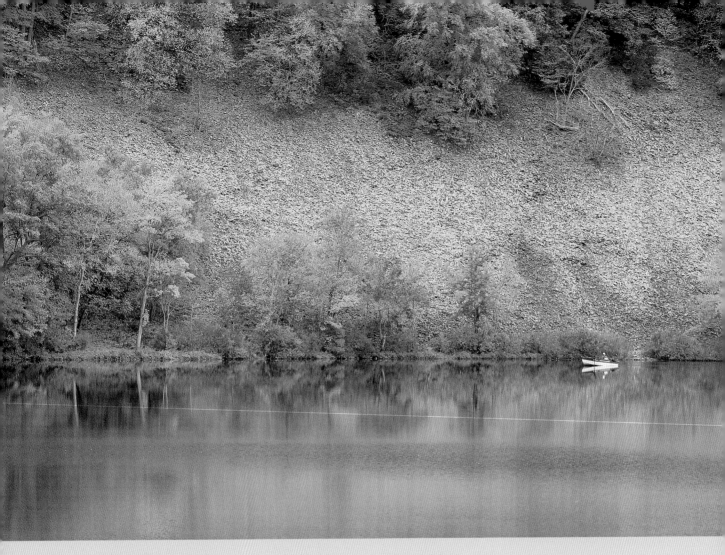

Framed by the steep talus
slopes of Beseck Mountain,
a boater enjoys the traprock
scenery at Black Pond,
Middlefield, Connecticut.

in point of cultivation and fertile beauty."[3] For Silliman, Dwight, Coke, Willis, and other early students of New England geography, the landscape of the Connecticut Valley was the living canvas on which the cultural expressions of a young nation—its agriculture, industry, religion, and civic functions—were laid down in strokes both bold and precise.

As a result of its favorable geography, robust economy, and long history of settlement, the Connecticut Valley emerged as a vital center of the arts and sciences. There, landscape painters, illustrators, geologists, geographers, and travel writers combed the traprock hills seeking scenic overlooks, interesting geologic features, and evidence of the economic, social, and cultural progress of the young nation as revealed in views of the thriving towns and villages that surrounded the stony heights. By the mid-nineteenth century, the characteristic "tilted" profiles of the Connecticut Valley traprock crags had become iconic

The skillful use of talus blocks by nineteenth-century masons created pleasing patterns in stone on English Bridge in New Haven's East Rock Park. The use of traprock for construction has deep roots in the Connecticut Valley.

American landforms, immediately recognizable at home and abroad. Views of East and West Rocks near New Haven, Meriden's Hanging Hills, Talcott (West) Mountain near Hartford, and Mounts Tom and Holyoke in the northern Connecticut Valley were widely disseminated in illustrated books, lithographs, paintings, and even collectible ceramics from England and Germany.

Following in the footsteps of the scientists, writers, and artists, landscape tourists flocked to the traprock crags in the Connecticut Valley from about 1830 to 1930. To accommodate the rising flow of visitors, entrepreneurs developed some of the earliest and most elaborate mountaintop facilities in the nation at East Rock, Sleeping Giant, the Hanging Hills, Talcott Mountain, Mount Tom, and Mount Holyoke, including rustic refreshment pavilions, elegant hotels, observation towers, a tramway (Mount Holyoke), and a cable railroad (Mount Tom).

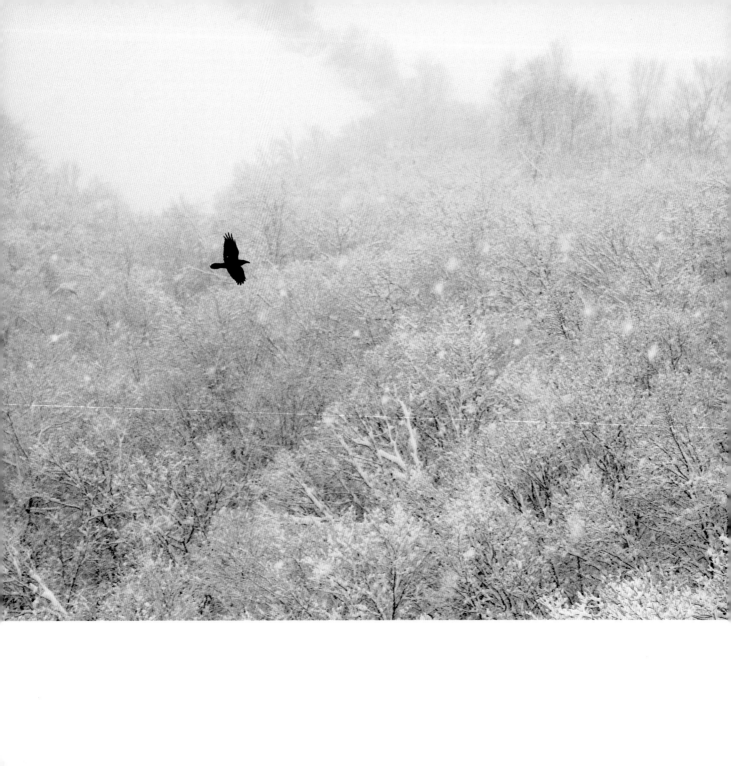

The sight of a raven soaring
through a gentle snowfall is a
reminder of the importance
of open space in the highly
populated region. Chauncey
Peak, Meriden.

Encased in frozen fog, the
ancient traprock cliffs of
Chauncey Peak seem to
rise out of the mists of time.
Though the cliffs are wrapped
in lush growth in summer,
winter brings out a fiercer as-
pect that gave rise to eerie tales
and legends in earlier times.
Giuffrida Park, Meriden.

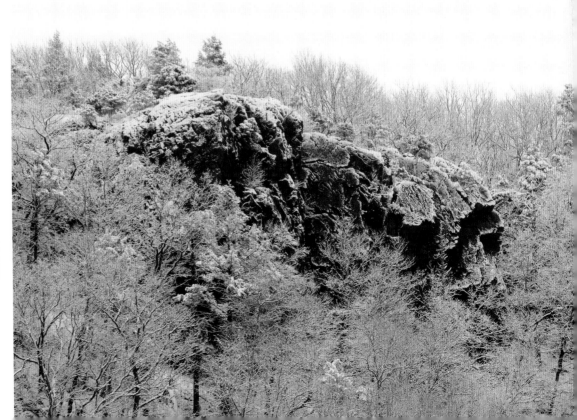

Autumn colors paint the
surface of a traprock reservoir
with an impressionist's brush.
Numerous lakes and ponds
nestled within the traprock
hills reflect the beauty of the
surrounding cliffs and crags.
Merimere Reservoir, Meriden.

Droplets of pure water captured
high on the traprock ridges
replenish dozens of public-
supply reservoirs throughout
the region. Protected watershed
lands form the backbone of the
regional open-space corridor.

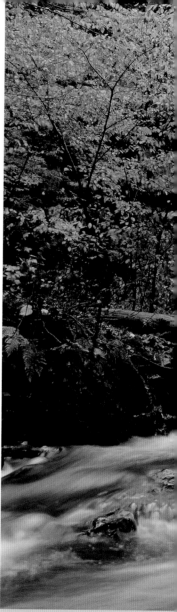

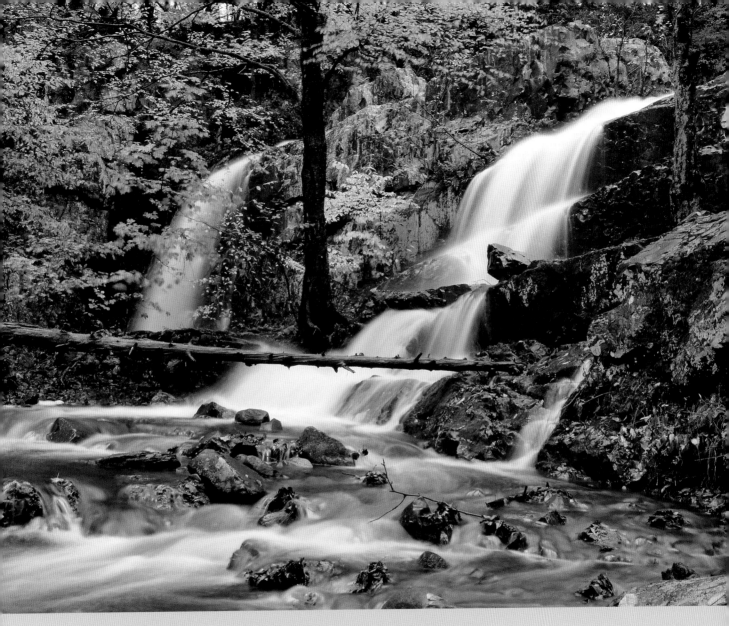

Aptly named Fall Brook drops more than twenty-five feet over ledges of Hampden basalt at Westfield Falls on the northwestern flank of Mount Higby. The Connecticut Valley hosts an unusually high concentration of cascades and waterfalls created by the rugged traprock terrain. Miner Road, Middletown, Connecticut.

Ancient eastern red cedars,
like this weather-beaten
specimen, assume bonsai-like
forms under harsh summit
conditions. Some trees
clinging to the cliffs are among
the oldest in southern New
England. West Peak, Meriden.

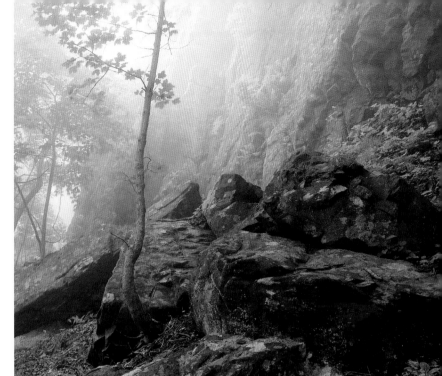

Car-size talus blocks form
buttresses at the base of
the massive cliffs of East Peak
in Meriden.

Once embedded in the national iden-
tity and the emerging American landscape
aesthetic, by the mid-twentieth century the
traprock cliffs had largely become forgot-
ten relics of an earlier age. Fortunately, in
the 1970s and 1980s a rising interest in out-
door pursuits and increased environmental
awareness led to a new appreciation of the unique ecological and recreational
values of the traprock highlands. Today, more than fifty municipalities, dozens
of nonprofit organizations, two states—Connecticut and Massachusetts—and
the National Park Service are managing the parks, conservation easements,
open-space parcels, and trails on the traprock ridges with renewed vigor.

Because the traprock highlands clearly meet the National Park Service crite-
ria for "landscapes of national significance," we hope that this book will serve
as impetus for establishing a Connecticut Valley National Heritage Corridor
following the example of the very successful Blackstone River Valley Heritage
Corridor and National Park in nearby Rhode Island and eastern Massachusetts.

We are excited that you are joining us on our journey through the traprock
hills of the Connecticut Valley, landscapes that the Amherst College geolo-
gist Edward Hitchcock so aptly described as "the grand and beautiful united."

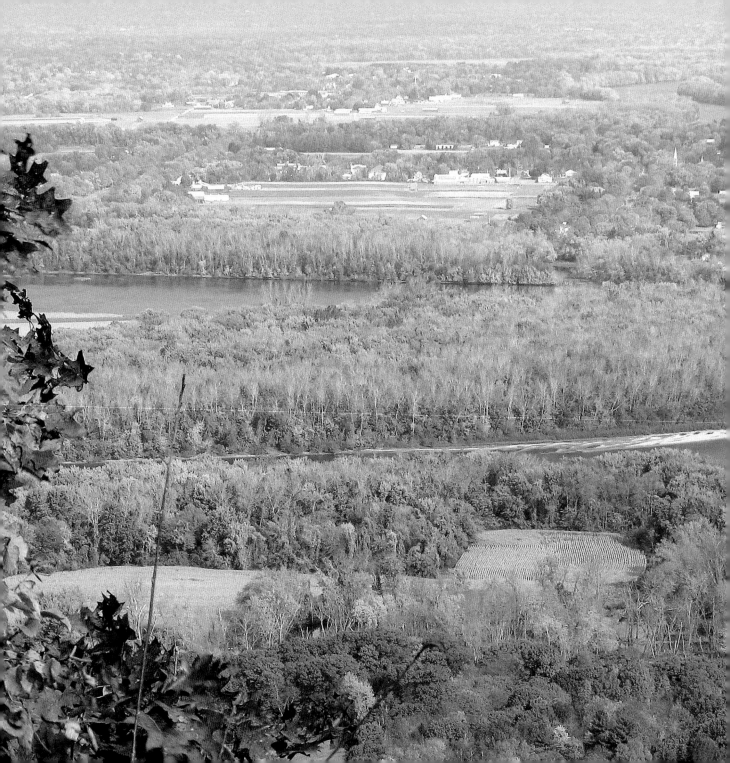

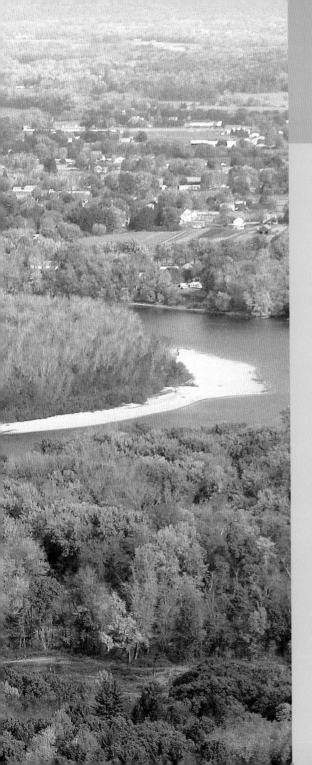

2

Rising in Shapes
of Endless Variety

GEOGRAPHY OF THE
TRAPROCK HIGHLANDS

The whole of this magnificent
picture, including in its vast extent,
cultivated plains and rugged
mountains, rivers, towns, and
villages, is encircled by a distant
outline of blue mountains, rising in
shapes of endless variety.

Benjamin Silliman, *Remarks Made
on a Short Tour between Hartford and Quebec
in the Autumn of 1819* (1820)

With its long and storied cultural history, interesting rocks and minerals, fascinating fossils, rich soils, and distinctive landforms, the Connecticut Valley is a region that holds special meaning for geographers, geologists, paleontologists, farmers, writers, artists, historians, landscape tourists, outdoor enthusiasts, and, surprisingly, even cigar aficionados. A locus for important cultural, scientific, technological, academic, agricultural, and economic developments in the nineteenth and twentieth centuries, the Connecticut Valley continues today as a vital center of technology, education, and finance.

For geographers, the Connecticut Valley is the elongate lowland in central Connecticut and Massachusetts. Comprising the most prominent physiographic feature in southern New England, the Connecticut Valley, with its chain of traprock hills, is clearly visible in satellite imagery. On the ground, the Connecticut Valley is recognized not only by its lowland topography, but also by its distinctive geology. The main part of the Connecticut Valley measures about 85 miles long from Northampton to New Haven and just over 20 miles from east to west at its widest point north of Hartford. The historic Deerfield Valley is a small northern extension of the main Connecticut Valley measuring about 5 miles wide and 15 miles in length from Greenfield to Amherst, Massachusetts.

The terms *Connecticut Valley* and *Connecticut River Valley* refer to separate, but partly overlapping, geographic features, a fact that has caused considerable consternation among geographers at least since the late 1800s, when Harvard's William Morris Davis outlined the characteristics of the two distinct regions. Even more vexing for geographers is the fact that, although the Connecticut River appears comfortably ensconced in the Connecticut Valley lowland, it nonetheless makes an abrupt easterly exit at Middletown by cutting through more resistant Paleozoic-age metamorphic and igneous rocks of the Eastern Highlands on its way to Long Island Sound. Thus, the name Connecticut River Valley refers to the lowlands surrounding the largest river in New England, a watercourse that passes through the northern part of the Connecticut Valley on its 410-mile journey from the Connecticut Lakes in northern New Hampshire to Long Island Sound at Old Saybrook, Connecticut.

PREVIOUS PAGE According to noted landscape historian John Brinckerhoff Jackson, the rich soils and mild climate of the Connecticut Valley offered the early English settlers their "first reassuring glimpse of the rich New World they had dreamt of, but had failed to find on the shores of Massachusetts Bay." View of the Connecticut River from Mount Holyoke, looking north.

Viewed from Chauncey Peak, the Metacomet Mountains form a great wall from Mount Higby near Middletown (*left*), to Beseck Mountain, Middlefield (*center*), and Pistapaug Mountain, Durham (*right*). These formidable landforms exerted a strong influence on patterns of settlement and travel corridors. George Washington passed through the rugged gap between Pistapaug and Fowler Mountains when he traveled from Wallingford to Durham, Connecticut, first in 1775 to gather supplies for his soldiers, and again on his presidential tour of 1789. Historical monuments in East Wallingford and Durham, Connecticut mark the route.

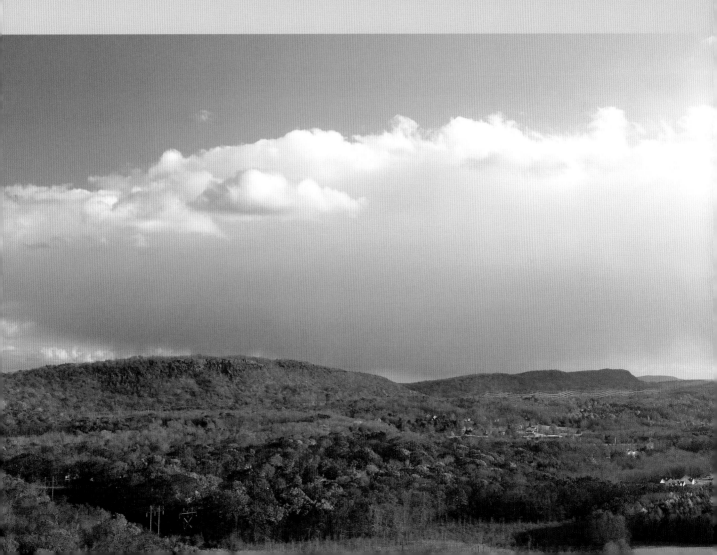

For farmers and students of New England history, the Connecticut Valley is synonymous with rich soils possessing a favorable mixture of sand, silt, and clay, high organic content, and good water-holding capacity. From the Woodland Period through the early years of European contact, the alluvial terraces bordering the Connecticut River and its major tributaries supported substantial Native American villages with a nutritious triumvirate of corn, beans, and squash, supplemented by fish and game from adjacent waters and forests. The Dutch explorer and trader Adriaen Block was the first European to explore the Connecticut Valley by mapping the Red Hills (Rodenbergh) region near New Haven and sailing up what he called the Versche, or "Fresh," River as far as the Enfield rapids in 1614. Attracted by the abundance of beaver, muskrat, and other furs, Dutch traders established Huys van Hoop (the House of Hope), a profitable but short-lived outpost at present-day Hartford, to process pelts arriving from the interior hinterlands. More interested in furs than farming, and facing the inevitable decline of an economy based on the reproductive rates of small mammals, as well as rapidly increasing numbers of English settlers who began arriving in the early 1630s, the Dutch began ceding their interest in the Connecticut Valley by the mid-1600s.

Lured to the Connecticut Valley by reports of arable lands bordering the Connecticut River and hopes of cutting into the Dutch fur trade, the English established the earliest permanent settlements in the region at Windsor (1633), Wethersfield (1634), Agawam (1635), Hartford (1635–37), and Springfield (1636), followed by Farmington (1640), Longmeadow (1644), Middletown (1651), Northampton (1653), and Deerfield (1673). According to the noted landscape historian John Brinckerhoff Jackson, the productive soils, ample precipitation, and long growing season of the Connecticut Valley provided the English with "the first reassuring glimpse of the rich New World they had dreamt of, but had failed to find on the shores of Massachusetts Bay."[1]

Setting the benchmark for agricultural productivity in New England, the Connecticut River "intervales" were widely sown with wheat and rye in the early years. In his exhaustive history of New England farming, *A Long Deep Furrow*

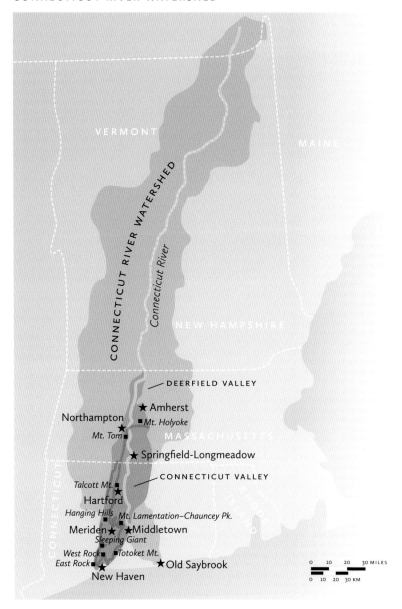

CONNECTICUT RIVER WATERSHED

VERMONT

MAINE

Connecticut River

NEW HAMPSHIRE

DEERFIELD VALLEY

★ Amherst

Northampton
■ *Mt. Holyoke*

Mt. Tom ■ ★

MASSACHUSETTS

★ Springfield-Longmeadow

CONNECTICUT VALLEY

Talcott Mt. ■

★ Hartford

Hanging Hills *Mt. Lamentation–Chauncey Pk.*

CONNECTICUT

Meriden ★ ★ Middletown

Sleeping Giant

West Rock ■ ■*Totoket Mt.*

East Rock ■ ★ ★ Old Saybrook

New Haven

| 0 | 10 | 20 | 30 MILES |
| 0 | 10 | 20 | 30 KM |

The Connecticut Valley and the Connecticut River Valley are separate, but overlapping, geographic regions. After flowing through the Connecticut Valley for more than seventy miles, the Connecticut River exits the central lowland at Middletown, Connecticut.

(1982), Howard Russell rightly called the Connecticut Valley "the continent's first wheat belt . . . the . . . breadbasket of New England: first the area around Hartford, then the middle section" (that is, from Northampton to Springfield). Production of wheat on the Connecticut River intervales was so successful that the Pynchon family, among the first settlers of Springfield, shipped around 1,500 to 2,000 bushels of the valuable grain to Boston each year, beginning in the late 1660s. Wheat from the northern Connecticut Valley also relieved a severe famine in Virginia in 1674. After a series of wheat rust blights, the farmers realized that the warm humid lowlands were more favorable for corn and hay, crops that came to dominate the central and northern Connecticut Valley.

Today, with sprawling housing developments and commercial strips dominating the landscape, it is hard to picture the vast amount of land under cultivation by the early nineteenth century. Referring to the Connecticut Valley in 1810, the New England geographers Jedidiah Morse and Elijah Parish declared: "The most important production of New England is grass. This not only adorns the face of the country, with a beauty unrivaled in the new world, but also furnishes more wealth and property to its inhabitants, than any other kind of vegetation. A farm of two hundred acres of the best grazing land, is worth, to the occupier, as much as a farm of three hundred acres of the best tillage land."

Cresting a traprock ridge near Rocky Hill south of Hartford in 1833, British travel writer Edward T. Coke was impressed by the "magnificent view of . . . the light yellow corn fields covering the whole extent of the valley to a range of forest covered hills 20 miles distant." Nearby Wethersfield, one of the oldest of the "river towns," produced such prodigious crops of red onions in the sandy alluvial soil that travelers in the early 1800s noted that they could detect the pungent vegetable aroma far outside the village bounds.

The agricultural success of the river towns of the Connecticut Valley was soon joined by remarkable progress in craftsmanship and early manufacturing, the establishment of important academic and political institutions, as well as the founding of vibrant centers of national and international trade and commerce in New Haven, Hartford, and Springfield. By the early 1800s, the Connecticut

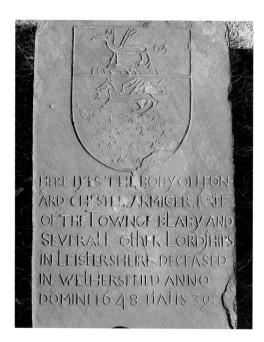

HERE LYES THE BODY OF LEON-
ARD CHESTER ARMIGER LATE
OF THE TOWNE OF BLABY AND
SEVERALL OTHER LORDSHIPS
IN LEISTERSHEIRE DECEASED
IN WETHERSFEILD ANNO
DOMINI 1648 HATIS 39.

The "river towns" of the Connecticut Valley, including Wethersfield (1634), are among the earliest permanent English settlements in New England. One of the oldest gravestones in Connecticut, dated 1648, belongs to Leonard Chester, an original settler of the town. He was allegedly lost for several days in the traprock hills, where he was beset by snakes and a fiery dragon, ordeals that gave rise to the geographic name Mount Lamentation. Image: author.

Valley was firmly established as the model of American productivity, wealth, and ingenuity—factors, along with the scenic volcanic landscapes, that would elevate the region to national prominence, and make it one of the foremost destinations for landscape tourism into the early twentieth century.

For cigar aficionados and agricultural historians, the Connecticut Valley is inseparable from fine shade-grown and broadleaf tobacco. Once noted for exceptionally high yields of hay and grain, by the late 1800s high-quality tobacco, mainly used for cigar wrappers, became the hallmark of Connecticut Valley agriculture in the region from Deerfield to Hartford. To simulate the very warm, humid, and cloudy climate of exotic tropical locations like Sumatra, Cuba, or Honduras, Connecticut Valley growers adopted the unique method of growing tobacco under large fabric enclosures. The tobacco "tents" also protected the large, but easily damaged, leaves from drying winds, harsh sunlight, and the deleterious effects of frequent summer thunderstorms. Long a premier vari-

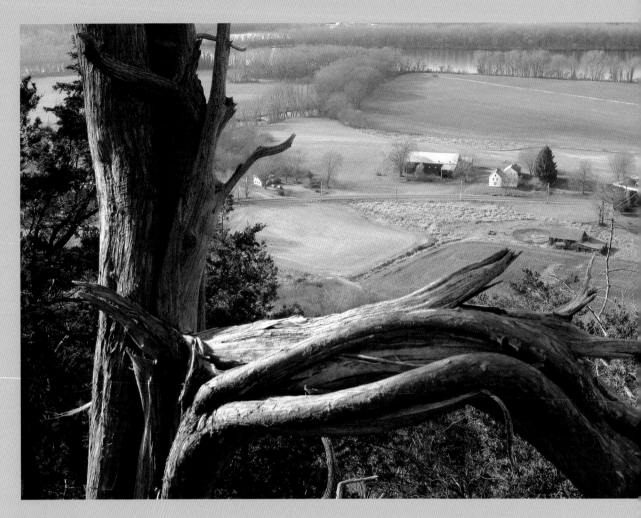

The fertile alluvial terraces, or "intervales," bordering the Connecticut River fostered some of the earliest permanent settlements in southern New England. View from Mount Holyoke.

ety, both shade-grown Connecticut Valley tobacco, and carefully tended sun-grown broadleaf, continue to command high prices as the preferred wrapper for the finest cigars. Although many tobacco fields were lost to housing developments, office parks, and commercial strips in the latter half of the twentieth century, the cultivation of tobacco remains an important part of the northern Connecticut Valley economy and an agricultural practice of historical significance.

25

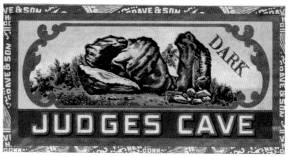

While hay, corn, and tobacco reigned supreme in the northern Connecticut Valley, fruit orchards and dairy farms came to dominate the region south of Hartford. There, broad, streamlined glacial hills called *drumlins* proved ideal for apples and other native fruits because of their well-drained soils, favorable solar exposure, and a reduced chance of damaging late frosts in comparison to the colder surrounding valleys. Beginning in the 1700s, many family-owned orchards were established on the higher terrain adjacent to the traprock ridges, including Lyman Orchards in Middlefield (1741); Norton Brothers (1750s) and Drazen (early 1800s), both in Cheshire; Rogers in Southington (1809); Bishop's (1871) in Guilford and near Totoket Ridge in North Branford; Blue Hills Orchards (1904) on the northern flank of Sleeping Giant ridge in Wallingford; and High Hill Orchards (early 1900s) in East Meriden near Beseck Mountain.

Similarly, dairy farmers found the well-drained drumlin hills better for grazing cows and growing hay than either the marshy alluvial lowlands or the stony traprock ridges. Today, only a few working dairy farms remain, but through the early twentieth century dozens of milk producers prospered on the glacial hills of the central and southern Connecticut Valley.

Because of the difficulties presented by their challenging terrain, the traprock

Tobacco has been a vital part of the agricultural history and culture of the Connecticut Valley since the 1700s. Early mid-twentieth-century cigar box with illustrations based on paintings by the renowned nineteenth-century artist George H. Durrie of New Haven. TOP Inside cover: West Rock and Westville. BOTTOM Side panel: Judge's Cave on West Rock. Images: author's collection.

The Eli Whitney Museum, Whitneyville, Connecticut. Taking advantage of the waterpower available at the traprock ledges between East Rock and Mill Rock north of New Haven in 1798, Eli Whitney, inventor of the cotton gin, revolutionized American manufacturing by using interchangeable parts to produce firearms and other metal goods. Local traprock was used to build many structures, including the coal shed seen here, through Ithiel Town's innovative lattice-truss bridge. An icon of the New England landscape, Town's modular design was an efficient and cost-saving solution for crossing the numerous streams and rivers in the region.

View of Hartford from Talcott Mountain near Farmington, Connecticut. An economic powerhouse founded on finance, precision manufacturing, and tobacco, Hartford long boasted the highest per capita income in the United States. Referring to its opulent homes, magnificent civic architecture, and shady, elm tree–lined streets, Hartford resident Samuel Clemens, better known as Mark Twain, stated, "Of all the beautiful towns it has been my fortune to see, this is the chief. . . . You do not know what beauty is if you have not been here."

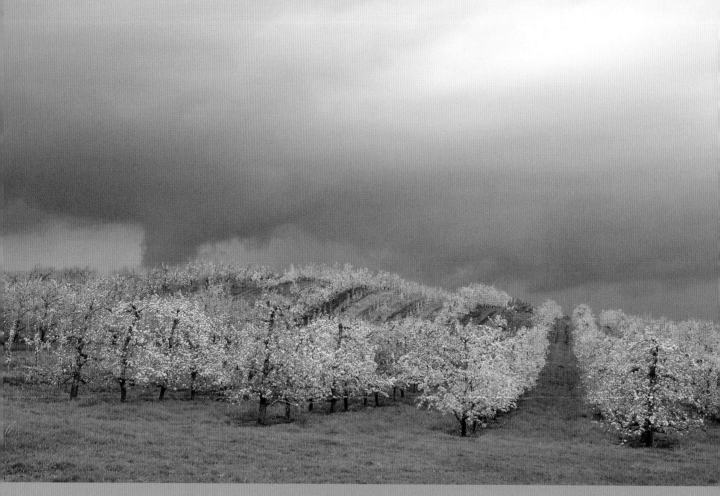

Lyman Orchards, which has been
providing high-quality fruit and
produce since 1741, is a major tourist
attraction featuring a farm market,
pick-your-own fruits and pumpkins,
seasonal activities, and three golf
courses.

Established on the northern flank of Sleeping Giant ridge in 1904, Blue Hills Orchard overlooks Meriden's Hanging Hills—from *left* (west) to *right* (east), West Peak, East Peak, Merimere Notch, and South Mountain. The prominent "step" beneath West Peak (*left*) is the Talcott Basalt, the oldest (lowest) lava flow in the Connecticut Valley.

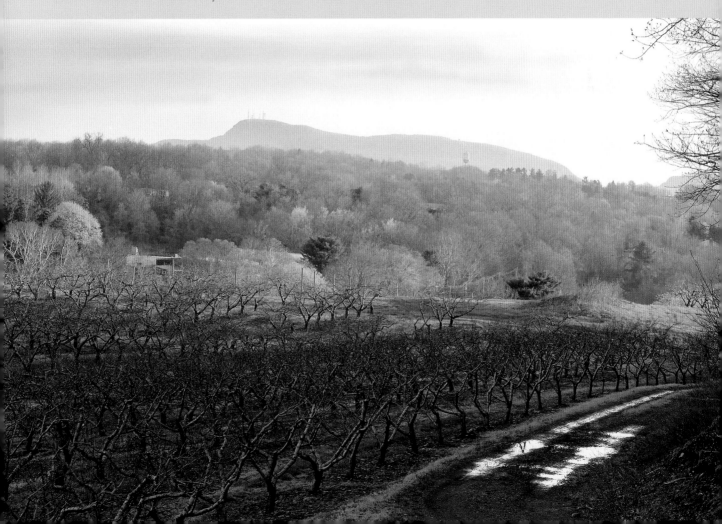

hills did not participate in the early agricultural productivity of the alluvial intervales or the glacial drumlins and remained marginal hinterlands of limited value. The steep slopes and thin, stony soils of the traprock highlands allowed only marginal grazing, and the dry montane forests were extremely slow to recover from cutting. Echoing the general opinion about the traprock highlands in their 1704 report to the Connecticut Colony, surveyors Thomas Hart and Caleb Stanley found Mount Higby "almost wholly consisting of steep rocky hills, and very stony land, we judge . . . to be very mean, and of little value."[2]

By the late 1800s, however, the growth of the major cities and towns brought a newfound appreciation of the traprock hills as valuable watersheds, and numerous water-supply reservoirs were constructed along the length of the Connecticut Valley. Even in the modern era, the formidable slopes, shallow depth to bedrock, and the difficulties of providing water and on-site sewage treatment precluded most residential and commercial developments on the traprock hills. As a result, the volcanic ridges remained largely undeveloped, becoming the most important natural corridor in southern New England, a vital green belt called "Connecticut's Central Park" by Wesleyan professor Jelle de Boer.

Meteorologists associate the Connecticut Valley with a distinct climate corridor in southern New England typified by warm humid summers and mild winters in comparison to the cooler surrounding hills. The floor of the Connecticut Valley rises from sea level at New Haven to an average of about 150

30 Taking advantage of the long steady slopes and snowy New England winters, Mount Tom Ski Area in Holyoke, Massachusetts, and Powder Hill Ski Area (now Powder Ridge) at Beseck Mountain in Middlefield, Connecticut, were developed during the alpine-skiing boom of the mid-twentieth century.
LEFT TO RIGHT Postcards from 1960s: Mount Tom Ski Area; the "Big Tom" trail; NASTAR race day at Mount Tom; Powder Hill Ski Area. Images: author's collection.

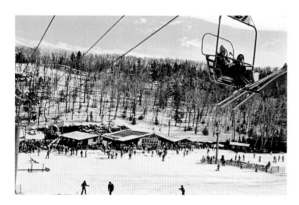

feet above sea level near Northampton; many glacial hills and terraces form elevations over 250 feet throughout the valley. As a result of its generally moderate elevations the Connecticut Valley enjoys a long growing season, averaging about 165 days in Hartford, but ranging from a high of 207 days in New Haven to a low of 125 days in Amherst. Precipitation is evenly distributed throughout the year, but occasional droughty periods typically occur in late summer. The central and northern Connecticut Valley average about 45 inches of precipitation annually; the southern coastal region near New Haven is slightly wetter with about 47 inches of precipitation. Summers in the Connecticut Valley are warm and humid, with an average high temperature in July of about 82°F. The generally mild winters have average high temperatures ranging between 30°F and 40°F, characterized by rain and freezing rain near New Haven, and snow north of Hartford.

The cold average winter temperatures and the long steady slopes of the traprock ridges fostered the development of two major ski areas in the Connecticut Valley. Powder Ridge Ski Area on Beseck Mountain in Middlefield, Connecticut, has been in operation nearly continuously since the 1950s. Mount Tom Ski Area operated on the traprock ridge of the same name near Holyoke from 1962 to 1998. Both Powder Ridge and Mount Tom ski areas were pioneers in the technology of snowmaking, necessary to supplement the unreliable natural snow.

For physical geographers and artists the signature landscape elements of the

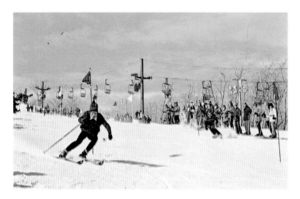

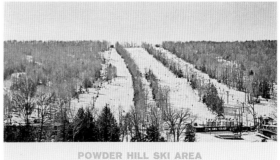

POWDER HILL SKI AREA
Middlefield, Connecticut

Snow softens the traprock landscapes at the former Bilger Dairy farm in Meriden. The early twentieth-century farm buildings seen here were built on ledges and outcrops of lava.

OPPOSITE Now part of the Meriden Land Trust, the green pastures of the former Bilger Dairy nestle beneath the cliffs of Chauncey Peak, Meriden, Connecticut. Dozens of family-owned dairy farms once flourished on the rolling glacial hills in the central Connecticut Valley. Today, only a few working dairy farms remain.

BELOW Hayfields in the central Connecticut Valley. With warm, moist summers and mild but often snowy winters, the Connecticut Valley enjoys the longest frost-free growing period in southern New England, exclusive of the coastal zone. Owing to the favorable climate, the Connecticut Valley produced some of the highest and most profitable yields of hay and corn in the nation in the early to mid-nineteenth century. Westfield Road, Meriden.

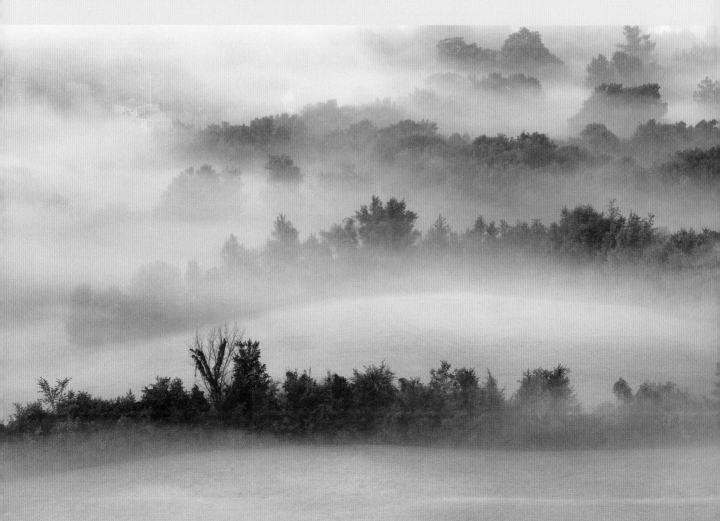

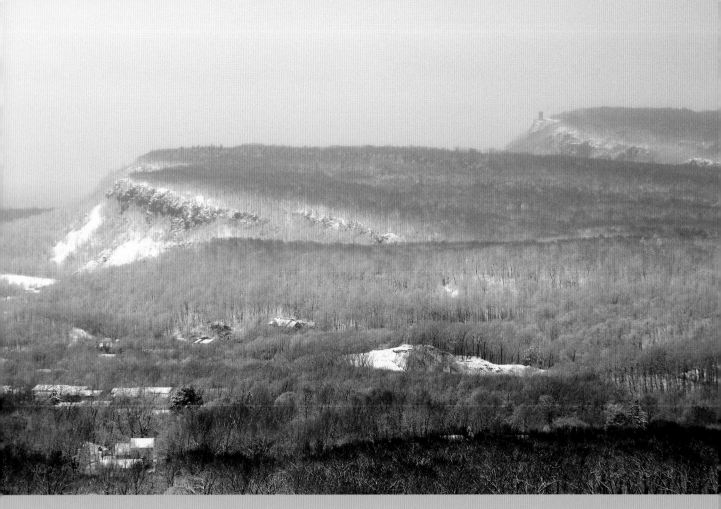

The Hanging Hills, including, *from right rear to middle foreground*, East Peak, Merimere Notch, South Mountain, Cathole Notch, and Cathole Peak, are the most rugged and picturesque traprock landforms in the Connecticut Valley. Termed *cuestas* by physical geographers, the characteristic "tilted" landforms were created by eons of earth movement and erosion. View from Chaucey Peak.

Connecticut Valley are the "tilted" traprock ridges, or *cuestas*, with steep cliffs on their upturned edges and extensive upper surfaces sloping about 15 degrees. The ridges generally have west-facing cliffs and east-dipping slopes, but their particular configuration depends on the local trend of geologic structures. In the southern Connecticut Valley, the crescent-shaped trends of Totoket Mountain and Saltonstall Ridge result from regional-scale folds in the rock layers. A broad fold also creates the unusual east-west orientation of the Holyoke Range in the northern Connecticut Valley. Numerous faults that offset the traprock layers in the central Connecticut Valley created the spectacular "crag and notch" topography in the picturesque region from Mount Higby to Ragged Mountain.

Rising abruptly in amphitheater-like ranks of rugged talus slopes and sheer cliffs, the traprock hills of the Connecticut Valley have a greater topographic prominence than many of the taller but more rounded mountains in New England. Thus, these "mountainous hills" project a more dramatic alpine aspect than anticipated from their relatively moderate elevations. For example, the southern cliffs of East Rock and West Rock near New Haven reach elevations of only about 350 feet and 400 feet, respectively, but because they rise in sheer cliffs from the tidal creeks at their base, they tower over the city, and once served as important landmarks for ships navigating Long Island Sound. A great east-west-oriented inlier of the Western Range, the Sleeping Giant massif (el. 708 ft.) in Hamden commands the Quinnipiac River lowlands as the largest isolated traprock landform in the Connecticut Valley. Noteworthy as the highest summits near the Atlantic coast south of Maine, West Peak (el. 1,024 ft.) and East Peak (el. 978 ft.) of Meriden's Hanging Hills similarly dominate the topography of the central Connecticut Valley. Mount Tom (el. 1,202 ft.), the tallest traprock summit in the Connecticut Valley, towers more than 1,000 feet above the Manhan River valley near Easthampton, Massachusetts. Nearby, the western cliffs and ledges of Mount Holyoke drop more than 800 feet to the extensive agricultural fields on the Connecticut River floodplain.

Because of the sheer number of traprock peaks, crags, cliffs, and ridges making up the volcanic landforms of the Connecticut Valley, and a long history of

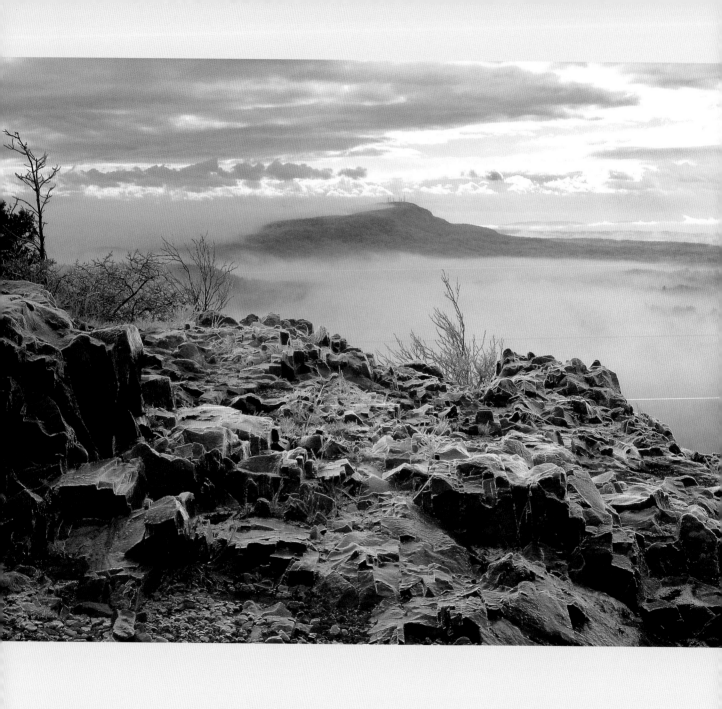

OPPOSITE Rising to an impressive elevation of 1,024 feet, West Peak (*background*) is the highest traprock summit in the Connecticut Valley south of Mount Tom in Massachusetts, and the tallest peak located within twenty-five miles of the Atlantic coast south of Maine. View from Ragged Mountain.

Illuminated by evening alpenglow, Ragged Mountain's sheer cliffs project an alpine majesty lacking in many of the taller, but more rounded, mountains of New England.

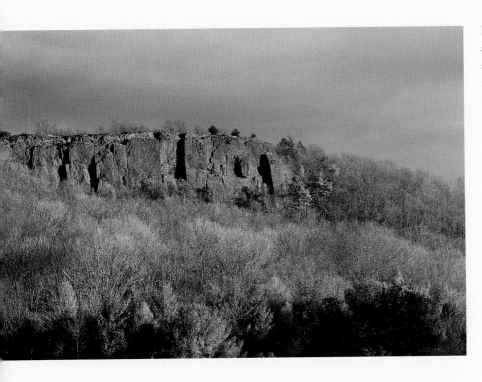

RIGHT The "blue hills" of the Western Range stand high above the misty Quinnipiac River lowland. From north to south along the horizon (*right to left*), Peck Mountain, Mount Sanford, High Rock, and the north end of West Rock Ridge form a line of lesser-known traprock peaks on the southwestern edge of the Connecticut Valley.

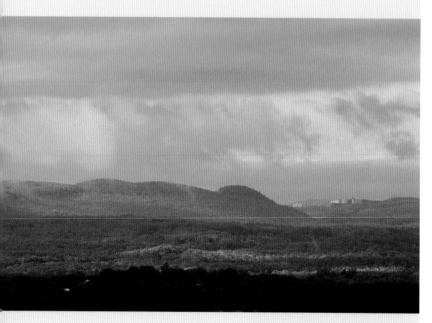

ABOVE In the legends of the Quinnipiac River tribes, Sleeping Giant (Mount Carmel) ridge was the reclining form of the giant, Hobbomock, put to sleep for all time for his mischievous deeds. Today, the diabase ridge is part of popular Sleeping Giant State Park, where dozens of hiking trails, a stone lookout tower, and picnic facilities await outdoor enthusiasts.

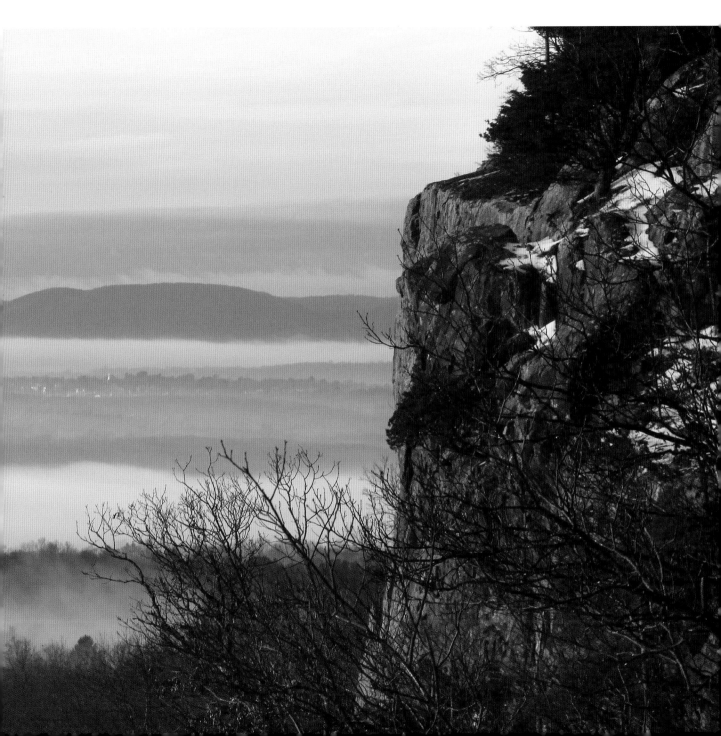

The two main trends of traprock hills in the Connecticut Valley result from slight differences in their geology. The Metacomet Mountains, from Saltonstall Ridge to Mount Holyoke, are made up of basalt, which is fine-grained lava that cooled quickly at or near the surface. The Western Range, from East Rock to Manitook Mountain, formed from basaltic magma that cooled slowly beneath the surface in dikes and sills, creating a coarse-grained igneous rock called diabase.

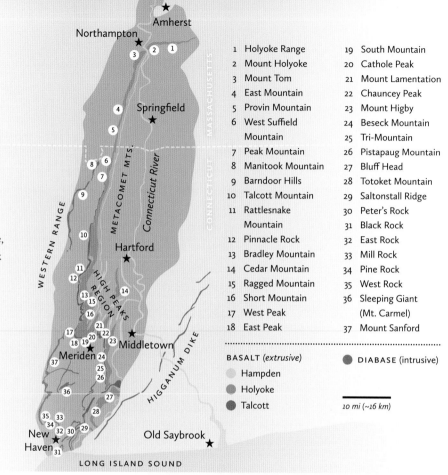

1 Holyoke Range
2 Mount Holyoke
3 Mount Tom
4 East Mountain
5 Provin Mountain
6 West Suffield Mountain
7 Peak Mountain
8 Manitook Mountain
9 Barndoor Hills
10 Talcott Mountain
11 Rattlesnake Mountain
12 Pinnacle Rock
13 Bradley Mountain
14 Cedar Mountain
15 Ragged Mountain
16 Short Mountain
17 West Peak
18 East Peak
19 South Mountain
20 Cathole Peak
21 Mount Lamentation
22 Chauncey Peak
23 Mount Higby
24 Beseck Mountain
25 Tri-Mountain
26 Pistapaug Mountain
27 Bluff Head
28 Totoket Mountain
29 Saltonstall Ridge
30 Peter's Rock
31 Black Rock
32 East Rock
33 Mill Rock
34 Pine Rock
35 West Rock
36 Sleeping Giant (Mt. Carmel)
37 Mount Sanford

BASALT (extrusive)
Hampden
Holyoke
Talcott

DIABASE (intrusive)

10 mi (~16 km)

human occupation, a large number of formal and informal names have been attached to the hills. Many of the designations have changed since colonial times, and the geographic names also vary with the local frame of reference; thus, East Mountain may well be West Mountain, depending on one's point of view. The nomenclature of the traprock hills is based on the following: geography (East Rock, West Rock, West Peak, East Mountain, South Mountain); topography and appearance (Ragged Mountain, Peak Mountain, Pinnacle Rock, Short Mountain, High Rock, Tri-Mountain, Bluff Head, Sugarloaf, the Hedgehog);

nearby towns (Farmington Mountain, Meriden Mountain, Avon Mountain, West Suffield Mountain); wildlife (Rattlesnake Mountain, Rabbit Rock, Cathole Peak, Goat Peak); historic associations (Mount Tom, Mount Holyoke, Chauncey Peak, Mount Higby, Peter's Rock, Hachett's Hill); the first inhabitants (Totoket, Pistapaug, Manitook, Nonotuck, Norwottock); colors (Black Rock, Red Rock, Blue Hills); and tales and legends (Mount Lamentation, King Philip Mountain).

The traprock hills follow two major trends through the Connecticut Valley. The main range forms a great "wall" of crags from Mount Holyoke in the north to Saltonstall Ridge near Long Island Sound. Benjamin Silliman described the particular linear arrangement of this range in 1820: "In many parts of this district, the country seems divided by stupendous walls, and the eye ranges along, league after league, without perceiving an avenue, or a place of egress." This main range of lava flows are herein designated the Metacomet Mountains, to distinguish their particular topographic aspect, and to streamline the cumbersome geographic nomenclature of the Connecticut Valley (please refer to Note on Terminology and Usage).

The volcanic veins and dikes that follow the western side of the valley as a series of discontinuous ridges and hills were named the Western Range by the noted geographer William Morris Davis in 1898. The Western Range runs from West Rock near New Haven to Manitook Mountain in Suffield, Connecticut, near the Massachusetts border. The specific rock type (diabase, see below) and characteristic "massif" landforms distinguish the Western Range from the typical cuesta ridges of the Metacomet Mountains. Known mainly to local hikers, the remote summits of the Western Range are among the least disturbed areas in the Connecticut Valley. The hills of the Western Range also have the most colorful names of any of the Connecticut Valley traprock crags, including Sleeping Giant, Onion Mountain, the Hedgehog, and the Barndoor Hills. Among the most scenic landforms in the region, East Barndoor Hill (el. 580 ft.) and West Barndoor Hill (el. 640 ft.) in West Granby, Connecticut, form a particularly interesting pair of steep traprock promontories separated by an unusually deep and shady notch.

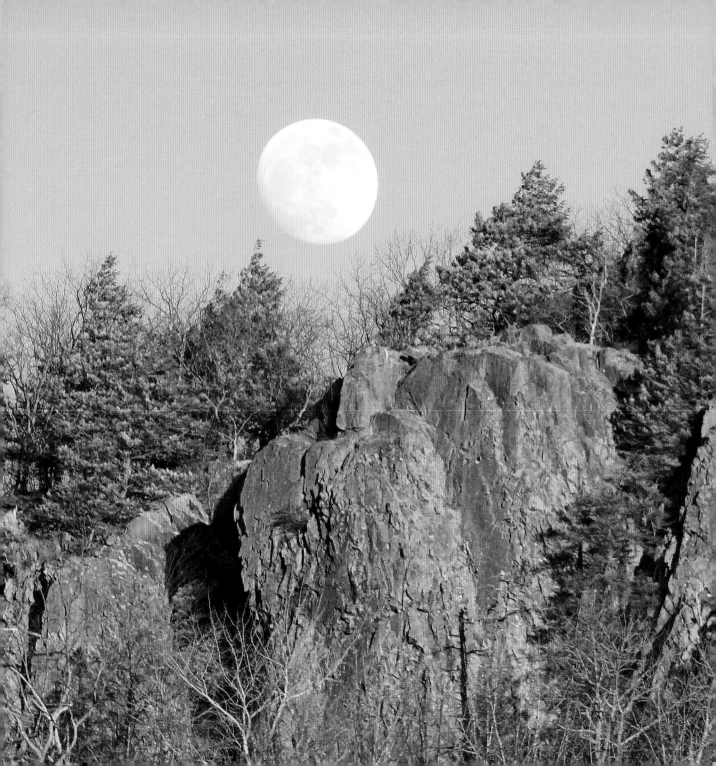

3

Born of Fire
TRAPROCK GEOLOGY

Eruptions . . . took place from
great fissures . . . of the earth's
crust. The lava which then
came up and filled the fissures,
and in many places outflowed,
is the rock we now call trap.

James D. Dana, *On the Four Rocks
of the New Haven Region* (1898)

The story of the Connecticut Valley begins in the early Mesozoic era (the age of dinosaurs), a time when the continents were joined in a single large landmass, or supercontinent, called Pangaea ("all land"). During the Late Triassic period, beginning about 220 million years ago, global tectonic forces caused the crust of Pangaea to thin and separate, a precursor to the eventual formation of the early Atlantic Ocean in the Middle Jurassic, around 160 million years ago.

The thinning and fracturing, or "rifting," of the continental crust was accompanied, and in part caused by, an enormous plume of basalt magma rising from the upper mantle and lower crust (melted rock beneath the surface is called *magma*; *lava* is magma that cooled at or near the earth's surface).

Approximately 200 million years ago the magma plume reached the surface, and voluminous quantities of lava erupted through cracks and fissures, flooding huge areas of the proto–North Atlantic region with basalt. The low-viscosity (very fluid) lava produced by the fissure volcanoes formed great "lakes" of lava in the low-lying rift valleys. Most of the traprock ridges and hills that dominate the landscape of the Connecticut Valley are the tilted and eroded remnants of these enormous lava flows.

Some of the magma did not make it to the surface, but instead cooled in cracks and veins forming *dikes* (vertically oriented bodies) and *sills* (roughly flat-lying layers or lenses). The entire Western Range, from East Rock in New Haven to Manitook Mountain in Suffield, including Mount Carmel in Hamden, are intrusive dikes and sills that have been exposed by erosion of the less resistant surrounding sedimentary rocks. A large number of dikes and sills also occur in East Haven, North Haven, and North Branford in the southeastern part of the Connecticut Valley.

Other large-scale dikes, including feeders for the lava flows, cut through the older Paleozoic-age rocks outside the Connecticut Valley, and in some cases form linear features that can be traced for hundreds of miles across the landscapes of eastern North America, the Iberian Peninsula, northwest Africa,

PREVIOUS PAGE Moonrise over the cliffs of South Mountain. Basalt is the most abundant crustal rock type on both the earth and the moon. The lunar "seas" were formed from enormous outpourings of basalt lava roughly 3 billion years ago. Radiometric ages determined from the samples of the CAMP basalts indicate that the lava flows of the Connecticut Valley are approximately 201 million years old.

and northeastern South America. On large-scale maps, these dikes form a distinct radial pattern pointing toward the main magma plume, or "hot spot," located near the southeastern U.S. Atlantic margin.

The volcanic rocks of the Connecticut Valley are part of one of the largest terrestrial eruptions of basalt in the geologic record—only the extensive lava flows of the Columbia River plateau in the northwestern United States, the Siberian Traps, or India's Deccan Traps are comparable. Volcanic rocks correlating in age with the Connecticut Valley basalts are found in South America, North Africa, and western Europe; for convenience this entire suite of Triassic-Jurassic-age volcanic rocks is termed the central Atlantic magmatic province, or CAMP.

In eastern North America the CAMP basalts form picturesque landforms such as Mount Pony near Culpeper, Virginia; the Watchung Mountains in New Jersey; the Palisades cliffs along the Hudson River; the Orenaug Hills in the Southbury-Woodbury area of Connecticut; the Pocumtuck Hills of the Deerfield Valley; and North Mountain on the Bay of Fundy. The vast quantities of carbon dioxide, sulfur dioxide, and volcanic ash that accompanied the CAMP eruptions are implicated in global climate change and disruptions of the biosphere at the Triassic-Jurassic boundary that, in part, led to the rise of the dinosaurs in the Early Jurassic period.

THE GREAT RIFT VALLEYS OF PANGAEA

Along with the eruption of the CAMP basalts, the geologic forces that were splitting the crust of Pangaea along the future Atlantic margin also created a series of elongate troughs, or "rift" basins, very similar in shape and size to the present-day great rift valleys of East Africa. The East African valleys containing Lake

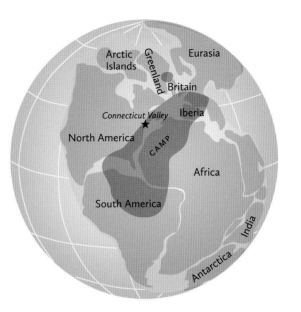

The supercontinent of Pangaea during the Early Jurassic, about 200 million years ago. The traprock hills of the Connecticut Valley belong to the central Atlantic magmatic province (CAMP), one of the largest outpourings of continental basalt lava in the earth's history. Illustration adapted from Kious and Tilling 1999; Marzoli et al. 1999; Goldberg et al. 2010; and Whiteside et al. 2010.

Malawi, Lake Tanganyika, and Lake Rukwa, among others, are good modern analogues for the size, shape, and regional configuration of the Triassic- and Jurassic-age rift basins of eastern North America. The interesting rocks, useful minerals, valuable coal deposits, and unique fossils found in the North American rift valleys have attracted the attention of geologists from North America and Europe since the 1800s.

As the regional-scale blocks of continental crust subsided like trap doors along active faults, large quantities of sediment washed down from the surrounding igneous and metamorphic uplands and filled the rift valleys; in the Connecticut Valley, more than three miles of sediment and interlayered basalt accumulated while the rift was active during the Late Triassic and Early Jurassic. The sedimentary rocks in the Connecticut Valley consist mainly of red-brown sandstone, siltstone, and shale, deposited in rivers, floodplains, and shallow lakes. Layers of black shale, some containing well-preserved fossil fish, plants, and other remains of early Mesozoic aquatic life, reveal the presence of deep lakes that filled the valley during humid climatic intervals. During dry periods, ephemeral streams, sand dunes, saline lakes, and mud flats occupied the valley floor.

Architects associate the name Connecticut Valley with the brown and red

46

Distribution of exposed and subsurface Triassic-Jurassic–age continental rift basins in eastern North America.

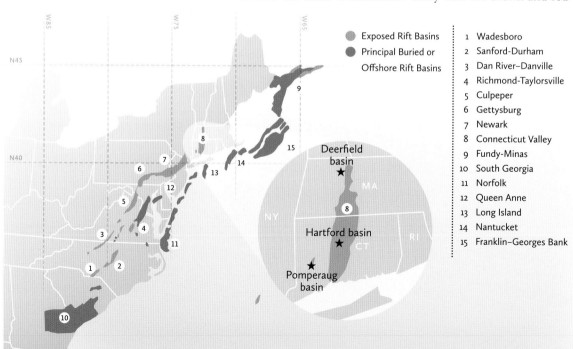

Exposed Rift Basins
Principal Buried or Offshore Rift Basins

1 Wadesboro
2 Sanford-Durham
3 Dan River–Danville
4 Richmond-Taylorsville
5 Culpeper
6 Gettysburg
7 Newark
8 Connecticut Valley
9 Fundy-Minas
10 South Georgia
11 Norfolk
12 Queen Anne
13 Long Island
14 Nantucket
15 Franklin–Georges Bank

Deerfield basin
Hartford basin
Pomperaug basin

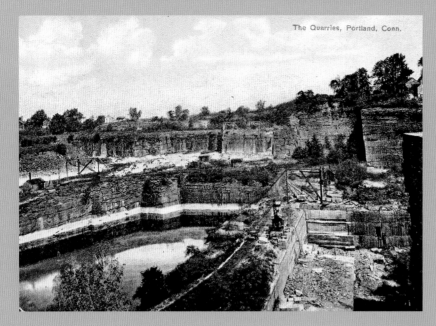

The Quarries, Portland, Conn.

The Portland brownstone quarry, circa 1915, Portland, Connecticut. The enormous demand for Portland brownstone in the late nineteenth century led to the excavation of one of the largest quarries of the time. The quarries were flooded in the 1938 New England hurricane. Today, the quarries are the site of the popular Brownstone Exploration and Discovery Park, featuring swimming and water sports. Image: author's collection.

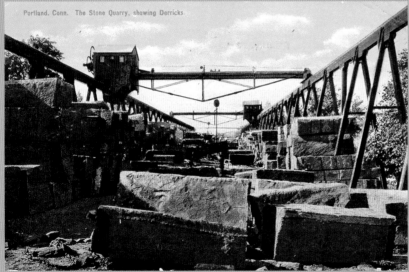

Portland, Conn. The Stone Quarry, showing Derricks.

Large blocks of brownstone await final shaping before transfer to barges called "stone boats" on the adjacent Connecticut River. The brownstone was shipped mainly by water to New York City, Boston, and other major cities; some Portland brownstone even made it to San Francisco via the Cape Horn shipping route. Image: author's collection.

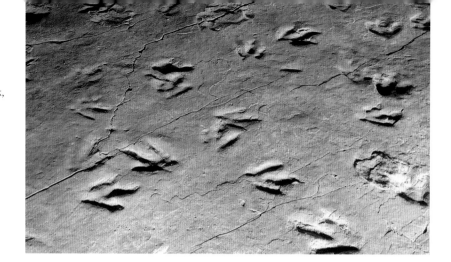

The Connecticut Valley is famous for its fossil dinosaur footprints. Dinosaur State Park, in Rocky Hill, Connecticut, features one of the largest known exposures of dinosaur tracks in the world. The twelve- to eighteen-inch long footprints, named *Eubrontes* by paleontologists, were left in wet sand as the carnivorous dinosaurs searched for fish and small reptiles along the shoreline of a large lake about 198 million years ago. The *Eubrontes* track makers were early ancestors in the lineage that produced *Tyrannosaurus rex*. Dinosaur State Park.

sandstone that virtually defined American cities, including New York and Boston, in the nineteenth century. Mined in prolific quantities from quarries in Portland and Longmeadow, Connecticut Valley "brownstone" was the favored building stone for fashionable townhouses, mansions, hotels, rail stations, academic buildings, and public monuments in the mid to late 1800s. A particularly fine collection of well-preserved brownstone buildings makes up Wesleyan University's picturesque "college row" along High Street in Middletown, Connecticut. By the early twentieth century its perceived lack of durability and changes in architectural fashion caused Connecticut Valley brownstone to fall out of favor, and the large quarries, once bustling with activity, fell silent.

The Connecticut Valley is also world-famous for its abundant dinosaur footprint fossils, preserved as impressions in layers of sandstone and shale. Their discovery in 1802 is attributed to the South Hadley, Massachusetts, farmer Pliny Moody, but undoubtedly stonemasons and others working with the local stone also noticed the curious three-toed tracks on the rock surfaces. At that time these fascinating traces of ancient life were believed to be the tracks of "Noah's Raven." Interestingly, scientific theories about the origin of the tracks has come full circle, as some of the dinosaurs that left their prints along the ancient rivers and shorelines of the Connecticut Valley are now considered the early ancestors of modern birds.

The largest collection of Connecticut Valley dinosaur tracks was assembled by Amherst College professor Edward Hitchcock in the early to mid-1800s. Today, the "Hitchcock Cabinet" in the Beneski Museum of Natural History at Amherst College, and Hitchcock's illustrated treatise, *Ichnology of New England: A Report on the Sandstone of the Connecticut Valley, Especially Its Fossil Footmarks* (1858), remain important resources for modern paleontologists.

Dinosaur State Park in Rocky Hill, Connecticut, displays one of the largest and most accessible exposures of dinosaur footprints in the world. There, an extensive trackway shows that the carnivorous theropod dinosaurs foraged for prey, including fish, along the sandy shore of an ancient rift lake. The Dinosaur State Park museum also includes full-scale dioramas reconstructing the Triassic and Jurassic life of the Connecticut Valley, along with exhibits of other dinosaur and reptile tracks, fossil fish, plants, invertebrates, and minerals found in the region.

An excellent collection of dinosaur footprints obtained from the nearby Portland brownstone quarries in the 1800s is on display in the Exley Science Center at Wesleyan University. Many other museums in the region, including Yale's Peabody Museum of Natural History, display fossil tracks found in the local ledges of sandstone and shale.

For generations of students and professors, from more than a dozen colleges and universities in the region, the Connecticut Valley is synonymous with enjoyable field trips to study its world-class geological features and fossils. The best known of the eastern North American rifts, the Connecticut Valley has been the focus of seminal geological studies since the early 1800s, when professors at Yale, Amherst, and Wesleyan began to unravel the fundamental principles of mineralogy, paleontology, and structural geology. Testament to the enduring scientific importance of the Connecticut Valley, more than one thousand studies have been published as scientific papers, state and federal reports and maps, water-supply surveys, paleontological monographs, field guides, undergraduate and graduate theses, popular books, and miscellaneous reports. Today, the tradition continues with modern studies of hydrogeology, ecology, and environmental science in the natural field laboratories.

Ledges at Ragged Mountain, Southington. The volcanic rocks of the Connecticut Valley are commonly referred to as "trap" or "traprock," a term derived from the Swedish *trappa*, meaning "stairs" or "steps."

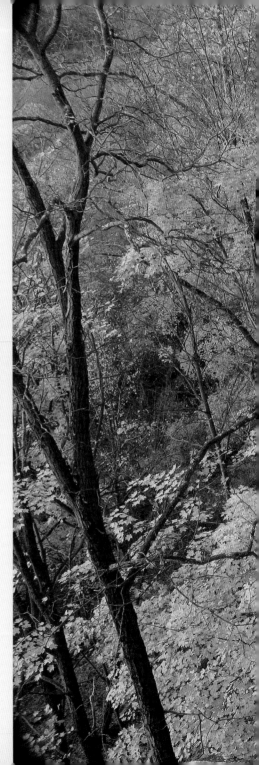

Fresh surfaces created in a recent rock fall at East Peak reveal the dark blue-gray color of the unweathered traprock blocks. Commonly called *bluestone* or *greenstone*, traprock ranges in color from black, to green-gray, depending on the particular mineral composition.

Oxidized and hydrated iron minerals formed during weathering, including hematite and goethite, coat the rock surfaces with beautiful shades of brown, orange, and red at Cathole Peak.

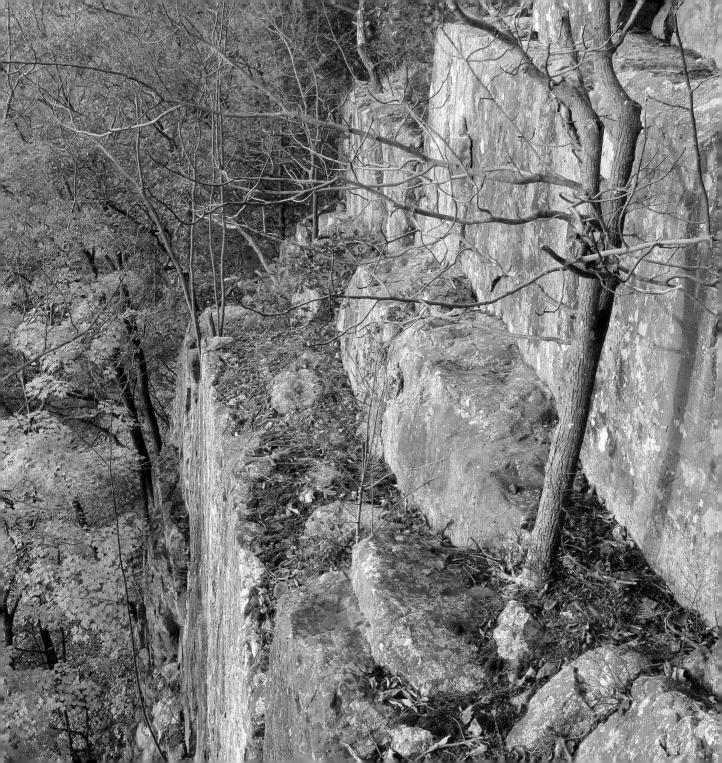

Pillow basalt in the Talcott lava flow, South Mountain. The color, shape, and form of the lava provides clues to its geologic history. Pillow basalt occurs when lava encounters water and cools quickly, creating the spheroidal forms seen here.

TRAPROCK

Both the intrusive (cooled beneath the surface) and extrusive (cooled at or near the surface) igneous ("fire-formed") rocks of the Connecticut Valley are commonly referred to as *traprock* (alternatively, *trap rock*, or *trap-rock*). In 1816, the influential early mineralogist Parker Cleaveland wrote that the term "derived from the Swedish 'trappa,' which is said to signify a stair, or a series of steps. It was hence originally applied to certain rocks whose beds, or strata, in consequence of the action of the weather on their edges, assumed the form of steps or stairs." Although it was applied informally to any rock type that exhibited blocklike fractures, by the early nineteenth century the term *trap* became synonymous with the volcanic rock basalt. Historical or colloquial terms for Connecticut Valley basalt include *greenstone*, *bluestone*, and *whinstone*, among other informal names.

Formed from iron-, magnesium-, and calcium-rich magma that originated in the upper mantle and lower crust of the earth, Connecticut Valley traprock is classified into two varieties based on the size of the mineral crystals. *Basalt* is the dark-colored, fine-grained, volcanic rock that cooled quickly at or near the surface. *Diabase* (or *dolerite*), distinguished by its larger crystals and coarser textures, cooled slowly beneath the surface in veins, dikes, or sills. The characteristic dark, greenish-black to bluish-gray color of the fresh rock is the result of its particular mineral composition, specifically, plagioclase feldspar, olivine, and hornblende. Based on detailed chemical analyses, specialists classify the CAMP lavas, including those of the Connecticut Valley, as a variety called *tholeiite basalt*, relatively rich in iron, calcium, and magnesium.

Vesicular basalt or *scoria* contains abundant bubbles and cavities (vesicles). The cavities in the vesicular basalt often contain a suite of interesting and beautiful minerals including, prehnite, datolite, amethyst, quartz, and metallic sulfides such as chalcopyrite, bornite, and galena. Basalt lava that flowed into ancient lakes, ponds, or rivers produced spherical and tubular forms known as *pillow basalt*. The Connecticut Valley lavas also exhibit varieties of eruptive

material, including beds of volcanic ash, or *tuff*; glassy pea-sized spherules called *lapilli*; and accumulations of basalt fragments called *breccia*.

Columnar basalt is made of elongate pillars—ideally large hexagonal prisms— created when the hot lava cooled and contracted. In the Connecticut Valley, fine examples of hexagonal basalt columns are found at Peter's Rock near New Haven and Titan's Piazza at Mount Holyoke. Considered among the most interesting of geologic features, examples of columnar basalt at Devil's Postpile at Mammoth Lakes in California, Devil's Tower in Wyoming, Giant's Causeway in Northern Ireland, and Fingal's Cave on the island of Staffa in Scotland have long been prime destinations for tourists, and have appeared in countless illustrations, paintings, and movies.

The product of ages of weathering, enormous piles of broken lava blocks form steep slopes of *talus*, or *scree*, banked against the traprock cliffs. These vast aprons of boulders, some containing enormous blocks and slabs, are among the most interesting and beautiful landforms in the Connecticut Valley. Too steep and unstable for any practical use, some of the Connecticut Valley talus slopes, as my studies indicate, are the oldest undisturbed landscapes in southern New England.

The best examples of talus slopes and scree fields occur in the central Connecticut Valley; noteworthy examples are found at the Hanging Hills, Mount Higby, Beseck Mountain, and Mount Tom. In the 1800s, the unusually rugged and picturesque talus slopes at South Mountain and Cathole Pass in Meriden attracted the attention of geologists, artists, and landscape tourists. There, the huge blocks and enormous slabs lying beneath the traprock cliffs were often compared to ancient ruins.

In 1822, Benjamin Silliman described the talus slopes in central Connecticut: "The immense masses of ruins which . . . are collected at the feet of the green stone ridges, form a very striking object. Often they slope, with a very sharp acclivity, half, or two-thirds of the way up the mountain, and terminate only at the rocky barrier; the ruins are composed of masses of every size, from that of a pebble, which may be thrown to a bird, to entire cliffs and pillars, of

Violent eruptions at volcanic vents near Lamentation Mountain created broken fragments of lava that form a rock called *basalt breccia*. Berlin, Connecticut.

Twisted joints swirl beneath the Merimere wall at East Peak, Meriden. Repeated freeze-and-thaw cycles pry fragments away from the cliffs, creating large piles of talus below.

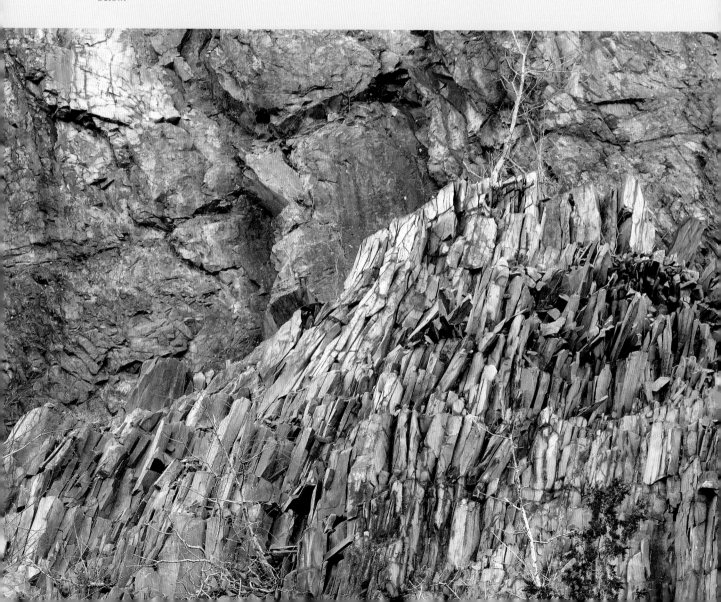

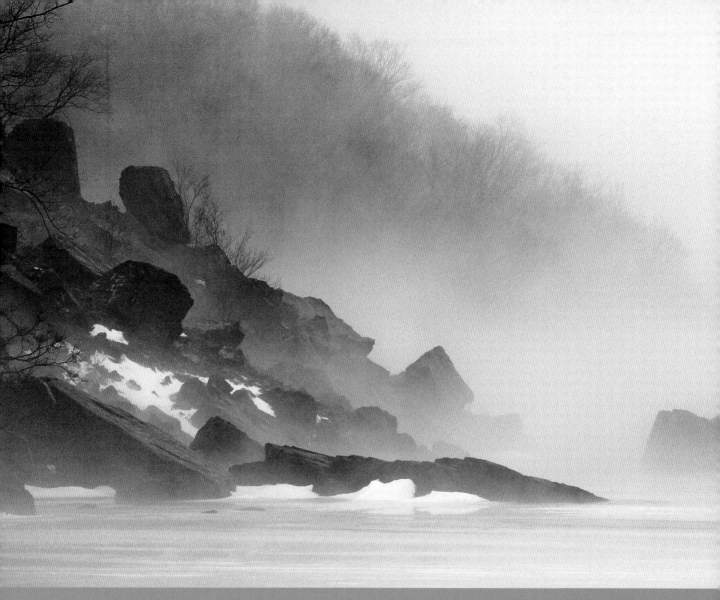

Enormous blocks of talus
appear to march downhill
through the fog. Merimere
Reservoir, Meriden.

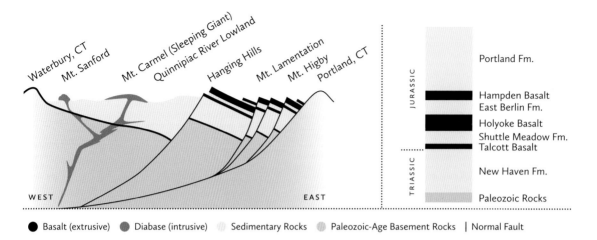

Waterbury, CT
Mt. Sanford
Mt. Carmel (Sleeping Giant)
Quinnipiac River Lowland
Hanging Hills
Mt. Lamentation
Mt. Higby
Portland, CT

WEST

EAST

JURASSIC

TRIASSIC

Portland Fm.

Hampden Basalt
East Berlin Fm.
Holyoke Basalt
Shuttle Meadow Fm.
Talcott Basalt

New Haven Fm.

Paleozoic Rocks

● Basalt (extrusive) ● Diabase (intrusive) Sedimentary Rocks Paleozoic-Age Basement Rocks | Normal Fault

57

of the lava. Large crystals of amethyst quartz and many other interesting minerals eagerly sought by collectors are found in cavities and pipes created when steaming pockets of water became entrapped in the lava. The collections at Yale's Peabody Museum, Dinosaur State Park, and the Pratt Museum at Amherst College contain fine examples of minerals found in the Talcott flow.

Averaging about 400 feet in thickness, the Holyoke Basalt forms the backbone of the Metacomet Mountains. Exclusive of the diabase crags near New Haven and Talcott Mountain, the Holyoke Basalt forms the highest and most prominent summits in the Connecticut Valley, including the Hanging Hills, Mount Tom, and the Holyoke range. Because of its thickness and resistance to erosion, the Holyoke Basalt forms nearly all of the major traprock cliffs in the Connecticut Valley. For this reason, most of the illustrations in this book show the Holyoke Basalt. All of the major traprock quarries in the Connecticut Valley mine the Holyoke Basalt because of its desirable properties, including homogenous texture and hardness. Although they have been quarried historically, the Talcott and Hampden flows are not as desirable as sources of crushed stone because of their highly variable textures and lower strength and durability.

Composed of two main flow units in the central Connecticut Valley, the upper flow of the Holyoke Basalt exhibits well-developed joints and sets of

Schematic geologic cross-section and stratigraphy (geologic formations) of the Hartford basin. Diagram not to scale. Illustrations adapted from Olsen 1986; McDonald 1996; and Olsen et al. 2005.

many tons weight, which, from time to time fall, with fearful concussion, into the valleys. This kind of rocky avalanche is so common among the green stone mountains, that it is often heard, and sometimes, in the stillness of the night, by those who live in the vicinity."[1]

During the Early Jurassic three distinct volcanic events produced lava flows that covered the floor of the Connecticut Valley within a span of about 600,000 years, a relatively short period in geologic time. Because of the fluid nature of the so-called flood basalts, the lava did not build large volcanoes, but instead formed only relatively small accumulations of lava, cinders, and ash adjacent to the vents, similar to those observed at fissure eruptions in Iceland. In the late 1800s geologist William Morris Davis from Harvard identified a volcanic "ash bed" and other features indicative of a small volcanic vent on the western flank of Mount Lamentation near the Meriden-Berlin, Connecticut, border (see page 53). The discovery of volcanic lapilli by geologist Nicholas McDonald, and my recognition of a volcanic "neck" or feeder pipe, confirms the presence of a small volcanic eruption in that area.

The three lava flows are named, from oldest (bottom) to youngest (top) the Talcott Basalt, the Holyoke Basalt, and the Hampden Basalt, respectively (see page 57). The Deerfield Valley contains only one lava layer, the Deerfield Basalt, which is the northernmost extension of the Holyoke Basalt.

The thickness of the oldest flow unit, the Talcott basalt, ranges from 50 to more than 200 feet, averaging about 150 feet. The irregular thickness and distribution of the Talcott Basalt provides evidence of the hilly topography of the basin floor when the rift was active. Today, the Talcott flow is mainly exposed as a prominent topographic bench beneath the cliffs of the thicker, main ridge-forming unit, the Holyoke Basalt. The only place that the Talcott flow forms prominent cliffs is along Talcott Mountain. There, the main lava flow, the Holyoke Basalt, atypically occurs as a series of subordinate ridges on the eastern flank of the traprock ridge.

The base of the Talcott flow commonly contains extensive layers of pillow basalt, indicating the widespread presence of water during the emplacement

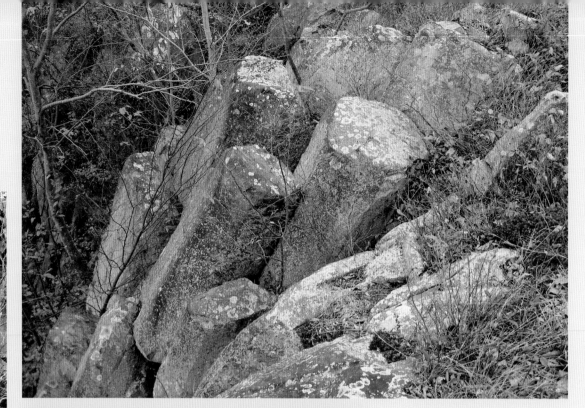

ABOVE Columnar basalt is
formed when thick layers
of lava cool and contract,
creating vertical joints that,
ideally, form hexagonal prisms,
such as these at Peter's Rock,
North Haven, Connecticut.
LEFT Charming "flower rock"
at Peter's Rock is formed by
the unusual arrangement of
five hexagonal basalt columns
surrounding a nearly perfect
pentagonal column. Images:
author's collection.

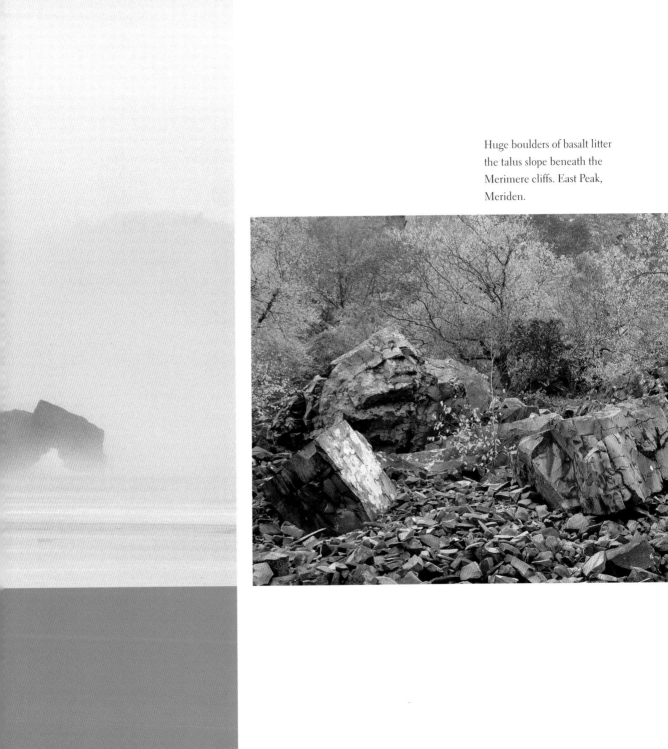

Huge boulders of basalt litter the talus slope beneath the Merimere cliffs. East Peak, Meriden.

intersecting fractures creating a blocky and massive appearance. Nearly all the panoramic traprock cliffs in the central and southern Connecticut Valley are formed of the upper flow unit in the Holyoke Basalt. In addition, the best rock-climbing routes in the central Connecticut Valley, including those at Ragged Mountain and nearby crags, are located on cliffs made of the upper flow of the Holyoke Basalt. In contrast, the lower flow unit of the Holyoke Basalt is highly fractured by numerous irregular columns and joints.

The youngest lava flow in the Connecticut Valley, the Hampden Basalt, averages about 120 feet thick. Forming only moderate topographic relief in comparison to the massive Holyoke flow, the Hampden is found as a series of low ridges along the eastern flank of the Metacomet Mountains, where it is commonly exposed in road and highway cuts. Near Mount Tom the Hampden Basalt becomes thinner and acquires a breccia (broken) texture as it grades into a pyroclastic ("fire fragment") volcanic unit called the Granby Tuff. The Granby Tuff continues as a low ridge along the southern flank of Mount Holyoke until it pinches out against layers of conglomerate near the eastern margin of the Connecticut Valley. The Hampden Basalt is noteworthy because two of the largest waterfalls in the Connecticut Valley, Wadsworth Falls and Westfield Falls, cascade over ledges formed of that lava layer.

Veins of magma that intruded into the crust, and, in part, fed the surface flows, cooled slowly to form coarse-grained (with crystals visible to the naked eye) igneous rocks. Exposed by erosion, these intrusive dikes and sills form the prominent traprock ridges in the southern and western areas of the Connecticut Valley, including East Rock, West Rock, Mount Carmel, Mount Sanford, the Barndoor Hills, and Mount Manitook, as well as many of the traprock outcroppings in the area of East Haven, Fair Haven, and North Haven.

Dikes related to the Connecticut Valley lava flows can be traced for hundreds of miles across the landscape of New England, from eastern Connecticut, into eastern Massachusetts and coastal Maine, to the Bay of Fundy. Three distinct trends of dikes that correlate chemically to the three individual Connecticut Valley lava flows cut northeast diagonally across the regional fabric of the older

Paleozoic-age metamorphic rocks. The Higganum, Buttress, and Bridgeport dikes correspond to the Talcott, Holyoke, and Hampden lava flows, respectively. Feeder dikes connected to the Talcott and Hampden flows have been identified in the southern Connecticut Valley.

A fine exposure of the Higganum dike is exposed in the road cuts at Exit 9 (Route 81) on southbound Route 9 near Higganum, Connecticut. Along with its affiliated segments, the so-called Higganum–Holden–Christmas Cove dike, is traceable from Branford, Connecticut, to the Bay of Fundy, making it one of the longest diabase dikes in the world.

Recently, the CAMP basalts, and the Connecticut Valley lava flows in particular, have become the focus of intense scientific inquiry by a global community of geologists exploring the evolution of the earth, the geologic timescale, the history of ancient life, and global climate change, among other topics. For

A climber tests his skill on the massive cliffs of Ragged Mountain.

example, scientists at Columbia University have recently suggested that excess carbon dioxide could be injected into the cracks and cavities of the CAMP lavas to offset the increasing atmospheric levels of the greenhouse gas. There, carbon dioxide would combine with elements in the basalt to form harmless calcium carbonate minerals. Thus, mineralogical studies that began more than two hundred years ago with Benjamin Silliman and James D. Dana at Yale are continuing with an international cadre of earth scientists who are making new discoveries about the fascinating lava flows of the Connecticut Valley.

TRAPROCK QUARRIES

For civil engineers, building contractors, and quarry operators the Connecticut Valley is the source of tough, durable traprock, or "bluestone." Preferred for its high strength and homogeneous texture, crushed traprock is used widely for concrete and asphalt aggregate, rail bedding, slope stabilization, drainage, bedding of utility pipes and conduits, among other uses.

Since the colonial period, many small quarries have taken advantage of the conveniently sized and easily excavated piles of talus found beneath many of the traprock cliffs. Quarrying of the talus was so vigorous at East and West Rocks, that by the early nineteenth century Yale geologist Benjamin Silliman noted that the local crags had been "in great measure despoiled of their ruins, and to some extent even of their columns in order to supply the demands of architecture."

The advent of "modern" traprock production in the Connecticut Valley can be traced to 1858, when Eli Whitney Blake of New Haven was granted a patent for his innovative reciprocal-jaw rock crusher. Designed with thick steel plates held in opposition in a V shape, stone fed at the top was crushed to the desired size as it worked its way through the oscillating mechanical jaws. With slight modifications in its design, Blake's revolutionary invention is still widely used in quarries around the world.

Historical maps reveal a large number of former traprock quarries that were

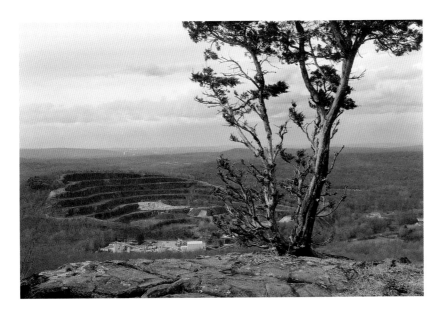

An earth resource of regional economic importance, Connecticut Valley traprock has long been prized for its strength and other favorable engineering properties. Asphalt made with Connecticut Valley traprock aggregate paves roads and highways throughout the region. This view of Chauncey Peak from the summit of Mount Higby reveals the extensive traprock mining at the Suzio–York Hill quarry.

active over the past hundred years or so; many stand as evidence of the importance of family-owned and municipally operated quarries in the late nineteenth and early twentieth centuries. One of the earliest quarries to mine "live" traprock, as opposed to loose talus, was established by the John S. Lane Company in the north end of Meriden, Connecticut, in 1890, mainly to provide ballast (bedding) for railroads. In 1891, John S. Lane and Sons expanded their operations to East Mountain in Westfield, Massachusetts, where traprock continues to be processed in one of the oldest continually operating quarries in the Connecticut Valley. The Suzio–York Hill traprock quarry at Chauncey Peak in Meriden has operated under sole ownership since 1912. In 1914, the New Haven Trap Rock Company opened an expansive quarry on the south end of Totoket Mountain in North Branford. Following the Holyoke Basalt for several miles along the ridge, the Totoket excavation is known as one of the longest continuous quarry faces in the world.

By the early to mid-twentieth century large traprock quarries were also operating on the "head" of Sleeping Giant (Mount Carmel) in Hamden, the south

Receipts for crushed traprock from (LEFT) Middlefield (Reed's Gap, 1928) and (RIGHT) Plainville (Cook's Gap, 1905), two of the largest quarries in the Connecticut Valley.

64

Advertisement for Connecticut Valley traprock, circa 1898. Images: author's collection.

end of Pinnacle Rock in Plainville, and at Rocky Hill ridge in the town of Rocky Hill, Connecticut. In Massachusetts, quarries were in operation on Provin Mountain, Mount Tom, and Mount Holyoke in Massachusetts. In the mid to late twentieth century many of these quarries, including New Haven Trap Rock, Connecticut Trap Rock Quarries, Blakeslee, Cinque, Balf, Tomasso, Audi, and Lane Construction, were either merged into regional operations, or closed.

Today, Tilcon, Connecticut Inc. is the largest producer by volume of Connecticut Valley traprock. Tilcon operates five traprock quarries in Connecticut:

Totoket Mountain in North Branford, Reed's Gap on the Wallingford-Durham line, Cook's Gap in Plainville and New Britain, Cedar Mountain in Newington, and near Peak Mountain in East Granby. The J. S. Lane and Sons plant on East Mountain in Westfield, Massachusetts, is the largest individual traprock quarry in the northern Connecticut Valley. O&G Industries in Southbury and Woodbury, Connecticut also produces significant quantities of traprock from the Orenaug Basalt, a layer of lava that is the equivalent of the Holyoke Basalt. The O&G quarries are located in the Pomperaug basin, a small rift located about twenty miles west of the Connecticut Valley.

Most of the quarried stone is used within about twenty-five to fifty miles of the quarries, although some traprock is transported farther afield by rail and barge according to demand and the engineering specifications of particular construction projects.

The traprock quarries are a prime example of the inherent conflicts resulting from obtaining necessary natural resources, on the one hand, and preserving areas of geologic, ecological, and cultural importance, on the other. Mining, as an extractive industry, has the undesirable result of permanently removing sections of the traprock highlands; rock is not a renewable resource. However, with its use in the Connecticut Valley spanning more than two hundred years, traprock mining is embedded in the cultural history of the region and remains an industry of economic significance.

Alternatives to traprock are limited by the cost of transportation, quality of material, and difficulty in establishing new quarries in an era of strict environmental and land-use regulations, as well as local opposition to heavy industries. Widely used for roads, railroads, and construction, there are no realistic substitutes for traprock in south-central New England. The high demand, coupled with limited land for quarry expansion, suggests that, in the coming decades, production at some of the quarries will decline, if not cease altogether. How this valuable mineral resource will be replaced is unclear, but ultimately the costs of crushed stone to consumers will rise, either from scarcity or increased distance of transport from other less desirable sources in the region.

The fate of the large traprock quarries, once they eventually become exhausted or abandoned for economic reasons, is unclear. Some proposals put forward include reuse for industrial or commercial tracts, siting of bulky-waste landfills, or—the most desirable option—development of drinking-water reservoirs.

MINES AND MINERALS

Hobbyists, mineralogists, archaeologists, and historians equate the Connecticut Valley with a rich variety of minerals, including copper ores, that were formed from the volcanic activity. The eruption of the enormous lava flows and the associated circulation of hydrothermal fluids through the crust created ideal conditions for producing a wide variety of metallic and nonmetallic minerals. Copper, occurring as native metal or copper sulfide and copper carbonate minerals, is relatively abundant in parts of the Connecticut Valley, especially at Bristol and East Granby, Connecticut. The intriguing finds of copper ore motivated early settlers to scour the Metacomet Mountains and the Western Range for economic deposits. Recognizing the potential for ores in the traprock hills, the Connecticut General Court of 1651 stated: "In this rocky country, among these mountains and rocky hills, there are probabilities of mines of metals, the discovery of which may be of great advantage."

The most famous copper mines in the Connecticut Valley were developed in the early 1700s beneath the western cliffs of Peak Mountain in Simsbury, Connecticut. There, in what is now the town of East Granby, prospectors exploited veins of chalcocite (copper sulfide) and malachite (copper carbonate) in a network of shafts and tunnels that followed the sedimentary layers.

After operating a nearby bog iron furnace that reportedly produced the first American steel in 1728, Samuel Higley began to work the Simsbury copper prospects. Along with extracting hundreds of tons of copper ore that was mainly shipped to England, he further secured a place in history by minting what are

The historic mines at Old New-Gate Prison State Park, East Granby, Connecticut, produced some of the first copper in the American colonies. Old New-Gate Prison later gained a fearsome reputation for housing prisoners in the mine shafts and subjecting them to hard labor and brutal punishments. Old Old New-Gate Prison, circa 1834. Woodcut: John Warner Barber, 1836.

OLD NEWGATE PRISON

SOUTH VIEW SHOWING GUARD TOWER.

Connecticut's Most Famous Ruin

EAST GRANBY, CONN.

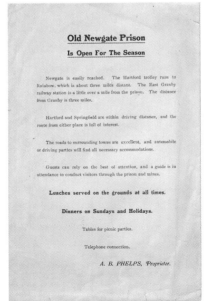

Old Newgate Prison

Is Open For The Season

Newgate is easily reached. The Hartford trolley runs to Rainbow, which is about three miles distant. The East Granby railway station is a little over a mile from the prison. The distance from Granby is three miles.

Hartford and Springfield are within driving distance, and the route from either place is full of interest.

The roads to surrounding towns are excellent, and automobile or driving parties will find all necessary accommodations.

Guests can rely on the best of attention, and a guide is in attendance to conduct visitors through the prison and mines.

Lunches served on the grounds at all times.

Dinners on Sundays and Holidays.

Tables for picnic parties.

Telephone connection.

A. B. PHELPS, Proprietor.

Tourist brochure for Old New-Gate Prison, early 1900s. A wooden viewing tower (*Left, at flag in center of view*) constructed for tourists provided spectacular views of Mani-took Mountain and the upper Farmington River valley. All images: author's collection.

widely regarded as the first, albeit unauthorized, coins in America, the famous "Higley coppers," from about 1736 to 1739. Prized by collectors, some Higley coppers in fine condition have realized prices over $50,000, due to their scarcity and connection to early American history.

In 1773 the mine was sold to the state of Connecticut and converted into the New-Gate Prison. There, under reportedly brutal conditions, Revolutionary War prisoners excavated the scant remaining ore in the very same dark, cramped, and dripping tunnels in which they were confined. After operating for half a century as one of the most notorious and feared American prisons, the New-Gate mines passed on to several companies, each failing in succession.

Native copper was also found in small quantities in veins at Sleeping Giant and a few nearby localities in the southern Connecticut Valley. Large native-copper nuggets, including the one weighing several hundred pounds on display at Yale's Peabody Museum, were also found in glacial deposits south of Sleeping Giant. In spite of extensive prospecting, a rich "mother lode" of copper was never found in that region. Nevertheless, the volcanic region between Sleeping Giant and the Hanging Hills, including parts of Cheshire, Wallingford, and Meriden, Connecticut, remains intriguing prospecting ground for collectors because of the well-documented deposits of copper minerals and barite, as well as unconfirmed historical reports of small finds of gold.

The "copper valley" and "Tallman" prospects in Cheshire intermittently produced enough ore to lure a steady stream of speculators from the 1700s to the early 1900s. The first copper coins authorized by Connecticut, and the first U.S. copper coins, were reportedly minted in 1785 and 1787, respectively, from Tallman mine ore. Fairing better than the copper prospects, the Cheshire barite mines produced economically profitable quantities through the 1930s. Today, the abandoned shafts and tunnels are an environmental hazard of ongoing concern to the town.

Hydrothermal mineral veins located along the western margin of the Connecticut Valley include the Bristol, Connecticut, copper mine, famous for its

museum-quality chalcocite crystals, and the Manhan-Loudville lead-silver prospects near Southampton, Massachusetts.

From about 1655 to 1679 Boston's John Winthrop Jr. and his partners from New Haven operated the first iron smelter in Connecticut, one of the earliest in colonial America, using local bog iron ore obtained from the swamps on the eastern flank of Saltonstall Ridge. Other early Connecticut Valley bog iron smelters sourced with local ore operated on the east side of Fowler Mountain near Durham, Connecticut, and in the lowland west of the New-Gate copper prospects near Peak Mountain in Simsbury (now East Granby).

For generations, mineral collectors and hobbyists have combed quarries, road cuts, and natural outcrops for showy specimens of prehnite, malachite, amethyst, galena, chalcocite, zeolite minerals, and many other varieties associated with the volcanic rocks and hydrothermal veins. Fine examples of Connecticut Valley minerals are on display at museums throughout the region, including Yale's Peabody Museum of Natural History, the Joe Webb People's Museum at Wesleyan University, Amherst College's Beneski Museum of Natural History, Dinosaur State Park, and the Springfield Science Museum.

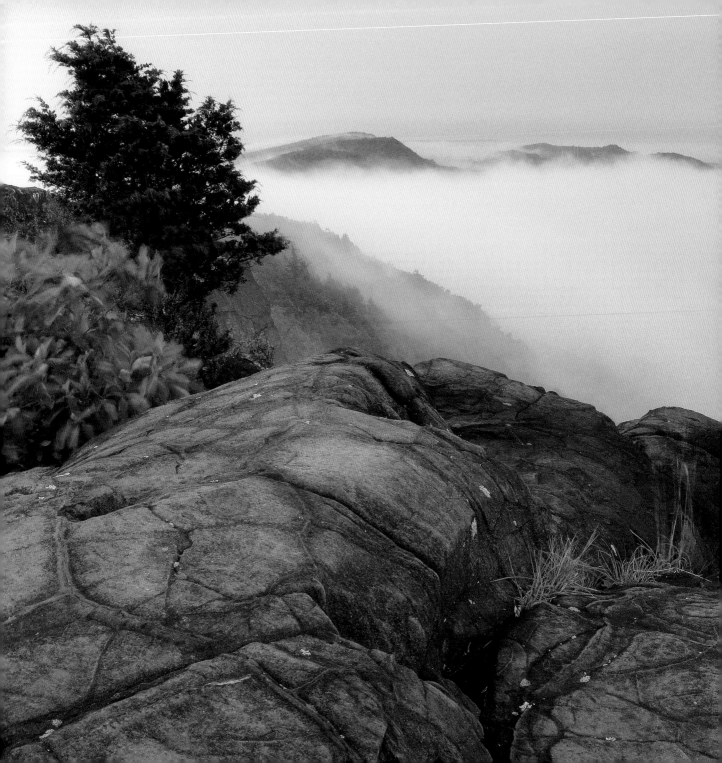

Sky Islands
ECOLOGY AND WATER RESOURCES

The diversified beauty of Nature
is nowhere better seen than in New
England, and particularly in the region
here to be described. . . . It is shown most
appealingly in the scenery at countless
points; also in a closer and more intimate
way in the ever-changing forms of the
vegetation: the trees, the shrubs, the
flowers, the ferns, and even the lichens.

C. R. Longwell and E. S. Dana, *Walks and Rides
in Central Connecticut and Massachusetts* (1932)

Perched high above the busy metropolitan corridor, the series of traprock ridges stretching from Northampton to New Haven forms the largest natural area in the Connecticut Valley. From a regional perspective, the vegetated slopes of the traprock highlands moderate the urban heat-island effect, filter air pollution, absorb noise from nearby highways, serve as public supply watersheds, and provide habitats for a diverse population of native plants, animals, and migratory birds.

The rugged terrain, varied solar aspect, and wide-ranging availability of water from the dry summits to the moist lower slopes of the traprock highlands, create a complex mosaic of microclimates, each supporting distinct ecological communities. As a result of the extreme vertical relief of the traprock crags, the plant associations change rapidly within their compact geographic area. Hikers entering moist broadleaf forests on the ridge flanks quickly rise through dry stands of stunted oak and hickory, before emerging into the open at the droughty summit glades and lichen-covered ledges. The dramatic zonation of microhabitats caused by elevation and proximity to the summit cliffs is one the most important, and appealing, characteristics of the traprock ridge ecosystem.

The rugged topography also creates areas where extreme climate conditions prevail, such as on the sunbaked south-facing cliffs, or unusually cold ravines and north-facing cliffs and slopes. Because of the topographic diversity, a number of plants and animals are able to survive at the fringes of their normal geographic range. Intolerant of cold New England winters, southern species such as eastern prickly pear cactus (*Opuntia humifusa*), yellow corydalis (*Corydalis lutea*), and the falcate orange-tip butterfly (*Anthocharis midea*), find suitable microhabitats on warm south-facing slopes and cliffs. Cold-loving northern species, including wild sarsaparilla (*Aralia nudicaulis*), Canada violet (*Viola canadensis*), bearberry (*Arctostaphylos uva-ursi*), and striped maple (*Acer pensylvanicum*) thrive in the shaded ravines and north-facing slopes.

More than seventy plants of special concern, including some that are rare or

PREVIOUS PAGE The Beseck Range viewed from Mount Higby. The traprock summits form ecological "sky islands" high above the metropolitan corridor.

endangered, have been identified in the traprock highlands of the Connecticut Valley. Detailed ecological surveys have been performed at West Rock, Sleeping Giant, Higby Mountain, Mount Lamentation, West Peak, and the Holyoke Range, but many of the traprock ridges remain terra incognita in terms of their specific plant communities and presence of rare and endangered species. Torrey's mountain mint (*Pycnanthemum torrei*), wild comfrey (*Cynoglossum virginianum*), downy arrowwood (*Viburnum rafinesquianum*), Virginia snakeroot (*Aristolochia serpentaria*), and purple hair grass (*Muhlenbergia capillaris*) are a few of the many rare plant species identified in the traprock ecosystem. Furthermore, a number of the traprock ecological communities, such as the summit sedge meadows and cliff-top "balds" or "barrens" are listed among the most unusual, and rarest, habitats in eastern North America. Although the surrounding lowlands are highly affected by invasive plant species and severe habitat fragmentation, most of the traprock crags in the Connecticut Valley maintain a surprisingly high degree of ecological integrity, considering their predominately urban and suburban setting.

COLONIZING THE CLIFFS

Temperature and moisture conditions at specific locations from cliff edge to the lower slopes vary widely, and each zone hosts a characteristic assemblage of plants. The cliff faces support coatings of green algae and growths of hardy lichens. Areas where water flows off the top of the cliffs or seeps through cracks commonly exhibit dark vertical streaks of "rock varnish" formed by cyanobacteria (blue-green algae) and mineral deposits. On the exposed summit ledges, pioneering communities of cyanobacteria and green algae form important microbiotic crusts that moderate harsh conditions on the bare rock. With time, the microbiotic crusts are joined by lichens, fungi, and mosses to form thin layers and pockets of cryptogamic soils. Eventually, hardy rushes (*Juncus* sp.), sedges (*Carex* sp.), and poverty grasses (*Danthonia* sp.) will join the succession. Be-

Flowers bloom in profusion
among the traprock hills.

RIGHT Birdsfoot violet
(*Viola pedata*).

Wood lily
(*Lilium philadelphicum*).

Red clover
(*Trifolium pratense*).

ABOVE MIDDLE Deptford pink
(*Dianthus armeria*).
ABOVE BOTTOM Wild geranium
(*Geranium maculatum*).

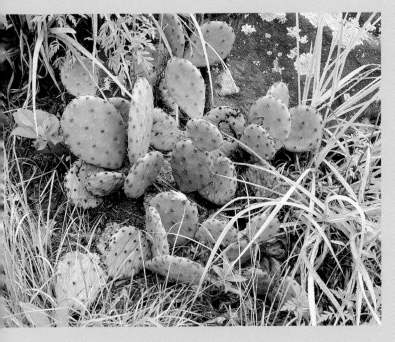

The extreme microclimates of the traprock ridges support many species at the edge of their geographic range. Here, a typically southern species, eastern prickly pear cactus (*Opuntia humifusa*), thrives near the northern limit of its range on the harsh summit of Peter's Rock in North Haven, Connecticut.

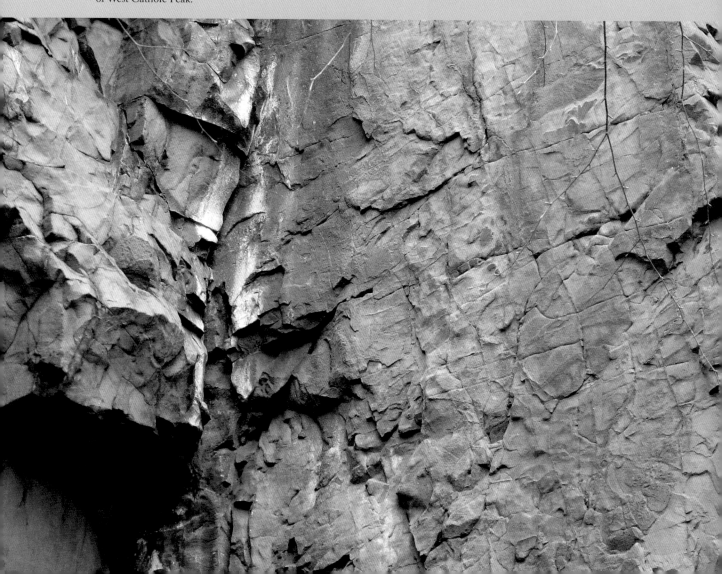

Rock varnish, algae, and
mineral deposits create
rainbow hues on the cliffs
of West Cathole Peak.

LEFT Map lichens (*Rhizocarpon* sp.), East Peak talus boulder, Meriden. Lichens, a symbiotic association of fungi and algae, moderate the extremely harsh surface conditions on bare rock, encouraging a succession of higher plants.

BELOW In the next stage of ecological succession, foliose lichens, including *Parmelia*, colonize the rock surfaces. Beseck Mountain, Middlefield, Connecticut.

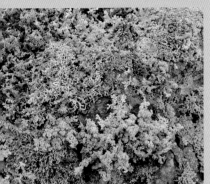

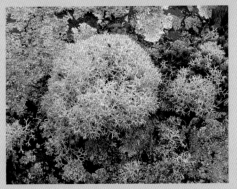

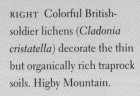

LEFT Rock foam lichens (*Stereocaulon* sp.) and reindeer moss (*Cladonia rangiferina*) indicate a maturing epilithic community on talus boulders at Beseck Mountain.

MIDDLE The arrival of hair-cap moss (*center right*) in the *Parmelia-Stereocalon-Cladonia* talus-slope lichen community reveals the development of incipient soils that retain moisture and provide nutrients, thus moderating the harsh epilithic environment. Charming pixie-cup lichens (*Cladonia pyxidata*) are visible at *lower center*. Beseck Mountain.

RIGHT Colorful British-soldier lichens (*Cladonia cristatella*) decorate the thin but organically rich traprock soils. Higby Mountain.

LEFT Thin cryptogamic crusts, comprising algae, fungi, lichens, and moss, are a vital early stage of soil development on the bare traprock summits. Cathole Peak, Meriden, Connecticut. RIGHT Fruticose lichens, such as (*center*) reindeer moss (*Cladonia rangiferina*), and thick mats of juniper haircap moss (*Polytrichum juniperinum*) indicate a mature stage of the cryptogamic soil succession. The appearance of tough poverty (*Danthonia* sp.) and bluestem (*Andopogon* sp.) grasses (*lower left*) signals the end of the cryptogamic soil community and the beginning of the summit meadow community. Beseck Mountain, Middlefield, Connecticut.

cause they retain scant moisture, trap sediment, and accumulate organic matter, the incipient cryptogamic soils are an important early stage of biological succession on the traprock summits.

In many locations, especially along popular trails, the slow-forming microbiotic crusts and cryptogamic soils have been severely disrupted or, in some cases, completely destroyed by trampling (see pages vii and 200). My ongoing studies of these important, but overlooked, traprock ecological associations suggest that they require additional protection as ecological features of special concern. Because of the high foot traffic, the thin summit soils are under particular threat at Ragged Mountain, Mount Higby, Cathole Peak, Talcott Mountain, and Mount Holyoke.

THE TALUS SLOPE COMMUNITY

The steep piles of talus banked against the base of the sheer traprock cliffs experience some of the most severe environmental conditions of any biological zone in the region. Nevertheless, most talus slopes are blanketed with beautiful and unique communities of lichens, a symbiotic association of fungi and algae, joined in wetter areas by mosses. Among the toughest plants on the planet, lichens thrive in the extreme ranges of temperature and moisture prevailing on

the boulder fields. With growth rates measured in fractions of millimeters per year, some talus-slope lichen communities in the Connecticut Valley have been growing for hundreds, and possibly thousands, of years.

The amount and type of lichen growth indicates the relative age and stability of different parts of the talus fields. Talus blocks beneath actively eroding cliffs have no lichen growth and only thin coatings of "rock varnish." In contrast, older and more stable talus slopes have thick growths of many different species of lichens, in particular the leafy or branching forms. As the vegetative succession on the talus slopes progresses, mosses and some grasses join the lichen community. Some particularly stable talus slopes eventually host stands of oak and hickory.

A jigsaw puzzle of interlocking blocks, sloping approximately forty degrees, forms an apron of talus beneath Beseck Mountain. Geologic features and lichen-growth patterns suggest that some talus slopes in the Connecticut Valley are the oldest undisturbed landscapes in southern New England. Black Pond, Middlefield, Connecticut.

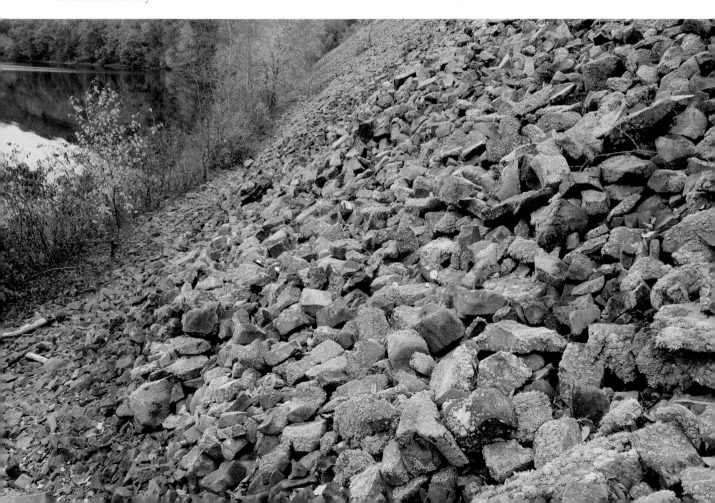

Even on the hottest days, cool air seeps out of the numerous cavities between boulders, moderating the temperatures at the base of the talus slopes. In the late nineteenth and early twentieth centuries, the talus-block "ice caves" at the Cold Spring Resort beneath South Mountain in Meriden attracted scores of visitors seeking cool air and refreshing springwater. In winter, the opposite effect occurs, and warm columns of water vapor rise from cavities at the top of the talus slopes. Here, warm moist air rising from cavities in the talus formed a coating of rime ice in January. East Peak, Meriden.

The numerous cavities surrounding the talus blocks create unique "cold seeps" that pour out icy air on warm days; some recesses between the talus blocks retain ice all year round. In winter, the opposite effect occurs, and warm air rising from the cavities creates steaming mists and coatings of rime ice. Thus, the flow of air through the permeable talus slopes, to some extent, moderates the seasonal extremes in temperature. Termed *algific slopes* by ecologists, such "cold seep" habitats are rare in the eastern United States, but relatively common in the traprock landscapes of the Connecticut Valley.

Jedidiah Morse, the "father of American geography," noted the occurrence of "ice caves" on Totoket Mountain in 1789: "Tetoket mountain in Branford . . . on the north-west part of it, a few feet below the surface, has ice in large quantities in all seasons of the year."[1] Tourists once flocked to the famous Cold Spring resort beneath South Mountain in Meriden to drink cold water from the clear springs and to enjoy the cool air flowing out of the recesses between talus blocks during the summer. Stories of the unusual "natural ice houses" at South Mountain motivated Yale Professor Benjamin Silliman to visit Cold Spring on a hot July day in 1821. He reported: "The ice is thick, and well-consolidated, and its gradual melting in the warm season, causes a stream of ice cold water to issue from this defile."[2] After exploring the talus slopes and observing the cold seeps firsthand, he carried several blocks of the Cold Spring ice back to his laboratory at Yale as curiosities.

Although the talus slopes are among the most prominent geological features of the traprock landscapes and host some of the most interesting biological communities, with the exception of my research, they have been largely overlooked in modern studies. Likely the oldest undisturbed landscapes in southern New England, the traprock talus slopes are easily disrupted; a single hiker may destroy hundreds of years of growth in the "lichen gardens" with one pass through an unstable boulder field. My ongoing work mapping the distribution, composition, and age relationships of the talus-slope ecological communities will be used to prepare management plans for protecting these unique habitats.

TRAPROCK SUMMIT AND SLOPE COMMUNITIES

A hardy community of grasses and low, woody shrubs find shelter in the numerous cracks and crevices along the summit ridges. There, trapped moisture, sediment, and organic debris create a suitable habitat for hardy species including lowbush blueberry (*Vaccinium* spp.) and bearberry, red cedar (*Juniperus virginiana*), red maple (*Acer rubrum*), chestnut oak (*Quercus prinus*), and bear oak (*Quercus ilicifolia*), as well as a variety of grasses and sedges.

The cliff-edge cracks and crevices also support stunted red cedars, pines, and junipers twisted into beautiful bonsai-like forms by long years of exposure to fierce winds and harsh summit conditions. These slow-growing traprock "bonsai" trees have survived for hundreds of years as some of the oldest organisms in southern New England, if not a wider region. The destruction wrought upon these unique and venerable specimens, used as rope anchors by climbers, cut for firewood, and otherwise abused, is heartbreaking to observe.

81

A single footstep disturbs centuries of lichen growth on a talus slope at Beseck Mountain. Image: author's collection.

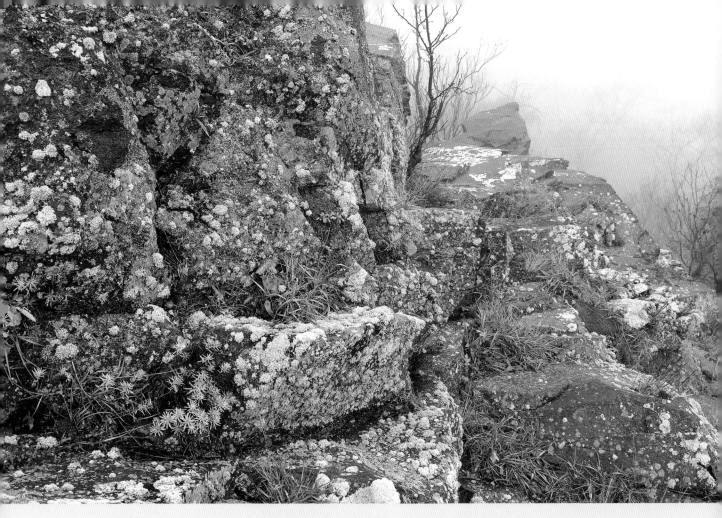

Shelter and moisture found in cracks and crevices encourages a succession of plants, beginning with lichens, fungi, algae, and moss (*top left*), followed by tough poverty (*Danthonia* sp.) and bluestem (*Andropogon* sp.) grasses, rushes, and sedges (*foreground*), and, finally, forbs, shrubs, and dwarfed trees (*background*). West Peak, Meriden, Connecticut.

Evidence of severe thunderstorms that besiege the summit community, two eastern hemlocks met their fate in an explosion of wood and water vapor after a lightning strike. South Mountain, Meriden, Connecticut.

The fire ecology of the summit barrens. Thin peat soils ignited by lightning or careless visitors may smolder for days. Shown here, West Peak in July 2015.

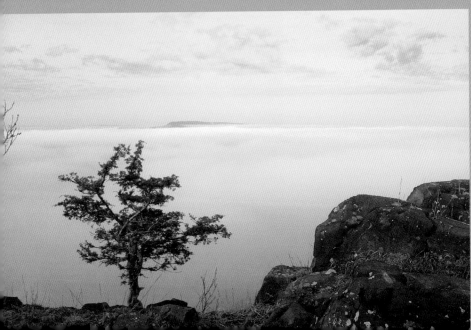

Shaped by the elements, natural "bonsai" trees cling to the trap-rock precipices. Pruned by the severe conditions, tough eastern red cedar (*Juniperus virginiana*), seen here, common juniper (*Juniperus communis*), and pitch pine (*Pinus rigida*) are twisted into fascinating forms; some beautifully weathered specimens may survive for a century or more. View from Mount Higby looking west to Meriden's Hanging Hills.

Savanna-like meadows, made up of Pennsylvania sedge (*Carex pensylvanica*) and several species of hickory and oak, form one of the most unique and beautiful ecological communities on the traprock summits. Higby Mountain.

RIGHT Prince's pine, a club moss (*Lycopodium* sp.) thrives on nutrients from decaying vegetation that replenish the thin traprock soil. *Lycopodium* club mosses are neither pines nor mosses, but rather representatives of an ancient lineage of nonflowering vascular plants that appeared in the Devonian period and had their greatest abundance in the great coal swamps of the Carboniferous period. Higby Mountain, Middletown, Connecticut.

Bracket fungi and other decomposers recycle nutrients through the traprock ecosystem. East Peak, Meriden, Connecticut.

BELOW Moist broadleaf forests on the lower slopes of the traprock ridges form important woodland habitats. Retaining its leaves through the winter, an American beech (*Fagus grandifolius*) brightens the woods near Chauncey Peak.

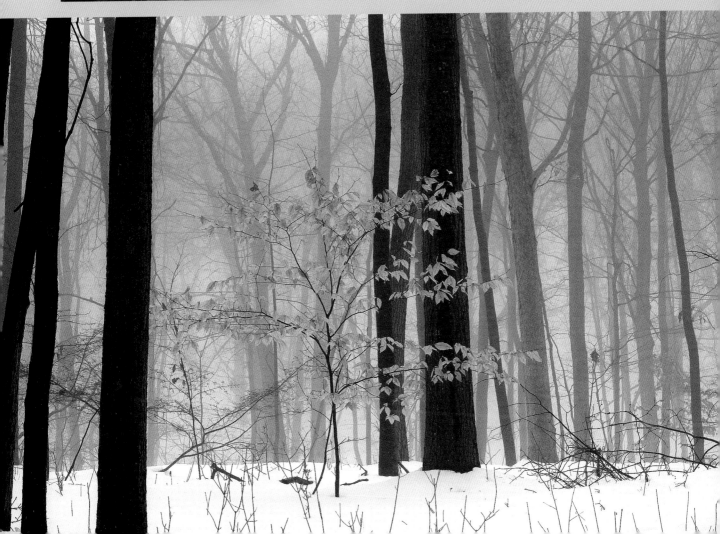

As soil and climate conditions improve with distance away from the edges of traprock cliffs, a transition to mixed shrub-scrub and stunted oak-hickory forests occurs. Trees on the upper fringes of the back-slope community are often "trimmed" by the fierce winds and ice storms. Within several hundred feet of the ridge crest, however, the trees of the back slope increase dramatically in height to become rich broadleaf forests and magnificent conifer stands.

Perhaps the most beautiful plant associations in the traprock highlands are the sedge meadows that occupy the droughty areas of the higher summits. Formed of a thick ground cover of Pennsylvania sedge (*Carex pensylvanica*) with sparse stands of stunted chestnut oak and hickory, these savanna-like glades are among the rarest plant communities in the eastern United States. Walking through the golden sedge meadows in the warm light of late summer is an unforgettable traprock experience. The summit barrens also host meadows of native grasses, including varieties of bluestem (*Andropogon* sp.) and poverty grass (*Danthonia* sp.).

Groves of eastern hemlock (*Tsuga canadensis*) preferentially occupy the thin rocky soils of the cool ravines and northern slopes. Once forming a dominant plant community of the higher elevations and cooler microclimates, many stands of eastern hemlock in the southern Connecticut Valley have been devastated by the invasive hemlock woolly adelgid (*Adelges tsugae*), an aphid-like insect. Where feathery hemlock branches once swayed in old-growth hemlock forests, dead trunks stand in mute testimony to the changing forest ecology and ongoing anthropogenic environmental impacts.

On the lower elevations, the trees of the mixed mesophytic forest attain heights of fifty feet or more, allowing the full development of understory and ground-cover plant associations. Recovering from a long history of cutting, clearing, and burning, the traprock slope forests are now firmly reestablished as high-quality components of the regional ecosystem. However, the traprock forest composition and structure is continuing to evolve as sugar maple (*Acer saccharum*), ash (*Fraxinus* sp.), and other native trees fall prey to invasive insects, diseases, and long-term climate change.

As the largest and most diverse natural landscapes in the region, the traprock ridges host a complete range of native mammals, birds, reptiles, amphibians, insects, and freshwater organisms, including many species of special concern, as well as a number of threatened or endangered species.

The combination of deforestation, subsistence hunting, and the practice of offering bounties effectively removed large predators and game animals from the traprock hills early in the period of settlement and expansion. By 1821, Timothy Dwight noted the scarcity of large mammals in the Connecticut Valley when he stated: "Bears, wolves, catamounts, and deer are scarcely known . . . hunting with us exists chiefly in the tales of other times."

Colonial records provide tangible evidence of bounties paid for eastern mountain lions and wolves taken in the traprock hills, although as apex predators their numbers must have always been relatively small. Local names, such as Meriden's Cathole Peak, the now-flooded Panther Swamp in Plainville, and several "painter" (i.e., panther) hills recall the days when these magnificent predators once roamed the basalt cliffs and used the numerous boulder caves and rock crevices as denning sites. The last cougars in the region were killed in the Berkshire Mountains of Massachusetts and Connecticut in 1858 and 1887, respectively; a remnant population on Cape Ann north of Boston was extirpated by 1905.

The eastern timber wolf (*Canis lupus lycaon*) was eliminated from southern New England by the late 1700s; therefore, little is known about its natural history. Eager to protect their livestock, and armed with negative Old World attitudes, the English colonists hunted wolves in southern New England with vigor.

In 1638, the Hartford colony passed a resolution to eliminate the eastern timber wolf from the area: "Whereas great loss and damage doth befall . . . by reason of wolves, which destroy great numbers of our cattle . . . any person, either English or indian, that shall kill any wolfe or wolves, within ten myles of

ABOVE A group of great spangled fritillary (*Speyeria cybele*) butterflies feeding on butterfly weed (*Asclepias tuberosa*), a member of the milkweed family. LEFT A bold example of mimicry, a spicebush swallowtail butterfly (*Papilio troilus*) larva displays large, threatening "false eyes" to scare off hungry predators.

Monarch butterfly (*Danaus plexippus*) larva feeding on swamp milkweed (*Asclepius incarnata*). The profusion of flowering plants on the traprock highlands is important for a variety of insects and birds.

A gallery of traprock insects.

Augochlora metallic green sweat bee (*Augochlora pura*).

The American hoverfly (*Eupeodes americanus*), mimics bees for protection.

A boldly patterned parasitic giant ichneumon wasp (*Megarhyssa* sp.).

A periodical cicada (*Magicicada* sp.) stops for a rest on an eastern box turtle (*Terrapene carolina carolina*).

Mainly nocturnal, and shy of humans, the presence of most small mammals is announced by their tracks or scats.
TOP Owing to the absence of natural predators, and an increase in preferred "edge" habitats, large populations of white-tailed deer (*Odocoileus virginianus*) exist throughout the traprock corridor. Deer droppings, South Mountain.
BOTTOM Droppings containing seeds and fur mark territory on the edge of West Peak and reveal the omnivorous diet of the red fox (*Vulpes vulpes*).

any plantation . . . shall have for every wolfe . . . ten shillings . . . provided that due proofe be made thereof."[3]

In 1678, Meriden stepped up its efforts to eradicate wolves from the traprock hills, and a large swamp called Dog's Misery that was known to harbor them, by adding two shillings to the bounty. The bounty was again raised in 1713, when "the town voted that they would allow five shillings to him that tracks a wolf or woolfs into a swamp, and then give notice of ye same, and then raises a company of men so that ye wolf or woolfs be killed."[4]

Springfield paid its last wolf bounty in 1682. Wolves were eliminated near Northampton by 1763, but some returned from 1772 to 1775. The last wolves in the Connecticut Valley, a lone pair harboring in the traprock hills near Hadley, were killed in 1805. Where wolves once howled, the sound of coyotes now echoes among the traprock hills. Once largely extirpated from the Connecticut Valley traprock ecosystem, eastern coyotes (*Canis latrans*) are now firmly established because of their regional range expansion in the mid to late twentieth century.

In the absence of large predators, and thriving on a well-tended banquet of lawns and ornamental plantings, the white-tailed deer (*Odocoileus virginianus*) population in the Connecticut Valley has grown to historic levels. Noted as scarce by the early nineteenth century, today they are found in high numbers in most suburban green spaces, including residential and commercial developments, golf courses, and parks. Although hikers enjoy seeing these graceful mammals, ecologists refer to their overpopulation as "the single greatest threat to the eastern forests." Preferential browsing by deer on favored plants has changed the composition and structure of many forests, in turn affecting the populations of birds and small mammals. By altering ground-cover and understory plant associations, spreading the seeds of invasive plants, consuming canopy tree saplings, serving as a vector for tick-borne Lyme disease, and frequently colliding with vehicles on roads and highways, the white-tailed deer has become less of a symbol of natural beauty than an indicator of an unbalanced traprock ecosystem.

Black bears (*Ursus americanus*) formerly occupied the entire traprock ridge system, but they were eliminated from the Connecticut Valley early during the period of settlement and expansion. Colonists viewed bears with appropriate caution and gave them a wide berth, particularly in "strawberry time," when they were accompanied by their cubs. Nevertheless, bears were greatly prized for their "very good meate, esteemed of all men above Venison." In his 1634 *New England's Prospect*, William Wood suggested "it would be a good change if the country had for every Woolfe a Beare, upon the condition all the woolves were banished; so should the inhabitants be not only rid of their greatest annoyance, but furnished with more store of provisions."

Black bears have returned to the traprock ridges of the northern Connecticut Valley in substantial numbers, and are now are listed as "moderately common" from Avon, Connecticut, to the Holyoke Range. Recent sightings indicate that black bears are using the traprock ridges as a natural corridor to rapidly expand their range south into the central Connecticut Valley. From 2013 to 2014, towns from north to south along the trend of the traprock hills reported black bears in these numbers: Granby (137), Bloomfield (92), West Hartford (54), Rocky Hill (19), New Britain (11), Berlin (30), Meriden (10), and Wallingford (2).[5]

In addition to the large mammals, the traprock highlands support a wide variety of small mammals. Up-to-date information about the status and distribution of the numerous mammal species occupying the traprock highlands is available from the Connecticut and Massachusetts state environmental departments; only a few are listed here. Species seeking rock dens, such as the red fox (*Vulpes vulpes*) and bobcats (*Lynx rufus*) find suitable homes among the traprock ledges, boulders, and talus slopes. In the northern Connecticut Valley, weasels and mink (*Mustela* spp.) and river otters (*Lontra canadensis*) are well represented along rivers and streams, and porcupines find food and shelter in the cool woodlands. Beavers (*Castor canadensis*) have repopulated the wetlands and ponds in large numbers after being severely reduced by trapping and hunting through the mid-twentieth century. The large number of ponds, brooks, marshes, and swamps named after this ingenious aquatic

mammal reveal its widespread distribution and economic importance for fur in colonial times.

Long recognized for their high populations of snakes, the ledges, talus slopes, meadows, forests, and wetlands in the traprock hills provide ideal habitat for many native species, including northern black racers (*Coluber constrictor*), eastern black rat snakes (*Elaphe* sp.), common gartersnakes (*Thamnophis* sp.), hognose snakes (*Heterodon platirhinos*), and northern water snakes (*Nerodia sipedon*). The traprock habitats of the southern Connecticut Valley sustain some of the highest regional populations of the common ribbonsnake (*Thamnophis sauritus*), a state species of special concern.

The traprock highlands are also noted for two species of venomous pit vipers, the northern copperhead (*Agkistrodon contortrix*) and the eastern timber rattlesnake (*Crotalus horridus*). The former practice of offering bounties, sport hunting, and the demand for "snake oil" as a remedy for numerous maladies reduced or eliminated most populations of copperheads and rattlesnakes from the traprock ridges by the early 1900s.

Through the nineteenth century, rattlesnakes were actively hunted for cash and sport. A rattlesnake hunter frequenting the Hanging Hills in Meriden reportedly sold hundreds over a period of several years; in 1898 alone, he bagged

Blending in with the forest floor on a cool April day, this small northern copperhead (*Agkistrodon contortrix*) recently arrived at the summit sedge glades after emerging from its winter den in the nearby talus fields. Shy and retiring, copperheads usually "freeze" in place until the threat passes. This makes them difficult to see. Belonging to a group called the "pit vipers," copperheads hunt small mammals using heat-sensing organs, or loreal pits, located near their snout (and visible in this picture), before subduing their prey with venom. Once hunted nearly to extirpation in the Connecticut Valley, copperheads are again relatively common in the traprock hills. West Peak, Meriden.

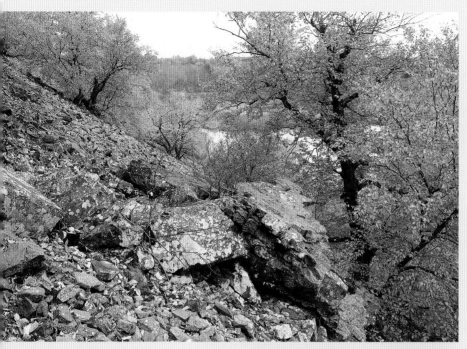

Traprock talus slopes like this one on Beseck Mountain form ideal habitats for a variety of snakes.

Common garter snake
(*Thamnophis sirtalis*),
Chauncey Peak.

Eastern milk snake
(*Lampropeltis triangulum*),
East Peak.

Northern water snake
(*Natrix sipedon*),
Merimere Reservoir.

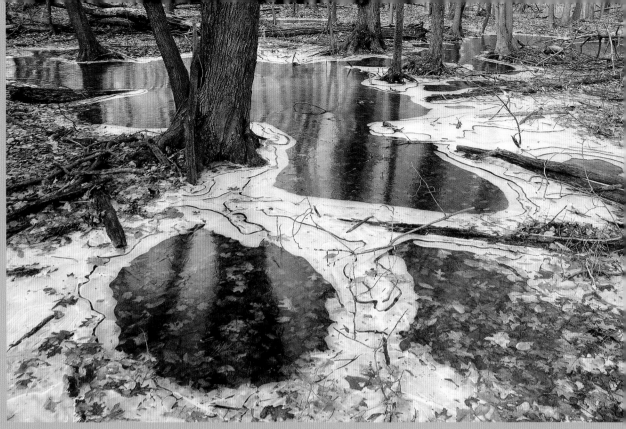

Shallow vernal pools, or "spring ponds," provide critical habitat for woodland amphibians at Higby Mountain.

Spotted salamander (*Ambystoma maculatum*).

Marbled salamander (*Ambystoma opacum*).

Wood frog
(*Lithobates sylvaticus*).

American toad
(*Bufo americanus*).

Pickerel frog
(*Rana pipiens*).

Mating American
toads.

Red efts, the terrestrial stage of the red-
spotted newt (*Notophthalmus* sp.).

more than thirty-five. By 1895, the rattlesnakes at Mount Tom were considered "more or less thinned out in recent years, though . . . sufficiently thick to afford a good day's sport." Historical records, as well as the names of geographic features—Rattlesnake Mountain (Farmington), Rattlesnake Ledges (Mount Tom), Rattlesnake Swamp (West Springfield), and others—attest to their wider distribution in earlier times.

Although rattlesnakes—with the exception of a small population reported from talus slopes in the northern Connecticut Valley—remain extirpated over most of their former range in the traprock hills, copperheads have recovered in substantial numbers. Recent studies conducted in central Connecticut identified a large population of copperheads that use the summit sedge glades as summer habitat and return to dens in the talus slopes for the winter.

The traprock swamps, marshes, and shallow seasonal ponds called vernal pools provide ideal habitat for woodland amphibians including wood frogs (*Lithobates sylvaticus*), spring peepers (*Pseudacris crucifer*), gray tree frogs (*Hyla versicolor*), and American toads (*Bufo americanus*). Dusky (*Desmognathus fuscus*), northern two-lined (*Eurycea bislineata*), marbled (*Ambystoma opacum*), and spotted (*Ambystoma maculatum*) salamanders, and red-spotted newts (*Notophthalmus* sp.), all find suitable habitats within the traprock hills. Important populations of several species that are rare in southern New England, including the Jefferson salamander (*Ambystoma jeffersonianum*), and the Jefferson/blue-spotted hybrids, are found in certain localities in the traprock hills.

The annual return of the woodland amphibians, becoming active even as late winter ice lingers, signals the certain arrival of the growing season. Hearing a chorus of frog and toad mating calls echoing through the traprock forests is a particularly delightful experience for early spring visitors.

The traprock highlands are important habitats for a diverse population of birds, including permanent residents and annual migrants. A wide variety of hawks and falcons take advantage of thermal updrafts along the ridge crests to assist them in their seasonal migrations. During peak fall migration, raptors

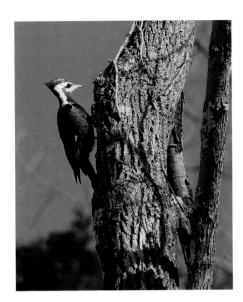

Preferring mature woodlands, (LEFT) pileated woodpeckers (*Dryocopus pileatus*) are common in the older forests on the flanks of the traprock highlands. Their presence is indicated by large, keyhole-shaped cavities (RIGHT), excavated during their search for insects.

numbering in the thousands are observed soaring south along the traprock ridges of Mount Tom, Talcott Mountain, West Peak, and West Rock.

Once hunted for sport and bounties, and reduced by the effects of habitat loss and pesticides, particularly DDT, nesting raptors have returned to the Connecticut Valley in good numbers. Recognized as essential top predators in healthy ecosystems, the traprock highlands provide cliffs and ledges necessary for nesting and roosting. Recovering from regional extirpation, peregrine falcons (*Falco peregrinus*) again nest on secluded traprock ledges and remote cliffs. Because they are easily disturbed by the presence of humans, their nesting ledges require additional protection, including rerouting of trails, during breeding season. The population of bald eagles (*Haliaeetus leucocephalus*) wintering along the Connecticut River has also increased dramatically since the 1980s, and now successful nesting is reported from the traprock regions near Northampton, West Springfield, Windsor, Hartford, and Lake Gaillard reservoir on Totoket Mountain. Also formerly reduced by the effects of pesticides,

Indigo bunting (*Passerina cyanea*).

Hermit thrush (*Catharus guttatus*).

With their colorful plumage and delightful songs, migratory birds brighten the traprock highlands.

Scarlet tanager
(*Piranga olivacea*).

Recovering from a dramatic decline in the twentieth century due to the combined effects of hunting, habitat loss, and pesticides, peregrine falcons again nest on isolated traprock ledges. Easily disturbed by humans, their continued success may require limiting access to certain cliffs during the breeding season.

ospreys (*Pandion haliaetus*) are now commonly observed hunting for fish at the numerous traprock lakes and reservoirs.

Migratory songbirds appear in large numbers along the system of traprock ridges each spring and fall. Birders consider East and West Rock, Sleeping Giant, Lamentation-Chauncey, Talcott Mountain, Mount Tom, and Mount Holyoke as dependable "hot spots" for observing colorful warblers and other spring migrants. Offering refuge for weary birds recovering from long night flights, the traprock highlands are a critical component of the eastern migratory corridor. Faced with shrinking open space, many species of birds in the region depend on the traprock habitats.

Prior to their successful reintroduction in the mid-twentieth century, wild turkeys (*Meleagris gallopavo*) had been extirpated from most of the Connecticut Valley by the early 1800s. The last historical record of the original southern Connecticut Valley population mentions a sighting in the traprock hills of North Branford in 1813. Reports of wild turkeys in the Holyoke range continued into the mid-1800s. Owing to the vigorous efforts of state wildlife managers in Massachusetts and Connecticut, wild turkeys are again abundant in the forests and meadows of the traprock highlands.

WATER RESOURCES

Like a string of sapphires set within the emerald hills, more than one hundred lakes and ponds decorate the traprock landscapes. Forming nearly perfect watersheds, the broad forested slopes of the traprock ridges capture precipitation and slowly release the naturally filtered water to lakes, ponds, wetlands, and reservoirs in the intervening valleys.

Reminiscent of England's fabled Lake District, the central Connecticut Valley with its fault-bounded crags has the greatest concentration of ponds, lakes, and reservoirs in the traprock ridge system. There, crystal-clear lakes set against the towering cliffs and sprawling talus slopes create what has long been considered the most spectacular scenery in the entire Connecticut Valley.

Seasonally flooded swamp
beneath the western slopes
of Mount Higby.

Patterns in vernal pool ice
mimic red maple leaves.
Countless seasonal ponds
in the traprock highlands
moderate flooding by
capturing precipitation and
slowly releasing the water to
the lower elevations.

Water droplets collecting
in the traprock highlands
nourish watersheds that supply
drinking water to thousands of
Connecticut Valley residents.

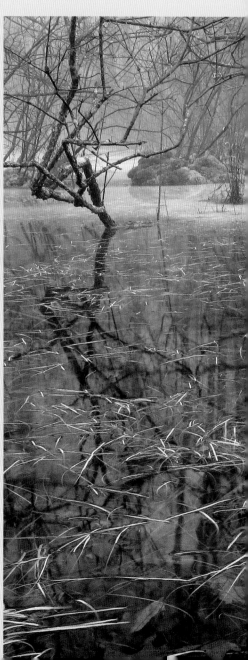

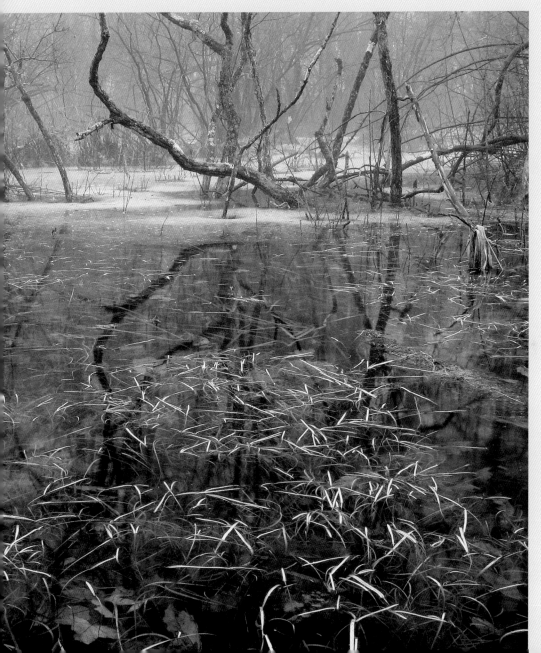

Wetlands, such as this shrub swamp at Preston Notch on Mount Higby, perform essential hydrologic functions, such as retaining runoff and replenishing groundwater, and provide habitat for a wide variety of organisms.

Cradled between the sheer cliffs of East Peak and South Mountain, Merimere Reservoir is the centerpiece of scenic Hubbard Park. Similarly, Crescent Lake (the former Bradley Hubbard Reservoir) shimmers beneath the bold cliffs of Chauncey Peak, and Black Pond reflects the towering cliffs of Beseck Mountain. The famous rock-climbing walls at Ragged Mountain overlook scenic Hart Pond and the Wassel and Shuttle Meadow Reservoirs. No visit to the traprock hills is complete without a short hike to view the beauty of these alpine lakes, hidden away from the hectic cities and busy highways.

Charming vernal pools and mountain ponds are scattered throughout the higher elevations of the traprock crags. Created by the irregular topography and relatively impermeable bedrock, the thousands of water bodies scattered throughout the traprock hills play an important role in the regional hydrology by storing and slowly releasing storm water, and recharging groundwater aquifers.

The traprock hills also feature a number of mountain ponds notable for their altitude. Sitting at an elevation of 757 feet, Hoe Pond at Daniel Wadsworth's former Monte Video estate on Talcott Mountain is the highest natural perennial pond of significant size in the Connecticut Valley. Nearby Ely Pond (elevation 652 ft.), claims its place as the second-highest perennial pond in the traprock ridge system; third place goes to Lake Louise (el. 525 ft.) on the Penwood State Park segment of Talcott Mountain. On Totoket Mountain, man-made Lane Pond has a surface elevation of over 550 feet.

As the Connecticut Valley population grew through the mid-1800s, many municipalities turned their attention to the nearby traprock ridges for water supply. By the late 1800s large reservoir systems were in place or under construction in New Haven, Meriden, New Britain, Hartford, and Holyoke. At the time, the traprock reservoir systems were some of the most advanced waterworks in the United States, and, as a result of careful management and watershed protection, they remain important public water supplies.

Naturally filtered by vegetation and the underlying soil and bedrock, the quality of the water from Connecticut Valley traprock reservoirs has long been recognized as the finest in the region, usually requiring only minimal treatment

before delivery. Commenting on the water-resource potential of the Hanging Hills watersheds in central Connecticut, a report from 1889 stated: "The Meriden reservoir would seem to be a most excellent one. Its location among the rocky hills, with but little of the higher forms of vegetation growing in it, a water shed wholly exempt from human pollutions, and with considerable depth; indeed, all its physical features seem among the best in the state."[6]

More than forty active or former reservoirs are found among the traprock ridges from New Haven to Northampton, and thousands of residents in the Connecticut Valley depend on clean water from the traprock watersheds every day. To meet demand, many of the traprock reservoirs are now by regional aqueduct systems.

Public water supplies in the central Connecticut Valley sourced from traprock-ridge watersheds include Pistapaug and MacKenzie Reservoirs in Wallingford; Merimere, Hallmere, Elmere, Kenmere in Meriden and Berlin; Middletown's Mount Higby and Adder Reservoirs; and the Shuttle Meadow system in New Britain. In the southern Connecticut Valley, Whitney, Gaillard, Salton-

Built in the late 1800s to supply a noted manufacturer of decorative metalware, the former Bradley Hubbard Reservoir (Crescent Lake) in Meriden, Connecticut, is replenished by runoff from Lamentation Mountain (*left*) and Chauncey Peak (*right*). Its surface elevation of about 300 feet above sea level allowed water to flow by gravity to factories near the city center. Surrounded by cliffs, Crescent Lake is the centerpiece of Meriden's popular Giuffrida Park.

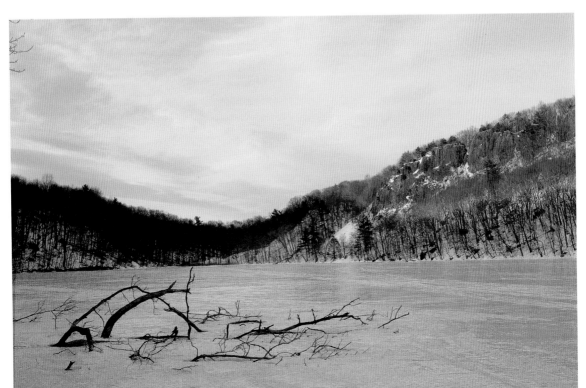

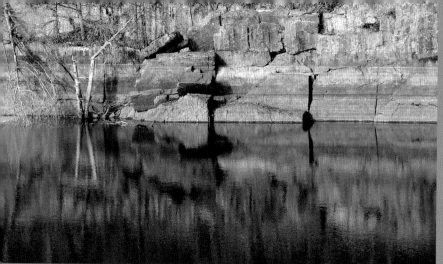

With a surface elevation of
512 feet, the New Britain
Water Company's Wassel
Reservoir is the highest major
water-supply pond in the
Connecticut Valley.

Outdoor enthusiasts ply
the waters of Black Pond
at Beseck Mountain.

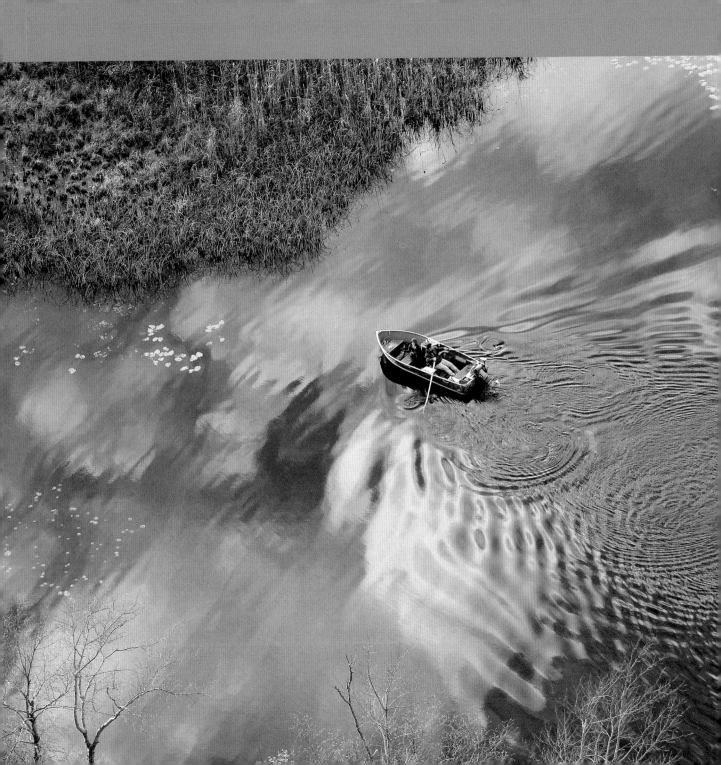

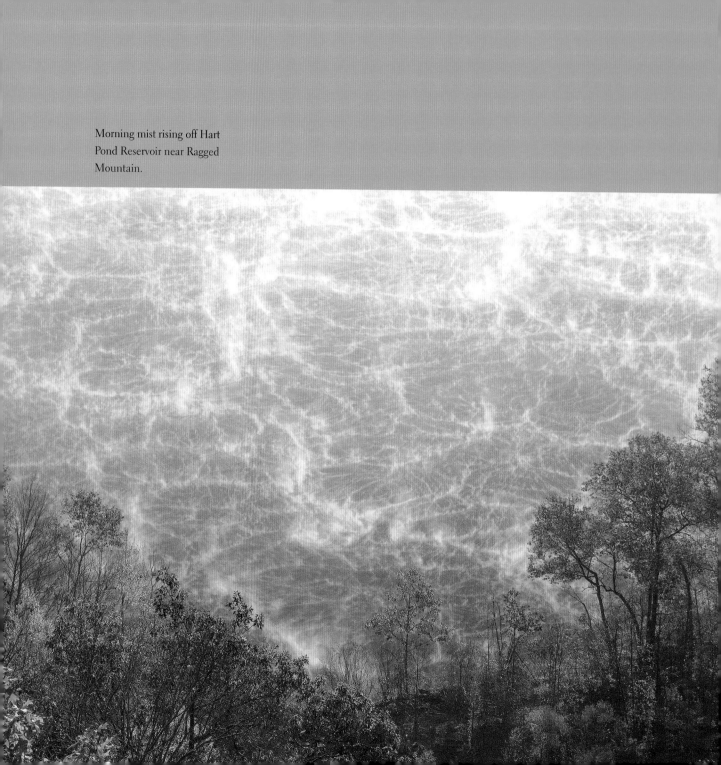

Morning mist rising off Hart
Pond Reservoir near Ragged
Mountain.

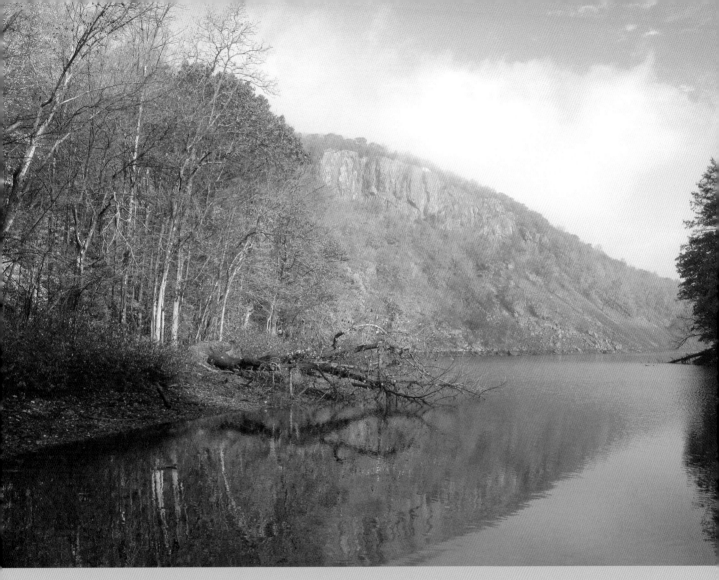

One of the first traprock reservoirs in the Connecticut Valley, Merimere Reservoir has supplied the city of Meriden with pristine mountain-fed water since 1879. Expansion in 1888 added nearby Hallmere, Kenmere, and Elmere Reservoirs to the system.

stall, Dawson, and Watrous Reservoirs are located within the traprock watersheds. In the north, East Mountain, Mount Tom, and Mount Holyoke form the major watershed supplying West Springfield, Holyoke, and South Hadley.

These critical water-supply reservoirs not only hold billions of gallons of clean water, but their surrounding watersheds also make up some of the most important open space in the region. Some water companies, including Hartford's MDC and the South Central Connecticut Regional Water Authority in New Haven, allow passive recreation in their watersheds.

During the great industrial age of the late 1800s, factories in New Haven, Meriden, New Britain, West Springfield, and Holyoke constructed and maintained private reservoirs in the traprock hills for industrial uses, drinking water, and fire protection. Today, most of these industrial reservoirs are inactive, but many remain protected and held as potential emergency supplies, while others have become part of local land trusts and parks, including the former Bradley Hubbard Reservoir (Crescent Lake) at Giuffrida Park in Meriden.

Building the dams, spillways, canals, aqueducts, pipelines, and treatment facilities for the traprock reservoirs and water-distribution systems required state-of-the-art civil engineering. For example, construction of the New Haven Water Company Totoket Reservoir (Lake Gaillard) in 1925 required building a large dam and three aqueduct tunnels, the longest about 2.5 miles long. To provide additional water to the Totoket system in the early 1930s, the Genesee tunnel, a 5-mile-long aqueduct, was built through solid rock from Lake Hammonasset in North Madison to the Menuncatuck holding reservoir in North Branford. Engineering marvels of the early twentieth century, large holding-tank reservoirs were built on the summits of Mill Rock in New Haven and Provin Mountain in West Springfield to improve the delivery pressure and overall capacity of their respective distribution systems.

Capturing about 45 inches of annual precipitation, the traprock watersheds supply water to a large number of rivers and streams. New England's largest river, the Connecticut, dominates the hydrology of most of the Connecticut Valley. The largest river in the southern Connecticut Valley, the Quinnipiac

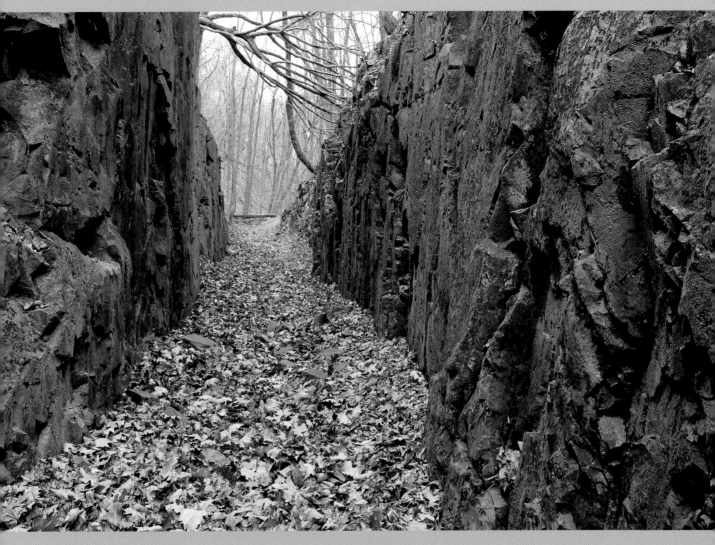

Located in the deep notch between Mount Lamentation and Chauncey Peak, the Bradley Hubbard Reservoir canal in Giuffrida Park, Meriden, is a reminder of the ingenuity of nineteenth-century water-resource engineers. Most of the traprock reservoirs in the Connecticut Valley utilize a system of canals that convey runoff into the main storage basins. Some traprock reservoirs, such as Lake Gaillard in North Branford, are also supplied by aqueduct tunnels thousands of feet in length.

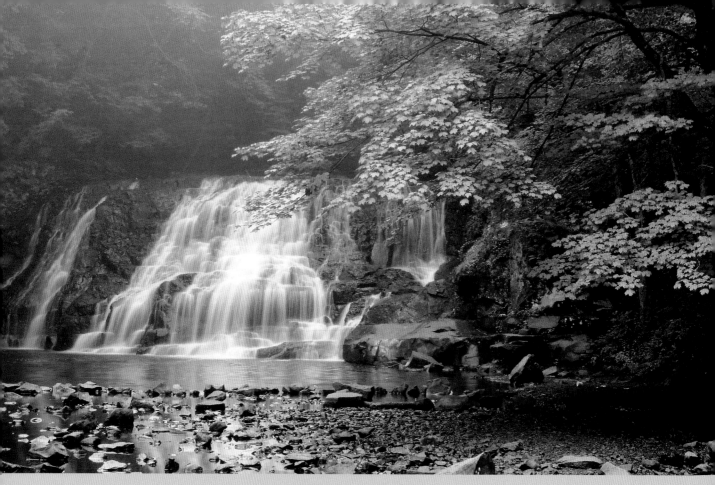

Wadsworth Falls, Middlefield, Connecticut. Low flow, summer 2014. Under normal flow conditions Wadsworth Falls on the Coginchaug River forms cascades over the ledges of the Hampden, or upper, lava flow. The falls are easily accessed from scenic trails at Wadsworth Falls State Park.

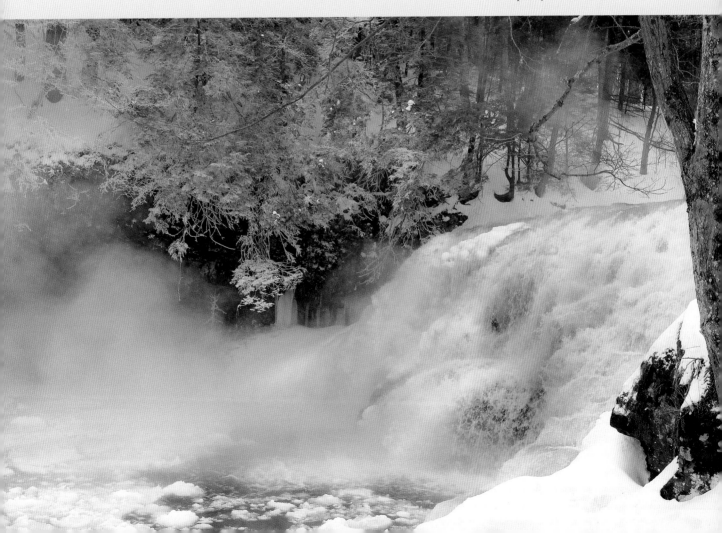

Wadsworth Falls, winter 2014.
During flood stage, normally
tranquil Wadsworth Falls
turns into a thundering torrent
enveloped by clouds of mist.

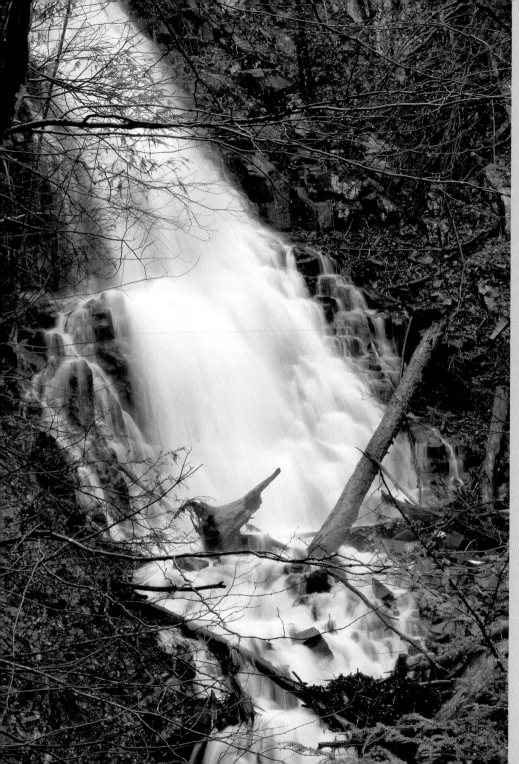

Roaring Brook Falls splashes
more than 180 feet down
the diabase ledges of Mount
Sanford in Cheshire,
Connecticut; the waterfall is
one of the scenic gems hidden
in the less frequented traprock
hills of the Western Range.

A prime outdoor attraction since
the nineteenth century, Westfield
Falls in Middletown, Connecticut,
presents fine views in all seasons.
Featured in early photographic
prints and postcards, Westfield
Falls remains a popular locale for
artists and photographers.

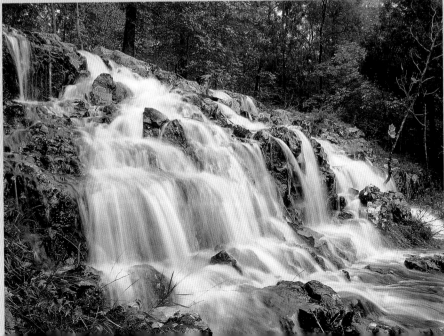

Traprock ledges create
numerous seasonal or
storm-fed cascades, such
as these at the Ragged
Mountain Preserve.

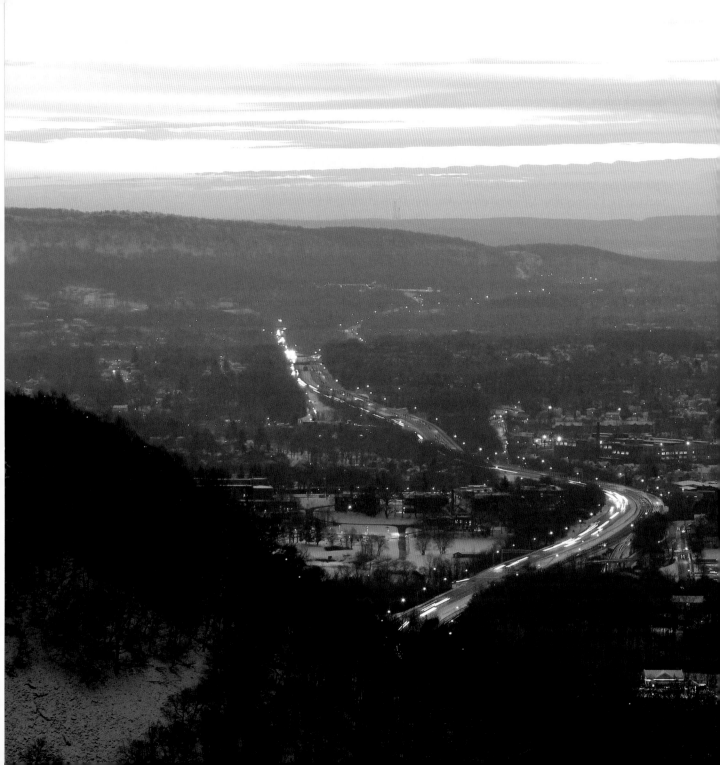

5

A Valley of Extreme Beauty and Great Extent

TRAPROCK LANDSCAPES AND LEGACY

Of the country along the
Connecticut . . . we . . .
find a rich diversity of scenery,
so that not only the geologist,
but the poet and the painter . . .
will find an interest in its beauties.

Edward Hitchcock, *A Sketch of the Geology,
Mineralogy, and Scenery of the Regions
Contiguous to the River Connecticut* (1824)

T he traprock ridges of the Connecticut Valley are among the most picturesque landforms in the eastern United States. Comparable in scale and topographic form to the celebrated crags, fells (boulder-strewn slopes), and edges (linear cliffs) of northern England, the Connecticut Valley traprock hills offer thrilling ascents over steep, rocky trails and magnificent summit views. Recalling his visit to Talcott Mountain in 1819, Benjamin Silliman wrote: "From the high cliffs of the ridge . . . you look almost perpendicularly into a valley of extreme beauty, and great extent, in the highest state of cultivation, and which, although apparently within reach, is six hundred and forty feet below you . . . and . . . every object is . . . perfectly visible, as if placed upon a map."[1]

The intimate maplike views from the traprock cliffs that had so impressed Silliman also garnered wide praise from many other American and European authors in the nineteenth century. At that time, the traprock summits were celebrated not only for their wilderness aspect, but also for providing elevated views, or "prospects," of the thriving farms and prosperous villages where the agricultural, industrial, and social progress of the young nation was on display.

Although other mountains in New England far exceed the elevations of the Connecticut Valley traprock ridges, the smaller crags earned widespread fame because they achieved an emotional resonance with visitors that was lacking at many of the larger mountains of New England. With sheer cliffs rising abruptly from the valley floors and barren windswept summits, they may rightly be called "hills for magnitude, but mountains in virtue of their bold design," to paraphrase Robert Louis Stevenson's opinion of the strikingly similar Salisbury Crags near Edinburgh.[2]

In 1808, early geographers Jedidiah Morse and Elijah Parish declared that the traprock ridges of the Connecticut Valley were "more precipitous and romantic" even though "less lofty than the highest parts of the" Green or White Mountains.[3] In 1829, the inveterate New England traveler Timothy Dwight called Mount Holyoke a "commanding mountain" in comparison to taller but more rounded hills of the Taconic and Berkshire ranges.[4] The British travel

PREVIOUS PAGE View of the city of Meriden at dawn from the summit of East Peak. The sheer cliffs on the traprock crags have long been celebrated for providing intimate maplike views of the surrounding lowlands.

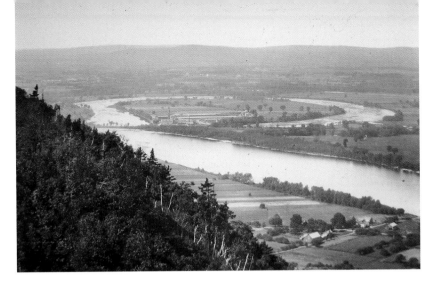

The view of rich farmlands, industrious villages, and the hardworking Connecticut River from Mount Holyoke represented the apex of nineteenth-century American prosperity. Glass lantern slide view of the Connecticut River and the oxbow looking south-west, circa 1900. The oxbow was cut off from the main channel when the isthmus was breached during a flood in 1840. Image: author's collection.

View from Mount Holyoke in Massachusetts, 1829. Basil Hall's detailed camera-lucida drawing of the Connecticut River valley from the summit of Mount Holyoke was reproduced as an engraving by W. H. Lizars for Hall's 1829 *Forty Etchings, from Sketches, Made with the Camera Lucida in North America, in 1827, 1828*. That portfolio of American scenes was published to accompany Hall's popular book, *Travels in North America, in the Years 1827 and 1828*. Reportedly, Hall's drawing inspired Thomas Cole to paint his masterful *View from Mount Holyoke, Northampton, Massachusetts, after a Thunderstorm—The Oxbow* (1836). Image: author's collection.

Soaring balloonists enjoy a bird's-eye view of the colorful cliffs at Merimere Notch, Meriden, Connecticut. Each year, thousands of hawks migrate along the traprock ridges, taking advantage of reliable thermal updrafts formed near the cliffs.

Nearly unchanged since the 1800s, the historic Hockanum district beneath Mount Holyoke preserves memories of earlier times in the Connecticut Valley.

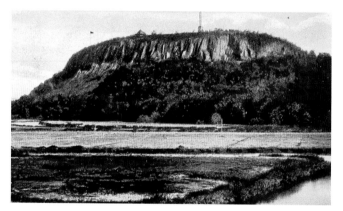

Benjamin Silliman, Basil Hall, and many other early geologists and travel writers noted the similarity between the traprock landforms near New Haven and the volcanic Salisbury Crags near Edinburgh, Scotland. TOP Salisbury Crags, early 1900s. BOTTOM East Rock, early 1900s. Images: author's collection.

writer Lieutenant E. T. Coke preferred the view from Mount Holyoke to that of Mount Washington (el. 6,288). In his popular travel narrative *A Subaltern's Furlough* (1833), Coke wrote that the view from New England's highest mountain was "most extensive . . . but it did not, I must confess, altogether answer my expectations, nor, to my taste, was it equal to that from Mount Holyoke."[5]

During his tour of England and Scotland in 1805–6, Benjamin Silliman noted the similarity between the volcanic crags, or "craigs," near Edinburgh and those near his New Haven home: "Salisbury Craig bears a most striking resemblance to the east mountain near New-Haven. . . . It not only resembles it in its picturesque features. It is the same kind of rock."[6] After climbing East Rock with Silliman in 1826, the noted British travel writer and landscape illustrator Basil Hall declared the crag "exactly resembling in its geological character, in height, and picturesque appearance, the well-known cliff called Salisbury Crags near Edinburgh."[7]

In his popular *Scenographical Geology* (1841), Amherst College geology professor Edward Hitchcock compared the picturesque basalt columns at Mount Holyoke to famous examples from the British Isles, not only to emphasize their geologic significance but also to justify the poetic names, Titan's Pier and Titan's Piazza, that he assigned to the features (see page 140). Writing in defense of his choices, Hitchcock stated that the basalt columns at Mount Holyoke were "very similar to those on the coast of Ireland, which form Fingal's Cave and the Giant's Causeway. The nature of the rock . . . is essentially the same.

. . . Why then may I not be permitted to denominate this rock, Titan's Pier? At least, may I not hope . . . to attract . . . visitors . . . to this spot?"[8]

The comparison of the British and American landscapes in early geographic descriptions of the Connecticut Valley was important not only for scientific purposes, but also because it elevated the traprock landforms to national, if not international, prominence, on a par with the storied landscapes of the Old World. Lacking the cultural artifacts and the long historical record of Europe, early nineteenth-century Americans were increasingly looking to land and landforms as the foundation of a national identity. New Englanders, in particular, boasted of their great forests, granite peaks, and rockbound coasts. There, they found cathedrals in the pines, castles in the crags, and fortresses in the sea cliffs.

Noted for its high concentration of academic institutions, position as a leader in agricultural, industrial, and commercial practices, and unique physical geography, the Connecticut Valley emerged as an important incubator for the scientific, economic, and social advancements of the early nineteenth century. Because of the vagaries of geologic history, the Connecticut Valley was the only place in southern New England where mountain crags provided aerial views directly into the settlements below, thus revealing the intellectual, entrepreneurial, and economic capital of some the most important centers of education, industry, and agriculture in the nation.

Observations of the landscapes and culture of the Connecticut Valley obtained from Mount Holyoke, Daniel Wadsworth's Monte Video estate on Talcott Mountain, the Hanging Hills in central Connecticut, and East and West Rocks in New Haven were more than pleasant diversions—in the early nineteenth century, the views from the traprock ridges were windows into the landscape history of the region, and a metric for assessing the progress of the nation.

For Yale's Timothy Dwight, the traprock ridges of the Connecticut Valley were the ideal locations to view the mixture of prosperous towns, productive agricultural fields, wild summits, and the untamed flow of the New England's largest river. After taking in the view from Mount Holyoke, Dwight declared: "The variety of farms, fields, and forests, of churches and villages, of hills and

Carrying on a legacy of landscape-observation towers on Talcott Mountain started by Daniel Wadsworth in 1810, the Heublein Tower welcomes hikers at Talcott Mountain State Park. Built in 1914 as the residence of liquor magnate Gilbert Heublein, its upper observation deck soars an airy 1,000 feet above sea level.

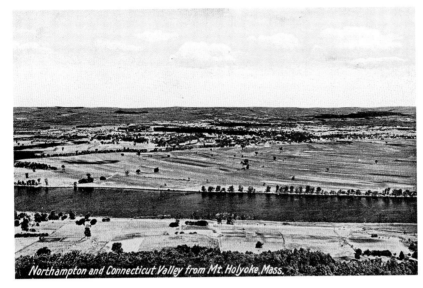

Northampton and Connecticut Valley from Mt. Holyoke, Mass.

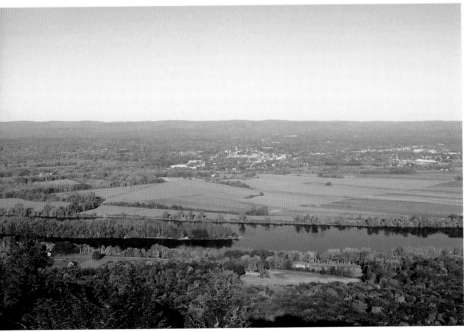

A landscape of national significance, the Connecticut River intervale at Northampton is a window into American history. Presenting the ideal combination of untamed nature and wilderness transformed, the view from Mount Holyoke attracted enormous numbers of tourists, including many prominent writers and artists. These two views, spanning about one hundred years, show remarkably little change other than the natural downstream migration of a sandy islet, and the addition of modern roads and highways. TOP Postcard view, around 1910. BOTTOM View from Mount Holyoke, 2008. Images: author's collection.

valleys, of mountains and plains, comprised in this scene, can neither be described nor imagined."[9]

Although the people of the United States, and New Englanders in particular, maintained a deep connection with the land, by the early 1800s many of the personal, cultural, and economic dynamics that had obtained since the colonial era were unraveling. The old social and economic order of New England was undergoing profound changes, as the inherited power of the founding families was yielding to a rising class of homegrown agriculturalists, industrialists, and merchants. Two centuries after the founding of the "river towns" of the central Connecticut Valley, farmers were specializing in certain profitable crops and varieties of livestock, craftsmen were turning workshops into innovative factories, and local merchants were establishing regional and international networks for commerce.

Mills sprouting along waterways throughout the region lured New England farm girls into factory towns with the promise of guaranteed wages and a fixed schedule of long, but at least regular, hours. By midcentury, the enormous demand for manufacturing labor led to a second great wave of European immigration that would shape the culture of the region in profound and lasting ways.

Long an important academic center, colleges from New Haven to Amherst were emerging as the foremost practitioners of the revolutionary science of geology, upending traditional ideas about the age of the earth, the evolution of life, and the origin of landforms. Important discoveries of dinosaur tracks and other fossils, identification of the volcanic origin of traprock, and the presence of copper ore and other interesting minerals, vaulted the Connecticut Valley into international scientific prominence.

Thus, by 1850, the profound economic and cultural changes that were sweeping through southern New England resulted in lifestyles that were far removed from those that had existed only a generation earlier. In the face of shifting cultural patterns, the landscapes of New England came to signify two powerful but seemingly contradictory ideas. The traprock hills of the Connecticut Valley, the immense peaks of Mount Washington and Mount Katahdin, and the rocky

New England coast represented permanence in a rapidly changing world. At the same time, these same landscapes were powerful evidence of eons of geologic change and profound revolutions in Earth's history, where mountains moved, seas rose and fell, and an endless parade of ancient life emerged and disappeared, in effect mirroring the social and economic changes reshaping New England culture.

Although the transformation of the southern New England landscape from forests to fields was celebrated as a visible manifestation of the wealth and industry of the inhabitants, by the early nineteenth century increasingly scarce wilderness areas were actively sought for healthful recreation, artistic inspiration, and spiritual contemplation. Americans began to visit, describe, and illustrate their regional landscapes with increasing interest and pride, raising natural features such as Niagara Falls, Virginia's Natural Bridge, the White Mountains, and the traprock cliffs of the Connecticut Valley to the status of national icons. The rise of a landscape aesthetic in the nineteenth century was aptly summed up by the cultural historian Kenneth J. Myers: "By midcentury the national landscape had become one of the major cultural battlegrounds on which Americans contested the meaning of their lives and of their nation."[10]

Publishers met the demand for information about the American land and people by printing a wide range of illustrated travel narratives, essays on natural history, state and federal geologic reports, and popular booklets describing the population, economy, culture, and natural resources of the nation. Books on regional geography and prints illustrating urban and rural landscapes were extremely popular.[11] In early nineteenth-century America, landscape exploration and imagery went hand in hand: reports from early travelers, mainly geographers and geologists, motivated artists to paint and illustrate significant natural features, which in turn inspired landscape tourism.

Beginning in the late 1700s, English pottery illustrated with scenes of American landscapes became popular pieces gracing many domestic collections. Manufactured in Staffordshire using a new image-transfer process, the affordable mass-produced ceramics lent Old World respectability to New World views,

thereby reflecting the aesthetic taste of the consumers who proudly displayed the fashionable imported wares. Responding to the growing demand for geographic imagery, the English manufacturers "decorated the pottery destined for the new market with faithful views taken from America itself,"[12] including Daniel Wadsworth's Monte Video estate on Talcott Mountain and Niagara Falls. As a result, "Americans purchased the wares in immense numbers."[13]

Except for the traprock highlands, by the early 1800s the landscape of the Connecticut Valley had been almost completely transformed into a mosaic of thriving manufacturing and commercial centers surrounded by productive farms and orchards. Firmly established as the most successful regional economy in the nation, the Connecticut Valley model became the de facto standard for American land use. With its long and storied history of settlement, emergence as an economic and intellectual center of national importance, and spectacular geologic features, the Connecticut Valley was prominently illustrated in books and prints throughout the nineteenth century. From Northampton to New Haven, the unique traprock landscapes of the Connecticut Valley played an enormously important role in the development of an American school of descriptive physical geography and popular landscape appreciation. The practices of illustrating scenic views and natural features, writing geography-based travel literature, engaging in landscape tourism, conducting field-based geological studies, and creating the architecture of parklands and leisure facilities all flourished in the Connecticut Valley beginning in the early 1800s.

The traprock landforms of the Connecticut Valley also provided refreshing vertical relief for landscape artists working among the gentle hills, river valleys, and low-lying coasts of southern New England in the 1800s. The traprock crags not only gave the artists panoramic views of the fertile Connecticut Valley, but also made interesting topographic backgrounds for farm and village scenes. Beginning around 1820, an increasing number of books on New England geography featured woodcuts, engravings, and lithographs of the traprock crags based on field sketches by Daniel Wadsworth, John Warner Barber, Thomas Cole, Basil Hall, and other noteworthy artists and illustrators of the early to mid-1800s.

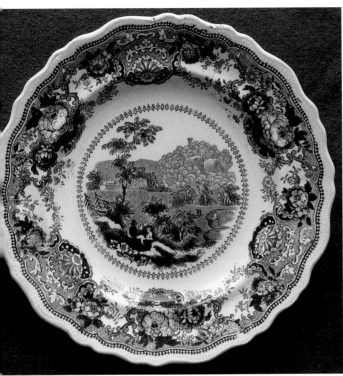

Daniel Wadsworth's Monte Video estate and landscape observation tower was featured in the popular "American Views" series of ceramic plates manufactured in Staffordshire, England, by William Adams & Sons.

The transfer-process image on this circa 1833 "English pink" plate is based on a drawing prepared by Thomas Cole for Hinton's 1832 *The History and Topography of the United States.* Author's collection.

Detail.

Maker's mark, reverse side of plate.

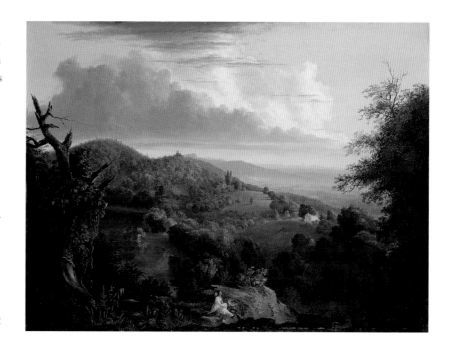

Thomas Cole, *View of Monte Video, the Seat of Daniel Wadsworth, Esq.*, 1828. Cole's south view of the traprock landscapes of the central Connecticut Valley is remarkable for its geographic fidelity. The view is located, or grounded, at the base of Wadsworth's former observation tower on Talcott Mountain, about one-quarter mile south of the existing Heublein tower. Landscape features, from mid-foreground to far background, include, Hoe Pond, Ely's Mound promontory, Rattlesnake Mountain, West Peak, and Sleeping Giant ridge. Many of the compositional elements and landscape features figured in this 1828 painting reappear in Cole's more famous 1836 *The Oxbow*, including the left-leaning blasted tree, the traprock ledge in the foreground, the twin summits of the ridge in mid-background, the southern aspect with lowlands on the west (*right*), and more. Oil on wood, 19¾ × 26¹⁄₁₆ in. Bequest of Daniel Wadsworth, 1848.14. Wadsworth Atheneum Museum of Art, Hartford, Connecticut. Image: Allen Phillips/ Wadsworth Atheneum.

134

Daniel Wadsworth, one of the most important patrons of American art, introduced the rising young painter Thomas Cole to the traprock landscapes of the Connecticut Valley when he commissioned Cole to paint a scene of his cliff-top estate on Talcott Mountain. Cole's *Monte Video, Seat of Daniel Wadsworth, Esq.* (1828) is notable for its highly accurate representation of the central Connecticut traprock ridges and use of many of the devices that he would later apply in his most famous work, *View from Mount Holyoke, Northampton, Massachusetts, after a Thunderstorm — The Oxbow* (1836). The similarities in format, motif, and style between Cole's *Monte Video* and his later *Oxbow* are striking; both traprock landscapes include foreground ledges, "blasted" and gnarled summit trees that lean to the left, views focused to the south and southwest, and the placement of lush, well-settled lowlands on the right side of the painting.

A native of Hartford and Thomas Cole's pupil, Frederic E. Church grew up surrounded by the traprock landforms of the Connecticut Valley. Almost

Northern view of Worthington, in Berlin.

View of Monte Video or Wadsworth's Tower.

Southeastern view of West Rock and Westville.

Southern view of the Churches in Meriden.

Woodcuts of traprock land-scapes featured in John Warner Barber's *Connecticut Historical Collections* (1836) were based on his detailed on-site sketches. Images: author's collection.

TOP LEFT Mount Lamentation and Berlin viewed from the north.
BOTTOM LEFT West Rock and Westville viewed from the southeast.

TOP RIGHT Monte Video estate on Talcott Mountain viewed from the south.
BOTTOM RIGHT View of Broad Street in Meriden with Mount Lamentation commanding the northern horizon.

Mid-twentieth-century calendar reproduction of George H. Durrie's *Winter-Time: Sunday Callers* (circa 1860) with traprock crag resembling Mount Higby in background. Image: author's collection.

136

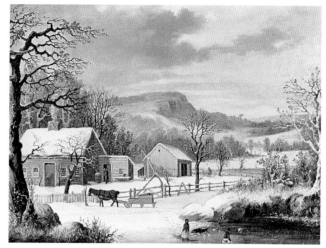

Early nineteenth-century calendar reproduction of an earlier lithograph of Durrie's painting *East Rock* (1853). The original painting is in the collection of the New Haven Museum. Durrie's work was first popularized in a series of lithographs published by Currier and Ives beginning around 1860, and continuing after his death in 1861. Sarony and Company also reproduced two of his paintings of East Rock and West Rock as a set of lithographs. Subsequently, derivative prints based on the lithographs were widely disseminated on all manner of decorative and household goods, ranging from calendars to ceramics and fabrics, through the twentieth century and continuing up to the present day. Image: author's collection.

certainly, he was also familiar with one of the main landscape attractions in the area, Wadsworth's Monte Video estate, where the grounds and observation tower were open to the public. The traprock landscapes of the Connecticut Valley played a critical role in Church's early career, when his monumental *West Rock, New Haven* (1849) earned wide acclaim, vaulting him into international prominence and securing his election as the youngest member of the National Academy of Design. Church also figured traprock landforms in his paintings *The Oxbow* (1844–46), *Hooker and Company Journeying through the Wilderness from Plymouth to Hartford, in 1636* (1846), *The Charter Oak* (1847), and *Grand Manan Island, Bay of Fundy* (1852).

Thus, the traprock landforms of the Connecticut Valley were the focus of what are widely considered two of the most important American landscape paintings, Thomas Cole's *The Oxbow* and Frederic Church's *West Rock.* These magnificent views of the traprock highlands not only established their careers, but also set the standard for artists venturing into the wilds of New England's coasts and mountains.

The most prolific painter of the Connecticut Valley traprock hills was, however, George H. Durrie, who not only painted a number of realistic landscapes featuring East and West Rocks near his home in New Haven, but also used traprock crags as a dominant motif in nearly all of his popular genre scenes of early American life. Based on the actual landforms near Meriden and New Haven, tilted traprock cuestas were Durrie's signature landscape element. Traprock crags readily identifiable as the Hanging Hills, Cathole Peak, and Mount Higby appear in most of his fictional scenes of country life.

About a dozen of Durrie's most popular works were reproduced as immensely popular lithographs by Currier and Ives and by Sarony and Company. Durrie's scenes of early American life have remained in nearly continuous production since the mid-nineteenth century. Gracing homes and businesses as calendars, postcards, prints, decorative household items, ceramics, and souvenirs, Durrie's scenes of country life with the traprock crags in the background are among the most recognizable of American landscapes.

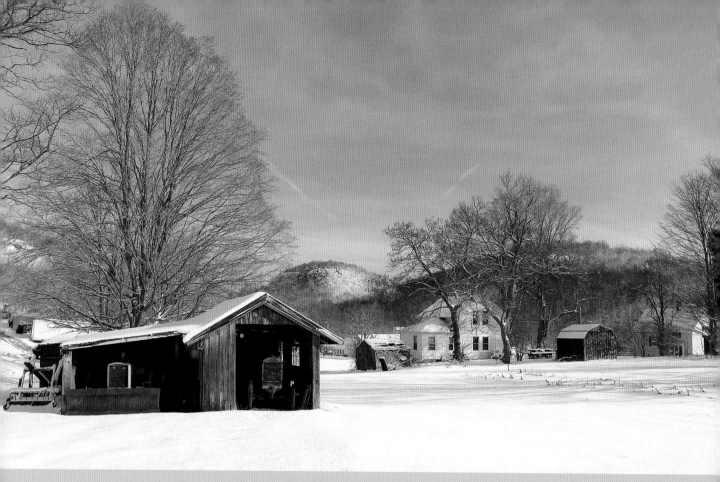

Reminiscent of a winter scene
painted by George H. Durrie,
the traprock landscapes near
Cathole Peak in Meriden
seem frozen in time.

Appearing to step out of
one of G.H. Durrie's winter
landscapes, ice fishermen test
their luck at Black Pond in
East Meriden.

Mount Holyoke.

Geological wonders featured prominently in the attractions at Mount Holyoke; the overhanging basalt columns at Titan's Piazza were a favorite tourist stop. Image: author's collection.

The Prospect House, circa 1860. The steep tramway offered thrilling rides to the summit. Because many tourists were terrified by the ascent, a roof was later added to the tramway. Image: author's collection.

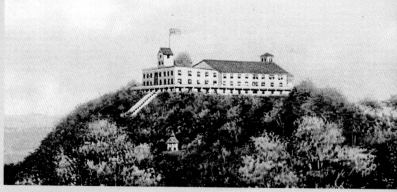

Prospect House in its early twentieth-century prime. The large 1849 extension to the hotel, shown at the *right* (east), was severely damaged during the 1938 hurricane, and subsequently demolished. Image: author's collection.

As a result of the popularity of Durrie's genre paintings, and the prominence of Cole's *Oxbow* and Church's *West Rock*, the traprock cuestas of the central Connecticut Valley maintained their status as iconic American landforms even after the midcentury arrival of the monumental landscape paintings of the American West by Thomas Moran, Albert Bierstadt, and others.

The traprock crags at East and West Rock, Sleeping Giant, West Peak, Mount Tom, and Mount Holyoke were particularly popular for challenging ascents culminating in panoramic summit views. Entrepreneurs responded to the steady streams of visitors by constructing refreshment pavilions, improving carriage trails, and creating scenic lookouts and well-graded walking paths. Over the course of the nineteenth century, the early rustic facilities were replaced with increasingly sophisticated amenities, including summit hotels, tramways, cable cars, and public parks designed by prominent landscape architects.

The high peak of landscape tourism: Mount Holyoke. View of the restored Prospect House.

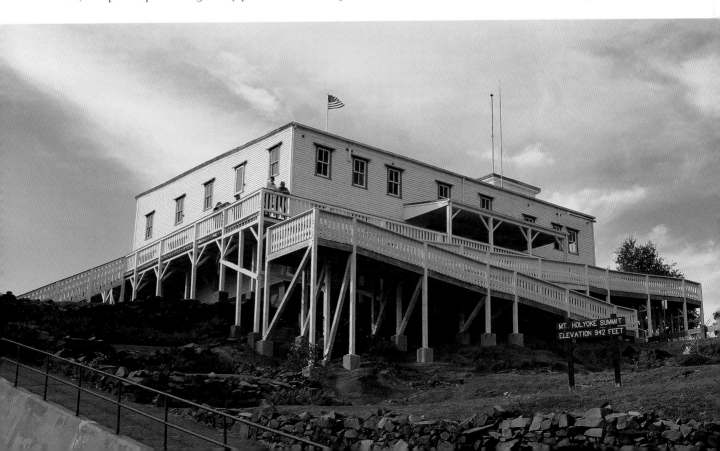

Period furnishings in this re-
stored hotel room hint at the
comfortable surroundings greet-
ing visitors in the latter half of
the nineteenth century. Pros-
pect House, Mount Holyoke.

MOUNT HOLYOKE.

Prices Reduced for 1875.

VISITORS that prefer to walk both
ways on Staircase, $0 50
OTHERS, who wish to ride one way
and walk one, $0 75
THOSE who ride both ways, 1 00
CHILDREN over 4 and under 12
years, half price.
SCHOOLS in numbers of 10 or over,
with Teachers, and paid for by one
person, Half Price.
TO those who pay either the above
Prices, the House, Grounds, Ob-
servatory, Telescopes and Water,
are free.
THE Cars do not run Sundays.
WATER and Ice are the most ex-
pensive of anything we provide for
Visitors, as they are drawn up the
Mountain.
THE above Prices are but 25 cents
more than they were 22 years ago,
and the comforts, conveniences and
luxuries are more than ten-fold.
PICNIC Parties bringing their own
refreshments, can have them car-
ried up free.

MOUNT HOLYOKE
Prospect House.

BOARD AND REFRESHMENT PRICES
REDUCED FOR 1875.

Transient Meals, - - - $0 75
Lodging, - - - - 75
Board per Day, - - - 2 50
" " Week, - - - 14 00

REFRESHMENTS.

Lunch, (extra calls charged extra,) $0 25
Tea, Coffee, Lemonade, Soda or
Milk, per glass, or Cup, 10
Cigars, 10
No Wines, Ales or Liquors, sold on
the place.
No Regular Hours for Meals ; calls
given at the Office, will be served
promptly as possible.

FEEDING STABLE.

Horses fed, each, - - - $0 50
Horses groomed, without feed, 25

All Bills Settled at the Office on the Summit.

J. W. FRENCH, Proprietor,
P. O. Address, Box 333, - - NORTHAMPTON, MASS.

Leisure pursuits on Mount Holyoke. Prospect House brochure, 1875, detailing the range of goods and services provided for tourists. Author's collection.

Mount Tom souvenir booklet, circa 1915. The highest summit in the Connecticut Valley, Mount Tom (el. 1,202 ft.) featured extensive amenities for tourists, including the elegant Summit House hotel and an electric cable railway that shuttled visitors from Mountain Park at the base of the mountain to the summit and back. Author's collection.

*Souvenir folder
of Mount Tom postcards.
Images: author's collection.*

Mount Tom
Summit House.

The lower station
of the Mount Tom railway.

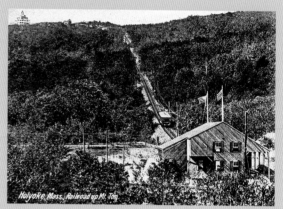

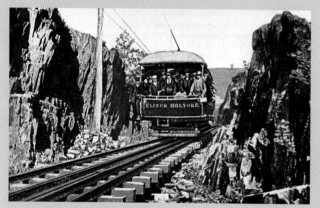

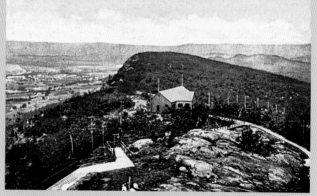

The "Elizur Holyoke"
inclined railway car.

Summit railway
station.

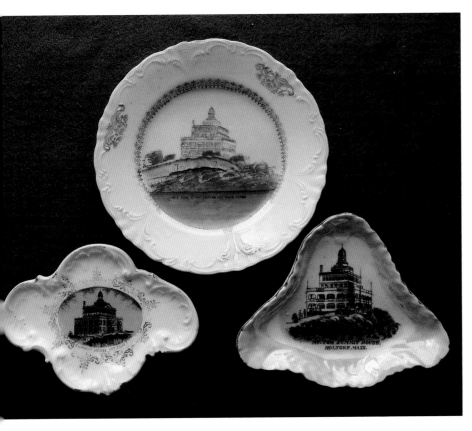

Hand-painted ceramics from England, Germany, and Austria provided visitors with pleasant reminders of their trip to the Mount Tom Summit House. BELOW Examples of maker's marks on reverse. Author's collection.

WHEELOCK
MADE IN GERMANY FOR
HOLYOKE STREET
RAILWAY CO.,
HOLYOKE, MASS.

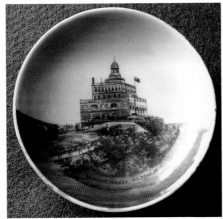

Made in Austria
expressly for
Mt. Tom Railroad Company
Holyoke, Mass.

The pleasures of summer: postcards
from Mountain Park at Mount Tom,
early 1900s. Author's collection.

TOP Holyoke Street Railway trolley car dropping off
passengers near the Casino.
BOTTOM Trolley car at the pavilion.

TOP Pavilions and landscaped grounds
BOTTOM Visitors streaming into the park.

The golden light of dawn illuminates East Peak in Hubbard Park, Meriden. On a clear day the entire Connecticut Valley from Mount Holyoke to East Rock, and beyond to Long Island, may be viewed from the Castle Craig observation tower. View from South Mountain.

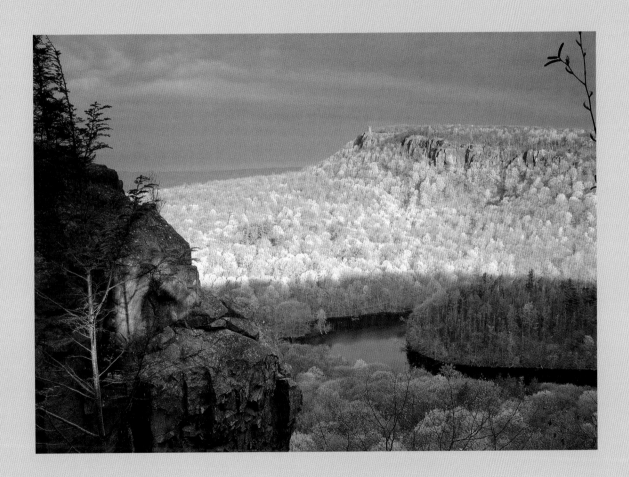

Designed by the Olmstead Brothers, Landscape Architects, successor to the Olmstead firm founded by the noted landscape architect Frederick Law Olmstead, Meriden's Hubbard Park is among the finest nineteenth-century municipal parks in the United States. The work was carried out in 1898 by John C. Olmstead and Frederick Law Olmstead Jr, who continued the family practice after their father, Frederick Law Sr., retired in 1895. Images: author's collection.

Fairview Pavilion.

Meriden, Conn., Fairview, Hubbard Park.

Castle Craig.

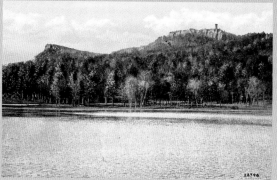

Mirror Lake surrounded by traprock crags rising more than 1,000 feet above sea level.

Fountains and picnic pavilion.

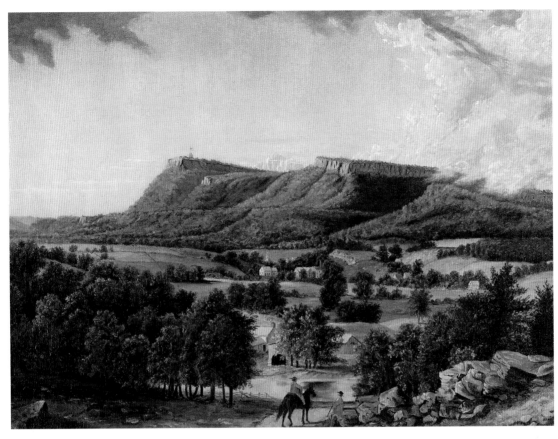

View of Meriden with Hanging Hills, about 1855, artist unknown. Oil on canvas. The flag on the far summit shows the location of the Peak House, an early tourist facility on West Peak in Meriden that operated from about 1853 to 1866. On the horizon, from left to right: West Peak, West Peak Notch, East Peak, Merimere Notch, South Mountain. The colors and the dip (tilt) of the sedimentary rocks shown in the mid-distance and foreground are accurately portrayed. Image: Newman S. Hungerford Museum Fund, Connecticut Historical Society.

Winter lighting display, Hubbard Park. In spring, thousands of daffodils are the focus of a popular annual festival. In summer, a concert series, picnic areas, playgrounds, hiking trails, and more, attract large numbers of visitors to the popular park in the Hanging Hills.

*The West Peak summer colony.
Following the demise of the
Peak House in 1866, ambitious
plans were drawn up for Percival
Park, a vacation community
on the summit of West Peak
in Meriden, Connecticut. The
elaborate proposal, including
more than one hundred
cottages, a large hotel, and a
summit tram, was thwarted
by lack of water, difficult
access, and the need to protect
Merimere Reservoir; only a few
cottages were built during the
late 1800s and early 1900s.*

Ruins of a stone chimney
and iron foundation posts at
a former summer cottage on
West Peak.

Giving the phrase "I have to
go" new meaning, this out-
house built into a retaining
wall perches nearly 900 feet
above the valley floor. Appar-
ently, human waste and gar-
bage were swept out of the
opening; the two slabs at bot-
tom are footrests for the "squat-
type" facility.

The Meriden YWCA "vacation
house" was pleasantly
appointed with porches and
decks to take advantage of
both the panoramic views
and cool mountain breezes.
Postcard, early 1900s, author's
collection.

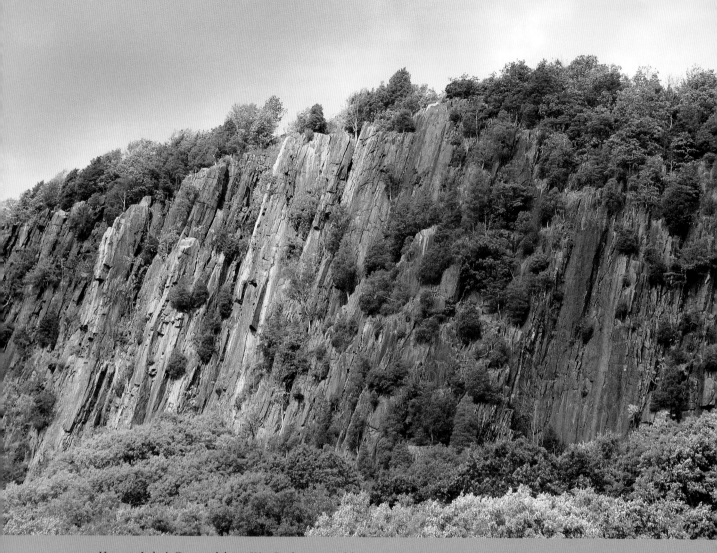

Home to Judge's Cave, and the focus of important landscape paintings by Frederic E. Church, George H. Durrie, and other noteworthy artists, West Rock was one of the most recognizable American landforms of the mid-nineteenth century. View from West Rock Playground.

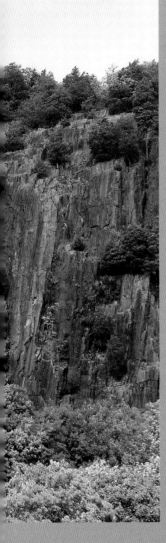

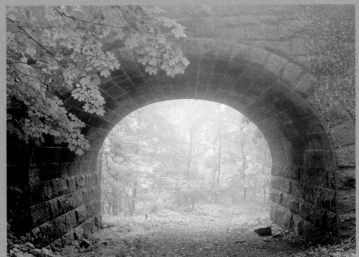

LEFT Built of local stone—
red sandstone for the center
arch and traprock talus
blocks for the abutments—
English Bridge at East Rock
Park blends into the natural
landscape.

BELOW The red cliffs
of East Rock overlook
the historic city and port
of New Haven. East
Rock Park.

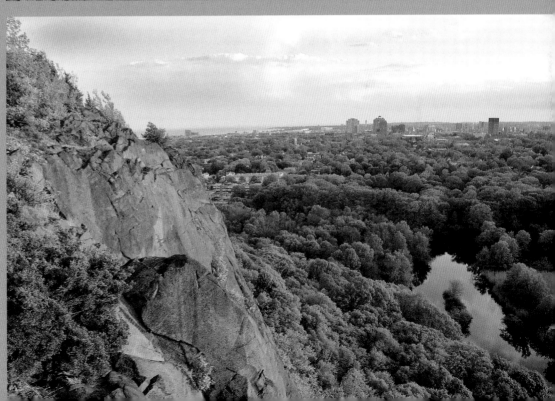

The 1937 Works Progress Administration (WPA) stone tower on the summit of Sleeping Giant has several airy picnic rooms with fireplaces and a rooftop observation deck accessed by a system of ramps.

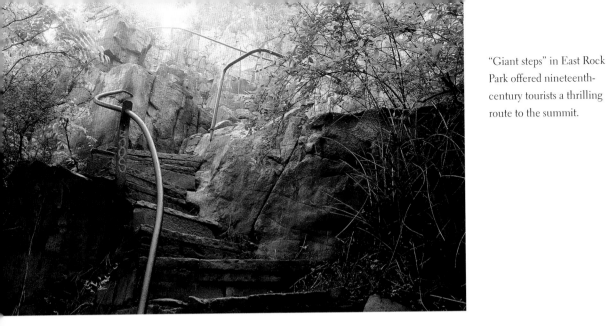

"Giant steps" in East Rock Park offered nineteenth-century tourists a thrilling route to the summit.

Through the works of British visitors, including travel writer E. T. Coke, the illustrator Basil Hall, and the geologist Charles Lyell, reports of the beauty and grandeur of the Connecticut Valley traprock landscapes filtered back to Europe, where descriptions and images of the land and the people of North America found an eager audience. As a result, from about 1830 to 1880 the traprock crags near New Haven, Hartford, and Northampton were essential stops on the American "grand tour."

Although the prominence of the Connecticut Valley as a tourist destination would fade after the Great Depression, the region retained its position as one of the most important American landscapes into the modern era. In 1984, the noted landscape scholar John Brinckerhoff Jackson named the Connecticut Valley "one of the classic historic landscapes of the United States." Firmly ensconced in the national identity, "the valley became something more than a topographical concept. It became a landscape, perhaps the most extensive and certainly the most clearly defined human landscape in New England."[14]

6

These Mural Cliffs

SCULPTED BY NATURE, PAINTED BY TIME

But the hills and mountains . . . are not all
similar in their outline, and, in one region in
particular the physiognomy of the country is very
peculiar. . . . The . . . mountains rise in bold ridges
. . . league after league. One front (and generally
it is that which looks westerly) is . . . composed
of precipitous cliffs of naked frowning rock,
hoary with time, moss-grown, and tarnished by a
superficial decomposition. This front is a perfect
barrier, looking like an immense work of art.

Benjamin Silliman, *Remarks Made on a Short Tour between
Hartford and Quebec in the Autumn of 1819* (1820)

An artist's paradise, the traprock ridges of the Connecticut Valley display an endless variety of colors, textures, shapes, and forms. Rising boldly above the rolling lowlands, the distinctive wedge-shaped outlines of the massive ridges are the defining landforms of the region, adding a distinct alpine flavor to the glacially rounded terrain typical of southern New England. Wreathed in mist after a spring shower, framed by the dense green growth of summer, bound with fog on a cool fall morning, or sharply delineated in the crisp winter air, the great masses of stone seem to shift and change with the weather and the seasons. Natural light shows, created when cloud shadows race over the crags, turn the expansive cliffs into giant "movie screens."

For brief moments at dusk, the region's finest displays of alpenglow light up the traprock cliffs, their colorful reflections dancing on the lakes and ponds beneath. Alpenglow occurs when the setting sun dips below the local horizon, thus, placing the viewer and foreground in shadow while bathing the summits in warm light. Alpenglow illuminating the traprock cliffs ranges from brilliant gold to deep red, depending on the weather and time of year. Because many of the traprock cliffs face west, entire ridges often light up with spectacular evening alpenglow. East-facing cliffs, such as the Merimere face on East Peak, or Bluff Head on Totoket Mountain, experience magnificent alpenglow just before dawn, especially in winter.

Every season in the traprock hills holds special pleasures. The pastel hues of emerging buds and the first flowers of the year provide a delicate counterpoint to the harsh tones of winter. Mist rising from the last patches of snow lingering under the shadowing cliffs wraps the stony landscape in soft scarves of gray and white. In the traprock wetlands, the calls of woodland amphibians echo off the cliffs. Soon migrating birds, especially warblers, will arrive, adding their flutelike phrases to the chirps, croaks, trills, and drumming of frogs and toads.

The full flush of summer covers the traprock cliffs and ledges with dense coatings of algae, lichens, and moss, and moist lower-slope forests and dry glades

PREVIOUS PAGE Clouds reflect off the still waters of Black Pond at Beseck Mountain.

A photographer captures the
panoramic view from the
summit of Beseck Mountain,
Middlefield, Connecticut.

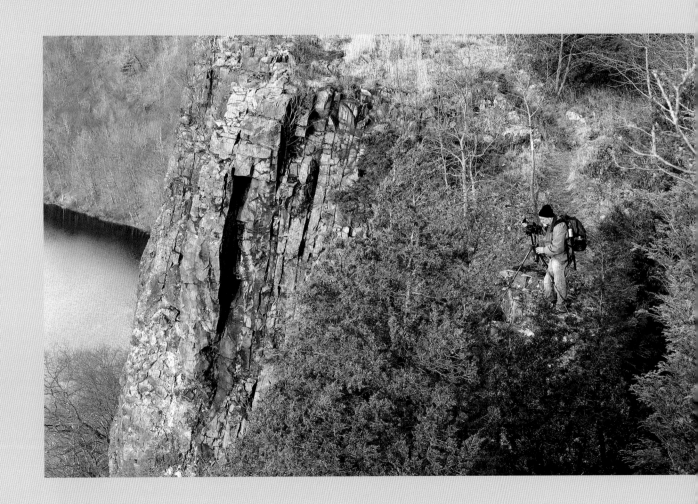

Shadows dance over Merimere
Reservoir and the cliffs of East
Peak in the Hanging Hills.

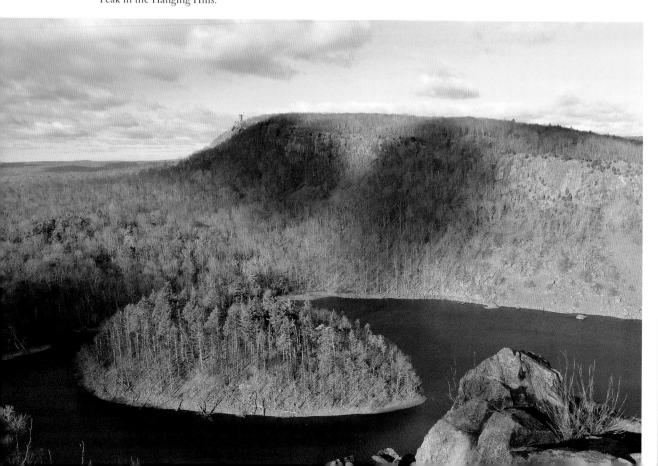

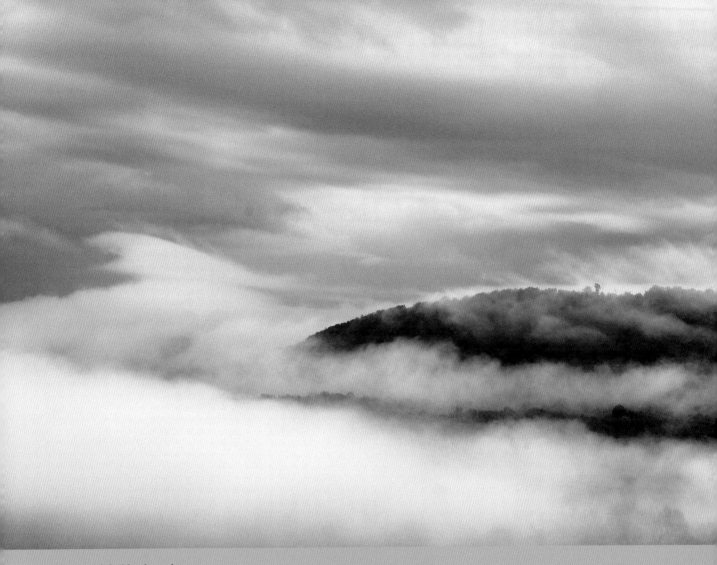

Earth and sky blend together
over Mount Higby.

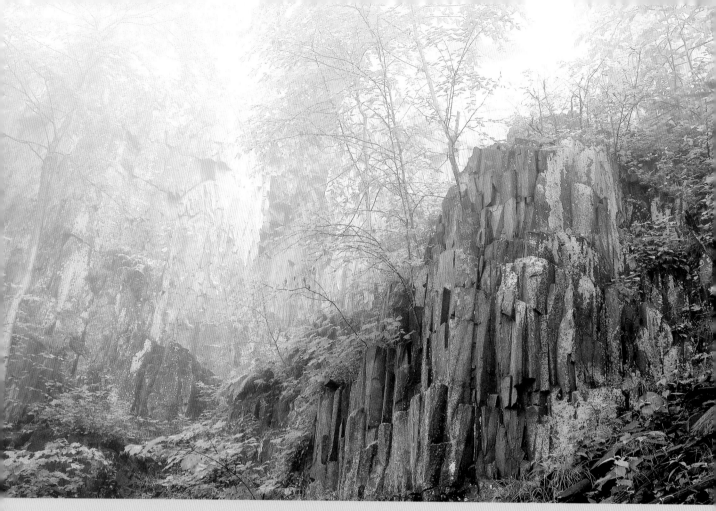

Like a scene from Arthur
Conan Doyle's *The Lost World*,
traprock crags emerge from the
mist at East Peak.

burst with luxuriant growth. In the humid air, distant ridges appear deep blue, and the valleys and notches often fill with steaming banks of fog.

In autumn, the traprock landscapes explode with a seemingly impossible display of colors, and the lava cliffs seem to glow with particularly warm tones of red, orange, and yellow. Add blue skies, brisk fall winds, and sparkling lakes, and the traprock landscapes easily compete with the classic autumnal scenery found anywhere in New England.

Winter brings the cycle of traprock seasons to a close with soft gray blankets of cloud, bluebird skies over painfully bright fields of snow, crystalline coatings on summit forests and meadows, and icy patterns on lakes, ponds, and vernal pools.

The Connecticut Valley basalt ranges in color from bluish black to greenish gray. Exposure to the elements over long periods of time produces a weathered "rind" mainly composed of oxidized and hydrated iron-bearing minerals includ-

Dawn alpenglow on the Merimere face at East Peak. Alpenglow occurs at dawn and dusk when the traprock summits are awash in light, while the lower elevations are in shadow. Traprock alpenglow is particularly colorful, owing to the warm red-orange tones of the rocks.

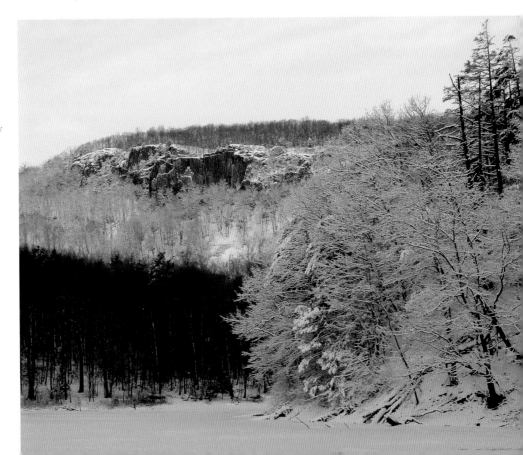

Alpenglow at sunset, Chauncey Peak, Giuffrida Park, Meriden.

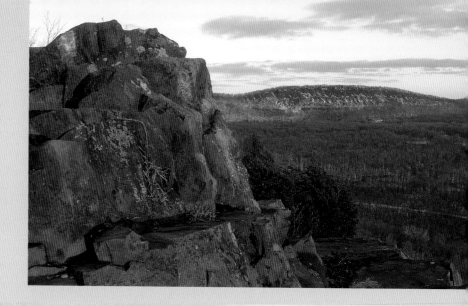

Brilliant evening alpenglow in winter at South Mountain, unretouched photo.

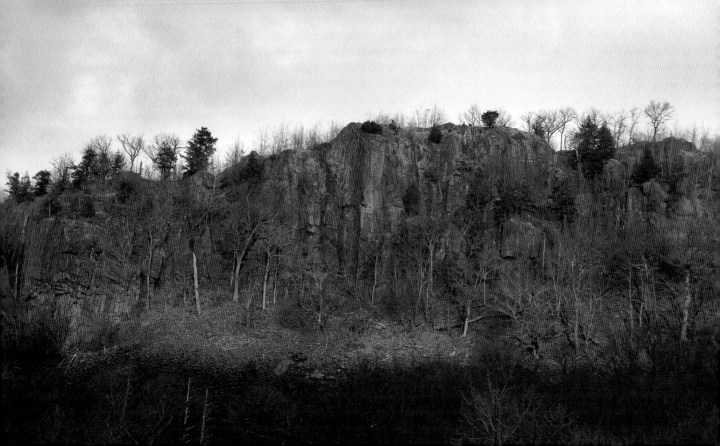

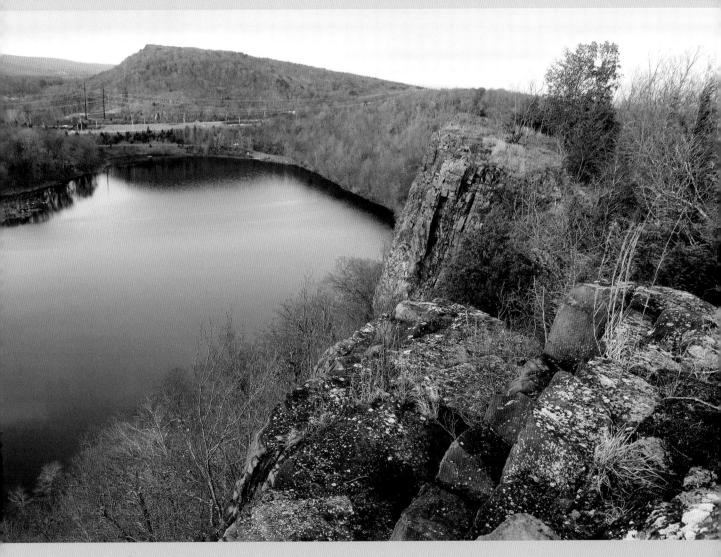

Beseck Mountain (*foreground*)
and Mount Higby bathed in
a late-fall evening alpenglow at
Black Pond.

A lush blanket of vegetation covers Mount Higby's rocky summit during the peak of summer.

The arrival of spring paints the traprock hills in pastel colors. Black birch catkins, Ragged Mountain.

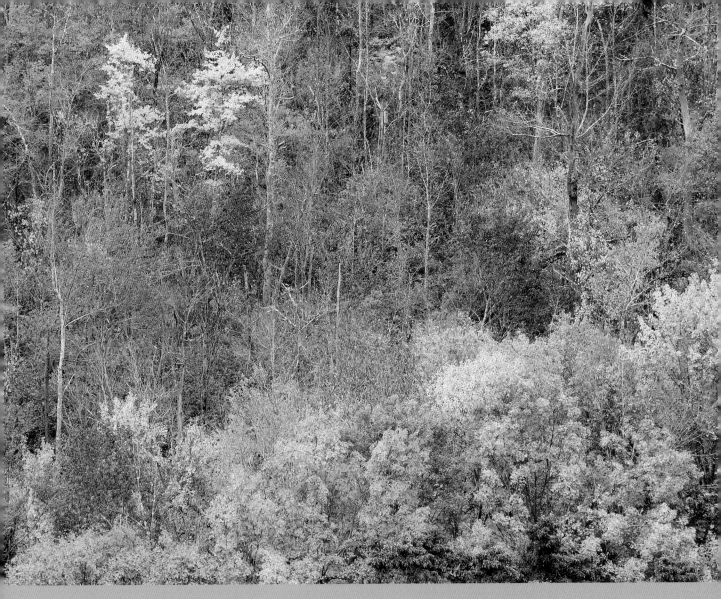

Fall colors brighten the traprock
landscapes of the central
Connecticut Valley. Red maple
swamp near Chauncey Peak.

168 Autumn leaves
 decorate Ragged
 Mountain after
 an early winter
 storm.

An ice storm transforms the summit of Ragged Mountain into a crystal fairyland.

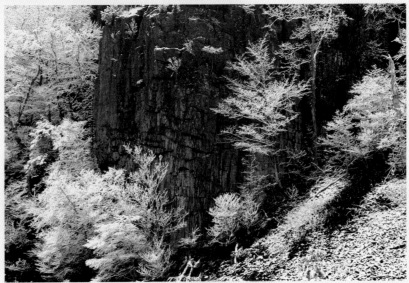

The warm colors of South Mountain relieve icy winter's grip.

ing hematite, goethite, and limonite in diverse shades of brown, orange, and red. As a result, the rock surfaces display a nearly endless palette of colors and array of textures depending on the time of day, the seasons, and the weather. Cliffs that appear reddish in one season turn to cool shades of greenish gray in winter. Normally somber ledges blaze with color during brief periods of sunset alpenglow. Add to these mineral colors coatings of algae, lichens, and moss, and it is easy to understand why early writers referred to the traprock crags as "the mural cliffs."

Since the colonial period, structures in the Connecticut Valley have been built of the conveniently sized traprock talus blocks, their polygonal form ideal for nestling stone against stone to create durable structures. The great piles of talus banked against the cliffs provided a readily accessible source of building material, and the talus quarries were valuable sources of stone throughout the Connecticut Valley. Disturbed by the amount of talus that had been quarried at East Rock and West Rock, Benjamin Silliman was relieved that "in most parts of the greenstone region of Connecticut and Massachusetts, the venerable piles are undisturbed, and the hoary columns, tempest-beaten for ages, stand, the durable monuments of other times."

Not only are the traprock cliffs themselves monumental landforms, but they also host a variety of formal and informal memorials, plaques, inscriptions, and carvings. The earliest reported inscription, discovered by the photographer Robert Pagini, dates to 1798. Most inscriptions date to the peak of nineteenth-century traprock tourism, between approximately 1850 and 1900. A famous example of inscribed traprock occurs at "Hospital Rock" in Plainville, where, at the turn of the nineteenth century, tuberculosis patients, including children, carved their names on an outcropping of basalt.[1] Although some of the historical carvings are merely idle scratches made with pieces of stone or knives, many were carefully tooled with steel chisels. Some of the more elaborate inscriptions show particular skill in stone-carving techniques.

Commemorative plaques are found throughout the traprock hills. One of the most interesting was placed on Sleeping Giant in honor of Arnold G. Dana

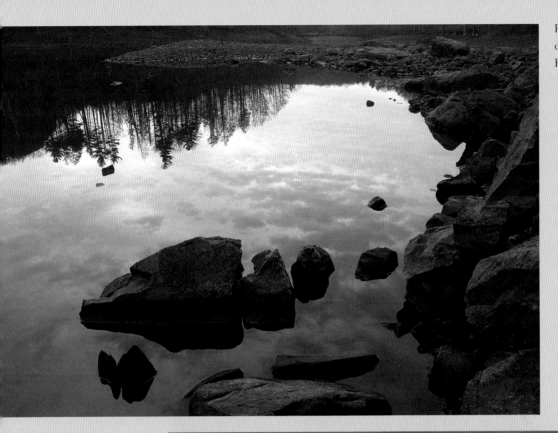

Rosy reflections at dawn, Merimere Reservoir.

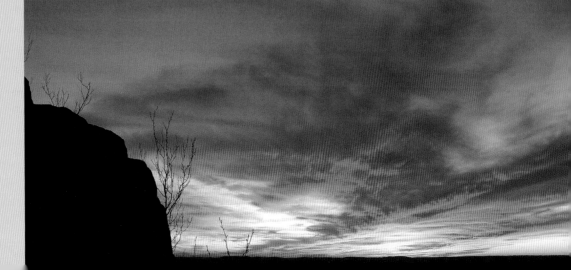

Sunset over the traprock hills, Beseck Mountain.

Virginia creeper berries on
traprock boulder, Merimere
Reservoir.

Mineral-filled fractures
create abstract shapes at
Cathole Peak.

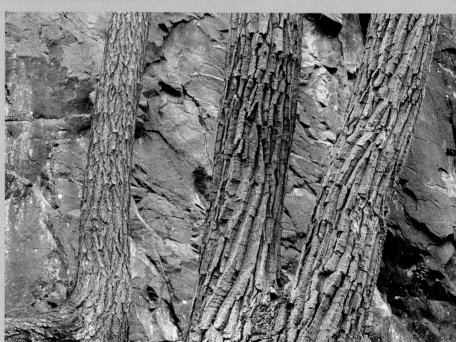

Patterns in wood and
stone, Cathole Peak.

LEFT Lacy leaf patterns and a spicebush swallowtail butterfly larva. Beseck Mountain.

ABOVE A carpet of haircap moss with colorful reproductive structures. Chauncey Peak.

A moment frozen in time: icy vernal pool in the traprock highlands. South Mountain.

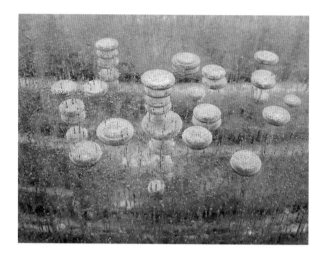

Three worlds created by vernal-pool reflections and patterns. Preston Notch, Mount Higby.

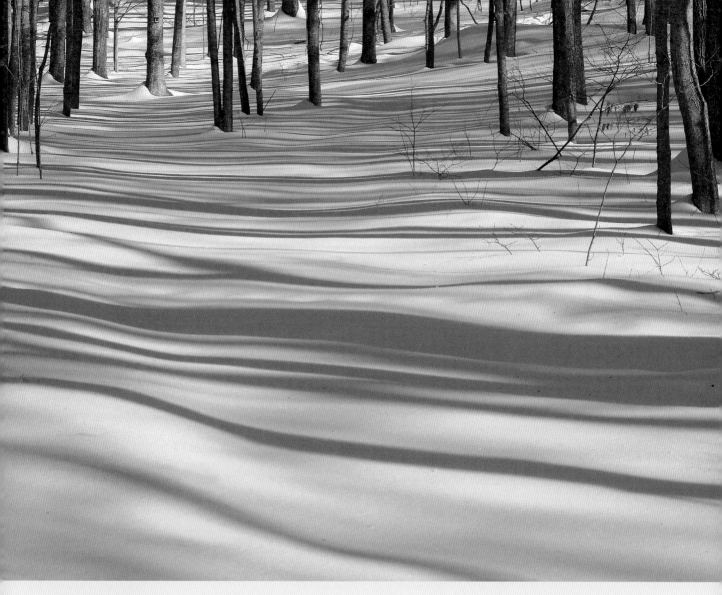

Snow softens the stony
traprock landscape at
Sleeping Giant State Park.

Masons working in the Connecticut Valley have long used the colorful weathered surfaces of traprock blocks to create beautiful walls. Eli Whitney Museum, New Haven.

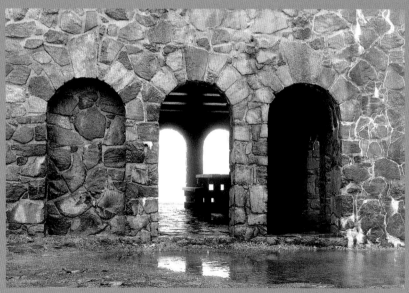

Built of native traprock, the WPA tower at Sleeping Giant State Park is a popular destination.

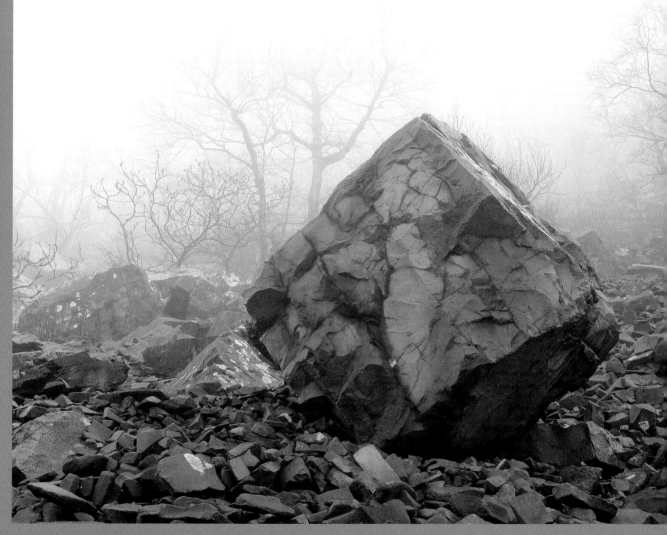

Chiseled by the forces of nature, traprock blocks break into bold geometric forms and fantastic shapes. Merimere Reservoir, Hubbard Park, Meriden.

Historic traprock inscriptions.

DOWNS 1848.

Cosmopolitan Club June 20 1875, showing reversed s.

Early inscriptions in traprock, Connecticut Valley. J Hall 1798.

Geo ● E ●BLAKESLEE and S D HYDE 1874. One of the most interesting and elaborate of the traprock inscriptions, the Blakeslee-Hyde carving includes a portrait in profile (*lower right*) and a device that is either a feathered headdress or stylized tobacco leaves (*not shown*). The carvings were apparently made by George E. Blakeslee

of New York, who was a student at the Yale Medical School in the early 1800s. The symbols "C II C" ("sea to sea," or "Connecticut to California"), *upper right corner of image*, may commemorate Blakeslee's move to California, where he spent part of his medical career (*Notebook of George E. Blakeslee*, 1831).

(1862–1947). Son of the renowned Yale geologist James D. Dana, who conducted extensive studies of the Connecticut Valley basalt, A. G. Dana played a prominent role in the history of Sleeping Giant beginning in 1875 when, as a twelve-year-old, he survived a remarkable fall of more than seventy-five feet from the cliffs of the chin. A founding member of the Sleeping Giant Park Association (SGPA), and president from 1932 to 1935, A. G. Dana dedicated himself to preserving the traprock ridge. In the year of his passing, the SGPA placed a memorial plaque on a large traprock boulder near the site of his precipitous fall. The current plaque replaced the original after it was stolen in the late twentieth century. A. G. Dana is also named on a plaque installed in 1939 to commemorate the founding of Sleeping Giant State Park.

A historical plaque dedicated in 1987 on Rattlesnake Mountain near Farm-

"W H 1900," on keystone block, Castle Craig, Meriden. This inscription was likely made by the benefactor of Hubbard Park, Walter E. Hubbard, during the dedication ceremony.

WHH 1887.

H O Nelson 1898.

G A HALL SEPT. 8th 1889, with reversed 9.

FANNIE KELSEY 1920.

P O HINMAN 1858.

WAC, in monogram style.

Traprock plaques and memorials.

Manzi memorial,
Ragged Mountain.

Arnold G. Dana memorial, Sleeping Giant State
Park. Son of Yale geology professor Edward S.
Dana, young A. G. Dana survived a fall of more
than seventy-five feet off the cliffs of the "chin"
on Sleeping Giant.

Will Warren's Den, Rattlesnake Mountain,
Farmington, Connecticut.

Joseph A. Skinner State Park,
Mount Holyoke.

James Adair memorial,
Ragged Mountain.

cuts at the top of the old Mount Tom cable railway, but the site remained unmarked until 1994, when a small, informal, stone cairn was built. After discovering debris during his hikes on Mount Tom and noticing the ad hoc monument, local resident Norman Cote started an effort to honor the fallen servicemen. In 1996, a memorial park and monument built near the summit were dedicated in a ceremony attended by veterans, local officials, and officers from the Coast Guard and the Air Force. The names of all twenty-five servicemen are carved into the surface of a black granite stone along with information about the crash. The sixty-fifth anniversary of the crash was observed at the memorial park in July 2011. Since the construction of the park, a large amount of debris from the plane has been collected and placed near the monument.

At least three small planes crashed, with fatalities, on Mount Higby in the mid-twentieth century; an ad hoc memorial on the summit made of traprock blocks and aircraft parts marks the site of one of the accidents.

The forces of nature also create fascinating natural sculptures and monumental remnants of erosion, including freestanding towers, columns, chimneys, sharp pinnacles, enormous broken slabs, overhanging blocks, Stonehenge-like trilithons, and even great stone "faces."

The irregular outline of the summit ridge on Sleeping Giant (Mount Carmel) in Hamden bears a striking resemblance to the outline of a human form. Topographic prominences, from west to east, are known as the Giant's head, chin, chest, hips, and knees. The Native American tribes of the Quinnipiac Valley ascribed its humanlike silhouette to the giant Hobbomock, who was put to sleep after a great battle. Since the colonial period the ridge has been widely known as the Sleeping Giant.

The jagged outline of a great stone face has been recognized on the southwest corner of West Cathole Peak at least since the early 1800s. John Warner Barber illustrated the stone face at Cathole in his 1836 *Connecticut Historical Collections*, writing: "Perpendicular rocks appear . . . one of which has very much the appearance of a profile of the human face, and it is thought by some to resemble . . . the profile of Washington, the Father of his country."[2]

Erosion creates fascinating shapes in the traprock hills. TOP A totem-pole column at South Mountain. BOTTOM A traprock version of Egypt's Colossi of Memnon, South Mountain.

TOP A rock tower at Ragged Mountain assumes a sphinx-like form. BOTTOM Ledges at South Mountain resemble a clock tower or an ancient monument.

A wafer-thin pinnacle reaches for the sky at Cathole Peak.

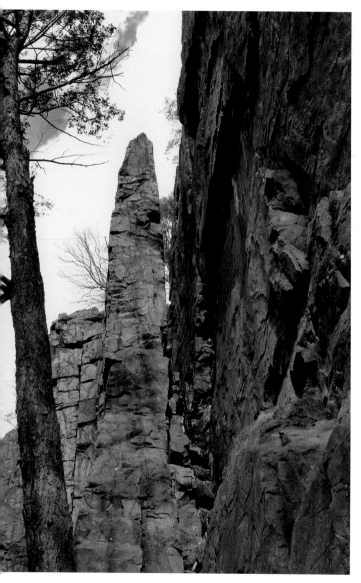

Chimney Rock at Sleeping Giant. In earlier times, leaping a distance of more than ten feet from the cliff to the top of the thirty-foot-tall pinnacle was a popular activity of daredevils.

A "diving board" ledge at Mount Higby projecting over the valley floor is reminiscent of Overhanging Rock at Glacier Point in Yosemite National Park.

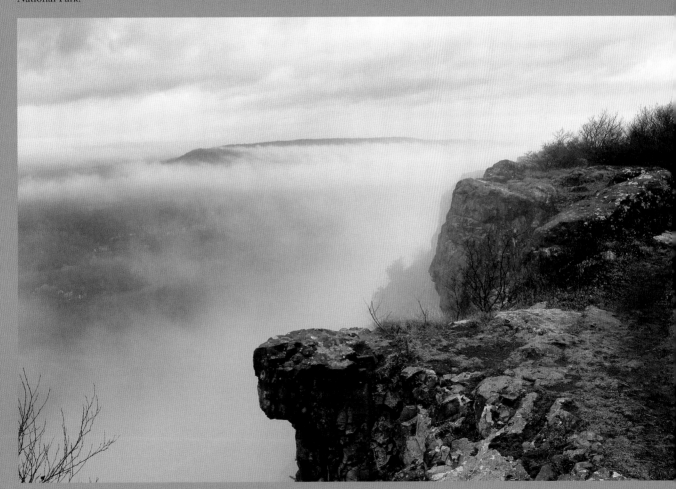

The Sleeping Giant, Mount Carmel, Winter

The most famous anthropomorphic form in the Connecticut Valley is the Sleeping Giant (Mount Carmel) in Hamden. The promontories on the ridgeline have long been named, from west (*left*) to east (*right*), the giant's head, chin, and chest.

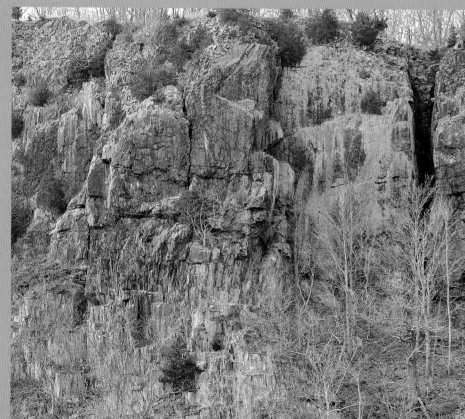

"Skull Rock," a pattern formed by lichens growing on the cliffs of South Mountain.

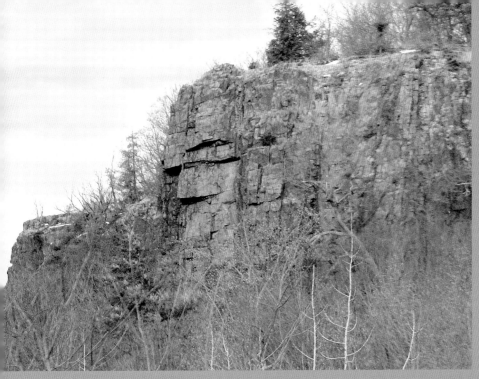

Lincoln's Head (aka Washington's Head), view from south, West Cathole Peak, Meriden. The ledges on the southwest cliffs of Cathole Peak form a pattern long thought to resemble the profile of George Washington; after the Civil War the cliffs became known as Lincoln's Head. In the afternoon light, the rugged copper-colored rocks look remarkably like the Lincoln penny coin.

Washington's Head, Meriden, Conn.

Early twentieth-century postcard, Washington's Head, Cathole Peak. Image: author's collection.

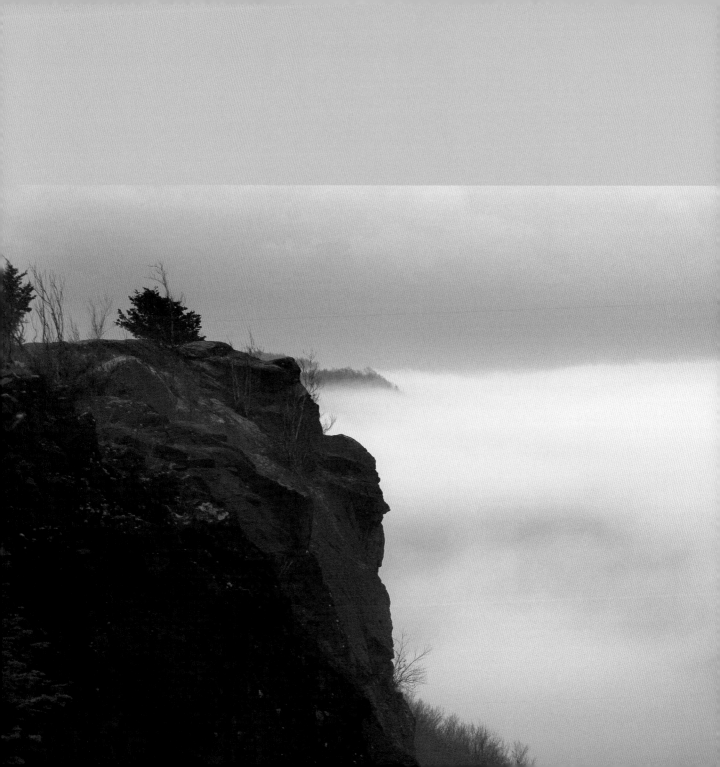

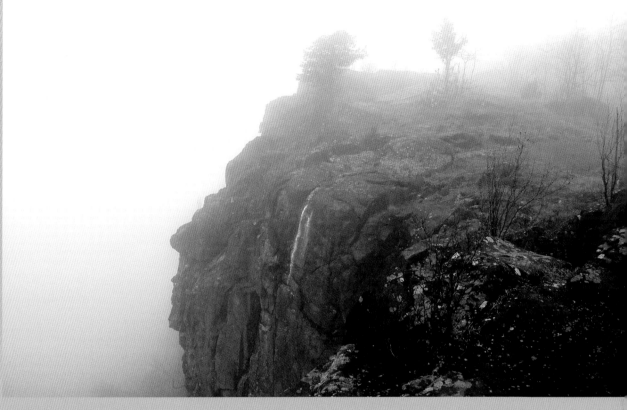

Reminiscent of New Hampshire's
"Old Man of the Mountain" at
Franconia Notch, the stone face
on Mount Higby watches over
the central Connecticut Valley.
View from north (LEFT) and south
(ABOVE).

George H. Durrie, *A Christmas Party*, 1852. The profile on the crag behind the house is remarkably similar to the great stone face at Cathole Peak. Having spent part of his early career working as a portrait painter in Meriden, Durrie was no doubt familiar with the local attraction. Twentieth-century calendar reproduction. Image: author's collection.

Viewed from the south, the same ledges bear a striking resemblance to the profile of Abraham Lincoln, particularly in the late afternoon, when the copper-colored cliffs look like his image on the U.S. penny. The same cliffs were noted as the "Man of the Mountain" on some early nineteenth-century postcards. The great stone face and the rugged crags and talus at Cathole were popular illustrations in the late nineteenth and early twentieth centuries. The Connecticut landscape painter George H. Durrie included crags very similar to the Cathole Peaks in several of his paintings, and his *A Christmas Party* (1852) shows the outline of a stone face on a rugged crag. Durrie was undoubtedly familiar with the great stone face on Cathole Peak from his time working as an itinerant portrait painter in Meriden, as well as his almost certain knowledge of its illustration in Barber's *Connecticut Historical Collections*, published by his father's company, Durrie and Peck Printers.

Traprock hills in popular literature. Part of a popular fiction series for young readers, the *Motorcycle Chums in New England: The Mount Holyoke Adventure* (1912) featured narrow escapes and harrowing adventures on the traprock crag. Images: author's collection.

The traprock hills of the Connecticut Valley also inspired works of fiction, in addition to a large number of books on geography and geology. One title of a popular series of adventures written for boys by Andrew Cary Lincoln, *Motorcycle Chums in New England: The Mount Holyoke Adventure* (1912), was set among the rugged crags, where the young lead characters encounter a burglar on the run, and an escaped tiger.

The traprock landscapes even found their way into drama and opera. The spectacular scenery at Merimere Notch inspired the noted German playwright and 1912 Nobel laureate Gerhart Hauptmann, to write his 1896 "fairy play," *The Sunken Bell*, during his extended visit to Meriden. Set among rocky crags and alpine lakes, and full of elves, sprites, and dwarfs, *The Sunken Bell* attracted the attention of the noted composer Ottorino Respighi, who based his elaborate and challenging opera, *La Campana Sommersa* (1927), on Hauptmann's play.

Since the early nineteenth century, the Connecticut Valley traprock landforms have played a vital role in the development of American arts and sciences, and the culture of landscape tourism. Today, thousands of visitors, eager to experience the charms and excitement of the traprock hills for themselves, are attracted to the scenic region every year.

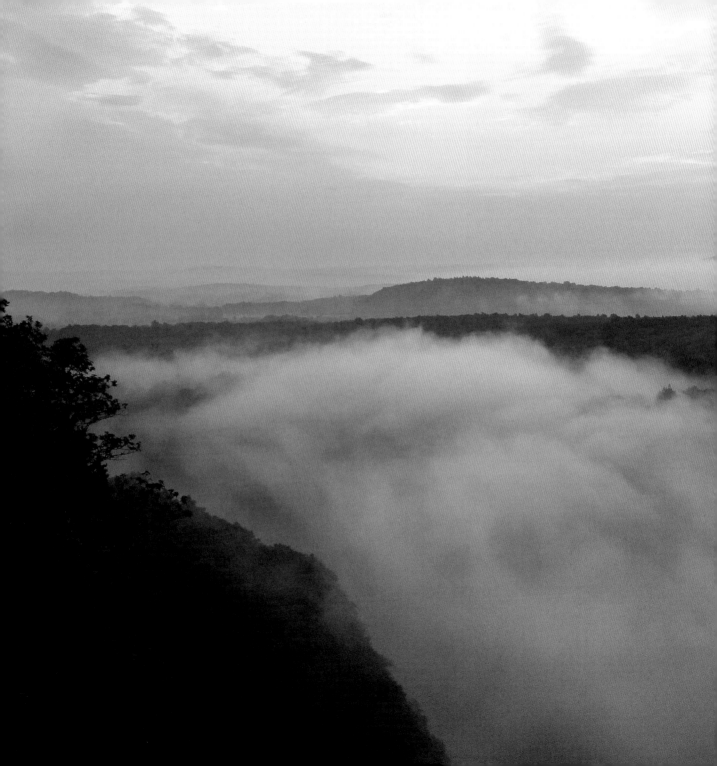

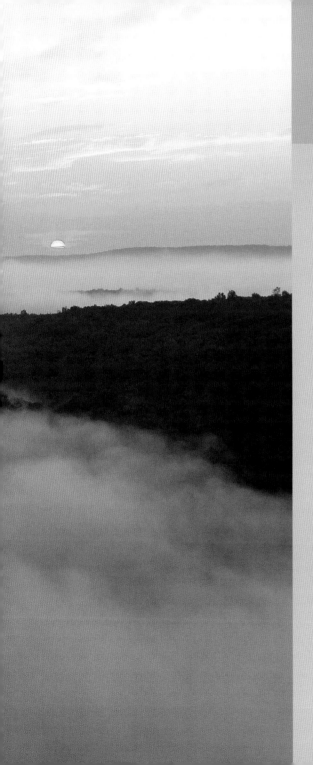

7

So Fine a Prospect

LANDSCAPES OF NATIONAL SIGNIFICANCE

It is an historic as well as a beautiful
panorama on which we are gazing.

George Munson Curtis,
Meriden's Early History (1906)

For one century, from about 1830 to 1930, the traprock highlands of the Connecticut Valley were considered among the most important landscapes in America. As the genteel era of painters, parasols, and poets faded at the close of the nineteenth century, once-popular destinations on the traprock summits entered into a period of decline. The grand hotels, ornate pavilions, and boardwalks, where international visitors, prominent politicians, and important artists once strolled, fell into disrepair and were demolished. Thus, some of the most important tourist attractions in America became "fallen giants," relics of an earlier age.

At Mount Tom, the cliff-top pavilions, wooden walkways, and the cable railway were abandoned after the Summit House burned for the third and final time in 1929. Mountain Park, the beloved amusement park at the base of Mount Tom, remained popular through the mid-1900s but finally succumbed to economic forces at the end of the century. Even natural forces seemed to turn on the traprock resorts as the Great New England Hurricane of 1938 destroyed the large 1894 eastern wing of the Prospect House hotel on Mount Holyoke.

Fortunately, the decline of commercial traprock tourism was offset by rising interest in conservation, leading to the establishment of numerous municipal and state parks at the turn of the twentieth century. During this critical period of transition, important tracts of the traprock highlands were acquired and set aside for public parks and preserves, including East Rock Park (1881) in New Haven; Hubbard Park (1898–1900) in Meriden; Mount Tom State Reservation (1902); Sleeping Giant State Park (1924); Skinner State Park (1940) on Mount Holyoke; Wadsworth Falls State Park (1942); Penwood State Park (1944); Talcott Mountain State Park (1965); and Mount Holyoke Range State Park (parcels assembled through the 1970s).

Nonprofit organizations also played an essential role in preserving the traprock highlands from development. Established in 1924, and still very active today, the Sleeping Giant Park Association (SGPA) was the primary force behind the establishment of Sleeping Giant State Park.

PREVIOUS PAGE A new day dawns with the increasing realization that the traprock highlands are critical to the quality of life in the Connecticut Valley. Northeast view from East Peak, Meriden, Connecticut.

The Mattabesett Trail passes through golden sedge glades on Mount Higby in the central Connecticut Valley. Thousands of hikers enjoy the scenic traprock landscapes, part of the National Trail System, along the Connecticut Forest and Park Association's blue-blazed trails each year.

Founded in 1895 as the Connecticut Forestry Association, the Connecticut Forest and Park Association (CFPA) took a lead role in the conservation of the traprock summits when it established its popular "blue-blazed" trail system in 1929. In the *Metacomet-Mattabesett Trail Natural Resource Assessment*, a 2004 study commissioned by the National Park Service, biologist Elizabeth Farnsworth called the CFPA blue-blazed trail system "a corridor of green in an urbanized context unlike any other trail before it." Furthermore, Farnsworth writes, "This trail system permitted a burgeoning number of recreation seekers to gain a new appreciation for Connecticut's natural ecosystems, and engaged a new class of volunteers in construction and maintenance. An utterly new literary genre—the trail guide—was invented to educate trail users about their environs (e.g., Longwell and Dana 1932), and the Trail received a great deal of attention in the popular press of the time."

Post–World War II suburban expansion resulted in profound land-use changes in the Connecticut Valley, which, in turn, put pressure on the traprock land-

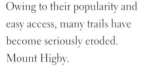

Owing to their popularity and easy access, many trails have become seriously eroded. Mount Higby.

Paint defaces the traprock ledges. Daytime use restrictions and gated access roads have greatly reduced vandalism at most parks and preserves. West Peak.

Symbols of neglect, abandoned autos are a reminder of the ongoing need for continued monitoring of the traprock landscapes.

A thicket of antennas sprouts from West Peak.

forms for housing, commercial development, infrastructure, and as a source of crushed stone. To ease permitting, natural gas and electric transmission lines were preferentially located on the traprock hills away from populated areas. Boasting the highest terrain in the region, the traprock crags proved ideal locations for telecommunication towers, and "antenna farms" sprouted in abundance on many of the peaks.

Today, urban and suburban expansion continues to nibble away at the lava ridges, and, at times, takes a large bite out of the traprock landforms. Having survived plans for Summitwood, a large residential and commercial project in the 1970s, the open space at Cathole Peak in Meriden was again targeted for development in the 1990s when the construction of an electric power generating station was approved. Although large areas of the traprock ridge were cleared and leveled, and the main structures were erected, the poorly planned project never produced a single watt of electricity. The abandoned power plant was recently dismantled, and part of the land was designated as open space, but the scarred landscape remains, a poignant reminder of the ongoing threats to the traprock corridor.

The rising popularity of outdoor recreation and increased concern for the environment in the 1970s and 1980s motivated a new generation of caretakers to take an interest in the traprock highlands. From Amherst to New Haven, a large number of land trusts, "friends" groups, and associations, along with municipalities and state agencies, began to restore trails, repair historic buildings, renovate monuments, and add increasingly scarce undeveloped parcels to existing conservation lands. By the end of the twentieth century, stories of successful preservation, restoration, and even expansion of traprock conservation lands reverberated throughout the Connecticut Valley. Steadily increasing numbers of visitors, including hikers, rock climbers, bird watchers, artists, and others, led to improved trails, better access and parking, renovation of facilities and historic structures, and broader appreciation of the joys of traprock tourism.

The 1851 Prospect House on Mount Holyoke was restored in the mid-1980s and currently serves as a visitors' center and museum. On neighboring Mount

Tom, historic structures, trails, and other amenities in the park were renovated. At Hubbard Park, the Castle Craig observation tower, Fairview Pavilion, and other original structures dating from 1900 were repaired. After extensive renovations in the 1990s, East Rock Park is once again one of the most popular outdoor attractions in the New Haven region.

In the same period, a number of organizations formed specifically to preserve and manage individual traprock crags became an important part of the regional framework for traprock conservation. The Ragged Mountain Foundation (RMF) was founded in 1991 to manage the best and most historic climbing area in southern New England. Following a successful trial period, ownership of the crag was transferred to the RMF in 1999, and it acquired an additional parcel in 2015. Peter's Rock Association (PRA) was founded in the early 2000s in response to a proposed residential development on the historic traprock crag, also known as Rabbit Rock, near New Haven. After the Town of North Haven acquired the land, the PRA repaired the extensive network of trails, constructed wooden footbridges and a picnic pavilion, erected interpretive signs, and improved parking.

Once again, many residents and visitors consider the traprock crags an essential part of their outdoor activities. A large number of enthusiasts, representing dozens of environmental and conservation organizations, are now promoting and protecting the traprock crags with increased vigor and effectiveness.

Currently, more than fifty municipalities and nonprofit organizations, two states, and the National Park System are responsible for managing parks, conservation easements, open-space parcels, and trails in the traprock hills. However, no comprehensive management plan or central agency exists to coordinate the efforts on a regional basis. An important step toward regional management of the traprock ridges took place in the mid-1980s, when sixteen municipalities in central Connecticut entered into a compact for ridgeline protection. The

Since the early 1900s, NGOs have played an important role in preserving the traprock highlands. The Peter's Rock Association was formed in 2004 to preserve the historic traprock crag in North Haven, Connecticut. The Meriden Land Trust (*inset*, small badge featuring Linclon's Head at Cathole Peak) plays a key role in managing its local traprock landscapes.

Landscapes of national significance. LEFT 1968 report on the proposed Connecticut River National Recreation Area. The ambitious initiative was derailed by concerns over possible land-use restrictions and loss of local control.

204　RIGHT Draft report for the Metacomet-Monadnock-Mattabesett Trail System, 2006. In 2008, the main traprock trails in the central and northern Connecticut Valley were designated part of the National Trail System by the National Park Service. Images: author's collection.

agreement established setbacks from the edges of the cliffs, and limited summit development to preserve the scenic landforms.

Some of the historic blue-blazed traprock trails managed by the CFPA were incorporated into the Mattabesett-Metacomet segment of the U.S. National Trail System in 2009. This federal recognition was a key step in establishing the traprock crags of the Connecticut Valley as a recreational, environmental, and scenic resource of national significance.

An early effort to bring the northern half of the Connecticut Valley under management of the National Park Service was initiated in the 1960s as part of the proposed Connecticut River National Recreation Area. In many ways ahead of its time, the ambitious project, stretching the length of the Connecticut River from northern New Hampshire to Long Island Sound, was ultimately derailed by its sheer scope and concerns about relinquishing local control over the land and water resources.

Arriving under favorable circumstances, and with a more clearly defined focus than the earlier Connecticut River project, the Blackstone River Valley

National Heritage Corridor was established in 1984 in nearby Rhode Island and southeastern Massachusetts. This successful project is an excellent model for the type of coalition that could be created to manage the natural and cultural resources of the Connecticut Valley. According to the National Park Service, "unlike a more traditional National Park, the Heritage Corridor does not own or manage any of the land within its boundaries. Instead, the Heritage Corridor Commission works in partnership with a variety of federal, state and local agencies, along with many non-profit and private organizations to protect not only the sites and resources of the Blackstone Valley, but to maintain the spirit of innovation and ingenuity that makes this a special place." The outstanding success of the Blackstone River Valley Heritage Corridor led to the establishment of the Blackstone River Valley National Historical Park in 2014, an act that also extended the authorization and boundaries of the Heritage Corridor.

Like the Blackstone River Valley National Heritage Corridor, the Connecticut Valley traprock highlands meet or exceed the criteria (see table 7.1) of the National Park Service for designation as a landscape of national significance:

it is an outstanding example of a particular type of resource;

it possesses exceptional value of quality illustrating or interpreting the natural or cultural themes of our nation's heritage;

it offers superlative opportunities for recreation for public use and enjoyment, or for scientific study;

it retains a high degree of integrity as a true, accurate, and relatively unspoiled example of the resource.

We hope that the publication of this book is the first step toward establishing a Connecticut Valley National Heritage Corridor. According to the NPS: "A 'national heritage area' is a place designated by the United States Congress where natural, cultural, historic and recreational resources combine to form a

206

Natural and cultural resources considered in evaluating the significance of a proposal for addition to the National Park System:	*The Traprock Highlands of the Connecticut Valley (Connecticut Valley National Heritage Corridor)*
a rare remnant natural landscape or biotic area of a type that was once widespread but is now vanishing due to human settlement and development;	More than two centuries of development have significantly affected the traprock highlands of the Connecticut Valley. Increasing urban and suburban expansion is further reducing the extent of the regionally important open space corridor.
a site that possesses exceptional diversity of ecological components or geological features;	Many municipal, state, and federal agencies, and numerous non-profit conservation organizations recognize the importance of the geological features, ecology, water resources, and recreational potential of the traprock highlands of the Connecticut Valley.
a site that contains biotic species or communities whose natural distribution at that location makes them unusual;	The traprock highlands include many biomes and habitats that are rare or unique in the region, including summit balds and barrens, xeric sedge meadows, and microbiont epilithic communities. The cold-seep talus slopes represent the oldest undisturbed landscapes in southern New England.
a site that harbors a concentrated population of a rare plant or animal species, particularly one officially recognized as threatened or endangered;	The traprock highlands host a wide variety of rare, endangered, or threatened plants and animals, and serve as habitat for a large number of native species. The traprock hills form an important migratory corridor and breeding area for large numbers of birds, including hawks, falcons, warblers, and a wide variety of other passerines.

an area that has outstanding scenic qualities such as dramatic topographic features, unusual contrasts in landforms or vegetation, spectacular vistas, or other special landscape features;

a site that is an invaluable ecological or geological benchmark due to an extensive and long term record of research and scientific discovery.

The traprock highlands of the Connecticut Valley have been recognized as significant American landforms for more than two centuries. Views from the traprock hills, including Mount Holyoke, were once considered among "the finest in North America." The ridges hosted the first tourist observation tower and the first summit tramway in the United States, as well as some of the very earliest summit hotels and visitor centers. The ridges were the sites of early vacation-cottage colonies. With summits exceeding 1,000 feet, some of the traprock hills are the highest topographic features along the Atlantic coast south of Maine.

Since the early 1800s, many hundreds of journal reports, monographs, field guides, theses, abstracts, and newspaper and magazine articles have been published about the science, culture, history, art, and outdoor recreation of the Connecticut Valley.

Scientific research in the Connecticut Valley spans more than 150 years, and includes some the earliest geological and biological studies in the United States. Important early scientists who worked in the Connecticut Valley include James G. Percival, Benjamin Silliman, Charles Lyell, James Dwight Dana, Edward Hitchcock, and William Morris Davis—among many others. The Connecticut Valley continues as the focus of important modern studies at numerous colleges and universities including Columbia, Yale, Harvard, Wesleyan, Amherst, the Massachusetts and Connecticut state systems, and others.

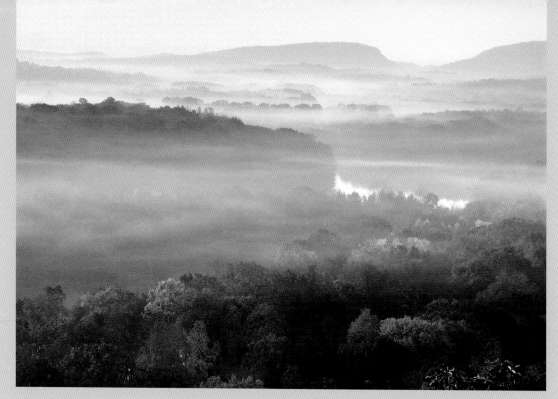
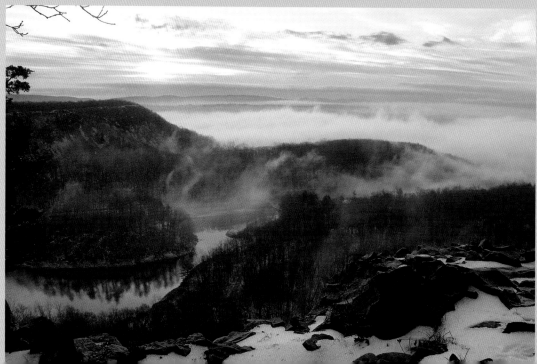

cohesive, nationally-distinctive landscape arising from patterns of human activity shaped by geography." National Heritage Areas are not units of National Park Service, but may receive guidance and limited funding from the NPS.

In addition to the Blackstone River National Heritage Corridor, there are good examples of national heritage areas in the region, including: the Quinebaug and Shetucket Rivers Valley National Heritage Corridor, the Upper Housatonic Valley National Heritage Area, the Hudson River Valley National Heritage Area, and the Champlain Valley National Heritage Area.

Federal authorization of a Connecticut Valley National Heritage Corridor, its sites linked by physical geography, and meeting all the criteria necessary for designation as both a "landscape of national significance" and a "national heritage area," appears to be a realistic goal. All the necessary pieces are in place in the Connecticut Valley, including ample public lands, numerous scenic landforms and points of geologic interest, recreational and cultural facilities, historical sites, transportation infrastructure, and a long history of landscape tourism. Federal recognition would create an important multiagency and multistate framework for preserving and managing the natural and cultural resources of this unique region, including promoting tourism and scientific study.

Thank you for joining us on this journey into traprock highlands of the Connecticut Valley. No words more precisely express our feelings about the traprock landscapes than those penned by the Trinity College geologist William Pynchon more than a century ago:

"To me the lonely lava ridges have a peculiar fascination. I have wandered over them in springtime and I have enjoyed the cool breeze on their summits in the scorching days of summer. I have watched them under the cold sunset of November, and I have been upon them when the winds of winter howled over the snows. They are never twice the same. There is always some new charm about them."[1]

OPPOSITE The traprock highlands of the Connecticut Valley have endured centuries of land-use changes to remain the most important natural corridor in southern New England. Meeting all the criteria necessary for federal recognition, the traprock hills could form the backbone of a new Connecticut Valley National Heritage Corridor in the model of the very successful Blackstone River Valley National Heritage Corridor in adjacent Rhode Island and Massachusetts. TOP View of the Hanging Hills from Ragged Mountain. BOTTOM View of South Mountain and Merimere Reservoir from East Peak in Meriden.

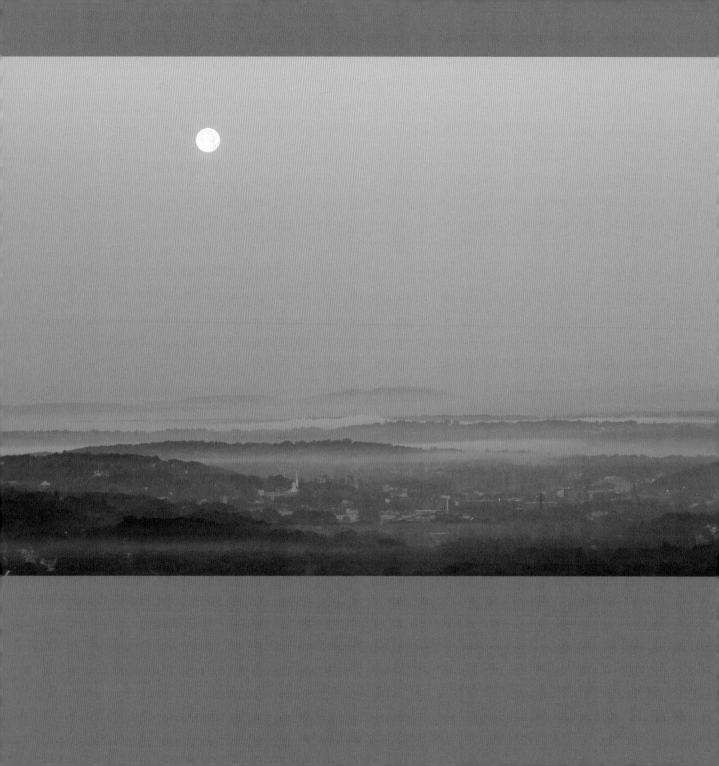

APPENDIX

Places to Visit in Traprock Country

Please refer to the online sources or tourist brochures and publications for details regarding hours, fees, driving directions, and other information about the attraction. Many of the suggested places to visit listed here are state or municipal parks, or commercial facilities, maintained for public access. Some of the locations, however, are unsupervised open space with rough, steep, non-maintained trails and cliffs rising hundreds of feet high. Visitors are cautioned that the traprock environment, including trails and summit ledges, may present a broad range of objective hazards, such as sheer unprotected cliffs, risk of severe or fatal falls, changeable weather, unstable surfaces, loose footing, and more. There are numerous documented occurrences of fatal and injurious falls from the traprock cliffs of the Connecticut Valley, including those in public parks and preserves. Visitors are warned to exercise appropriate caution and common sense, seek safety information relevant to their planned activities, and to know their own outdoor abilities and limits. Except for two specific locations, rock climbing is not permitted on any of the traprock cliffs because they are very steep and unstable; police conduct regular patrols of most cliffs. These listings do not constitute permission to enter any property, or suitability to any purpose. Visitors are encouraged to obtain information from the individual sites or attractions.

OPPOSITE Full moon over Meriden and the traprock landscapes of the southern Connecticut Valley. View from Chauncey Peak.

WHERE: East Rock Park (East Rock Ranger Station/
Trowbridge Environmental Center)
41 Cold Spring Street
New Haven, CT 06511
PHONE: (203) 946-6086
WEB: http://www.cityofnewhaven.com/parks
/parksinformation/eastrockpark.asp
WHEN TO VISIT: Open daily, hours may vary. There
are several options for entering the park; see Web for
access and parking
FACILITIES: Summit access road, nature center, picnic
tables, restrooms, playgrounds, ball fields.
WHAT TO SEE: Trowbridge Environmental Center;
1888 Soldier's and Sailor's Monument; historic park
structures, trails, and gardens.

WHERE: Fort Hale and Black Rock Fort
36 Woodward Avenue
New Haven, CT 06512
PHONE: (203) 946-8027
WEB: http://www.lisrc.uconn.edu/coastalaccess/site
.asp?siteid=418
WHEN TO VISIT: Open daily.
FACILITIES: Seasonal restrooms, picnic tables, fishing
pier, pavilion, playground.
WHAT TO SEE: From 1657 to the Civil War, a series of
forts were built on the coastal traprock ledges at the
east entrance to New Haven Harbor. The historic
fortifications played an important role in the 1779
battle of New Haven. General William Tryon directed
the British troops from the traprock escarpment at
Forbes Bluff on Morris Cove.
MORE INFO: http://www.courant.com/news/connecticut
/hc-marteka-fort-hale-lighthouse-point-0118–20150116
-column.html
http://www.ctmq.org/22-holding-it-down-at-the-forts/

NEARBY ATTRACTIONS:
Fort Wooster Park/Beacon Hill, 959 Townsend Ave,
New Haven, CT 06512. Historic fortifications built
on traprock bluff. http://www.fortwooster.com/
Lighthouse Point Park, 2 Lighthouse Road, New
Haven, CT 06512. Public beach, recreation area,
lighthouse, historic carousel; fees charged. http://
www.cityofnewhaven.com/parks

WHERE: Yale Peabody Museum of Natural History
170 Whitney Avenue
New Haven, CT 06511
PHONE: (203) 432-5050
WEB: peabody.yale.edu/
WHEN TO VISIT: Daily, closed Mondays; see Web page
for hours.
ENTRANCE FEE: Yes.
FACILITIES: Restrooms, coatroom, museum shop.
WHAT TO SEE: Spectacular dinosaur skeletons collected
by O. C. Marsh; Connecticut Valley fossils, minerals,
and natural-history displays; Rudolph Zallinger's room-
size mural *The Age of Dinosaurs*.

WHERE: West Rock Ridge State Park
Wintergreen Avenue
New Haven, CT 06514
Contact: West Rock Ridge State Park, c/o Sleeping Giant
State Park, 200 Mount Carmel Avenue, Hamden, CT
06518
PHONE: (203) 287-5658
WEB: http://www.ct.gov/deep
WHEN TO VISIT: Open daily; the summit drive open
seasonally.
FACILITIES: Seasonal summit access road, picnic tables,
restrooms.
WHAT TO SEE: West Rock Nature Center; Judge's Cave
historic site; Lake Wintergreen; Wintergreen Falls.

WHERE: Sleeping Giant State Park
200 Mount Carmel Avenue
Hamden, CT 06518

PHONE: (203) 287-5658

WEB: http://www.ct.gov/deep

WHEN TO VISIT: Open daily.

FACILITIES: Picnic tables, picnic shelter, restrooms.

ENTRANCE FEE: Fee charged seasonally on holidays and weekends.

WHAT TO SEE: WPA stone lookout tower; A. G. Dana memorial plaque; former traprock quarry; trails.

NEARBY ATTRACTIONS:

Blue Hills Orchard, 141 Blue Hills Rd.,Wallingford, CT 06492. (203) 269-3189, http://www.bluehillsorchard .com/. Open weekends late summer through fall, check Web for schedule. Classic Connecticut Valley orchard, established in 1904; views of the Hanging Hills; local fruit and farm products; autumn hay rides.

WHERE: Peter's Rock Preserve
133 Middletown Avenue
North Haven, CT 06473

WEB: http://www.petersrockassociation.org/

CONTACT: info@petersrockassociation.org

WHEN TO VISIT: Open daily.

FACILITIES: Picnic pavilion, marked trails.

WHAT TO SEE: Basalt columns; historic ruins; excellent views of the lower Connecticut Valley, from the Hanging Hills to Long Island Sound.

WHERE: The Shore Line Trolley Museum
Branford Electric Railway Association, Inc.
17 River Street
East Haven, CT 06512

PHONE: (203) 467-6927

WEB: http://shorelinetrolley.org/

WHEN TO VISIT: May to October, hours vary; see Web for details.

FACILITIES: Visitors' center, exhibits, restrooms, picnic grove.

WHAT TO SEE: Seasonal rides on historic trolley cars offer views of coastal traprock ledges at Beacon Hill and tidal marshes.

NEARBY ATTRACTIONS:

Beacon Hill Preserve, access from Dominican Road or Rose Hill Road, Branford, Connecticut. http://branford landtrust.org/explore/trail-maps/. Beacon Hill in Branford is the only lava flow in the Connecticut Valley that reaches coastal waters; remains of former traprock quarry; views of coastal marshes and trolley tracks.

WHERE: Pistapaug Mountain and Trimountain State Park
Whirlwind Hill Road
East Wallingford, CT 06492

WEB: http://www.ct.gov/deep

FACILITIES: None, undeveloped state preserve.

WHAT TO SEE: Traprock cliffs overlooking scenic Pistapaug and Ulbrich Reservoirs; views of Sleeping Giant ridge, the Hanging Hills, and the lower Connecticut Valley.

WHERE: Black Pond State Fishing Area
1690 East Main Street
(Route 66, on the Meriden-Middlefield line)
Middlefield, CT 06455

PHONE: (860) 424-3000

WEB: http://ct.gov/deep

WHEN TO VISIT: Open daily sunrise to sunset.

FACILITIES: Parking area, unpaved launch ramp for small, non-powered boats, accessible fishing platform, portable toilets.

WHAT TO SEE: One of the finest views in the Connecticut Valley, featuring tranquil Black Pond framed by the traprock cliffs of Beseck Mountain; trails; non-powered small-craft boating; fishing permitted with valid Connecticut license; ice fishing in winter is particularly popular.

WHERE: Lyman Orchards and Golf Course
32 Reeds Gap Road
Middlefield, CT 06455
PHONE: (860) 349-1793
WEB: http://lymanorchards.com/
WHEN TO VISIT: Open daily; see Web for seasonal hours and special events.
ENTRANCE FEE: No; fees charged for special activities, seasonal rides, and golfing.
FACILITIES: Apple Barrel Market, deli, bakery, snack bar, corn maze, sunflower maze. Three full-service golf courses.
WHAT TO SEE: Since 1741, seasonal pick-your-own fruits and berries, farm market, and bakery; spectacular views of Connecticut Valley from the drumlin hills of the upper orchards; golf; rotating calendar of special events and activities. One of central Connecticut's most popular destinations.

WHERE: Powder Ridge Mountain Park and Resort
Powder Hill Road
Middlefield, CT 06455
PHONE: (866) 860-0208
WEB: http://powderridgepark.com/
WHEN TO VISIT: Open seasonally for skiing; other activities offered throughout the year.
FACILITIES: Winter sports, equipment rentals, snack bar, restrooms. Fire at the Ridge Restaurant and Lodge features a pub with live music

ENTRANCE FEE: Fees apply for skiing and other seasonal activities.
WHAT TO SEE: Winter sports and seasonal events on the traprock slopes of Beseck Mountain.
NEARBY ATTRACTIONS: State-operated boat launch at Lake Beseck. Powder Hill Dinosaur Park, located near the ski area entrance, preserves rock layers dating from the age of dinosaurs. The upper entrance to Lyman Orchards and Golf Course is located one-quarter mile south of the ski area.

WHERE: Wadsworth Falls State Park
Main Entrance: 721 Wadsworth Street (Rt. 157)
Middletown, CT 06457
Parking for Wadsworth Falls: Cherry Hill Rd., Middlefield, CT 06455
PHONE: (860) 345-8521
WEB: http://www.ct.gov/deep
FACILITIES: Picnic tables and charcoal grills, seasonal swimming beach with changing rooms.
ENTRANCE FEE: Fee is charged when lifeguards are on duty at the swimming area; waterfall parking area is free.
WHAT TO SEE: Wadsworth Falls; Little Wadsworth Falls; hiking trails; swimming pond in season; exposures of the Hampden Basalt; a birdwatcher's "hot spot" during spring migration.

WHERE: Mount Higby
Parking on Route 66 west, about a half mile west of Route 147
Middlefield, CT 06455
See also: The Nature Conservancy
Mount Higby Preserve
Old Preston Avenue
Meriden, CT 06450

WEB: http://www.nature.org/
FACILITIES: None.

WHAT TO SEE: Popular hiking trails with spectacular summit views.

WHERE: Westfield Falls
Miner Road
(GPS coordinates: N4°34.800'; W72°42.909')
Middletown, CT 06450

FACILITIES: None; parking is limited to a few cars.

WHAT TO SEE: One of the most beautiful waterfalls in the Connecticut Valley; exposures of the Hampden Basalt.

WHERE: Giuffrida Park
800 Westfield Road
Meriden, CT 06450

PHONE: (203) 630-4259 (Parks Dept.)

WEB: http://www.cityofmeriden.org

See also: Meriden Land Trust; http://www. meridenlandtrust.com/

FACILITIES: None.

WHAT TO SEE: Access to hiking trails leading to the summits of Chauncey Peak and Mount Lamentation; a birdwatching "hot spot." The mountainous landscapes at the north end of the reservoir are among the most scenic in the Connecticut Valley. Hunter Memorial Golf Course (688 Westfield Road), with casual dining facilities, is located adjacent to the Giuffrida Park entrance.

WHERE: Hubbard Park
West Main Street
Meriden, CT 06450

PHONE: (203) 630-4259 (Parks Dept.)

WEB: http://www.cityofmeriden.org

WHEN TO VISIT: Open daily. The annual Daffodil Festival draws thousands of visitors in April. The summer concert series features oldies, jazz, and band performances. Weather permitting, Mirror Lake is a popular ice skating area.

FACILITIES: Seasonal summit access road, playgrounds, bandshell, picnic pavilion, restrooms.

WHAT TO SEE: Designed in the late 1800s by Frederick Law Olmstead's sons, Hubbard Park is one of the finest municipal parks in the region. Slabs of sandstone with dinosaur tracks are displayed on the east side of Mirror Lake. Castle Craig, a stone observation tower on East Peak (el. 978 ft.), and West Peak (el. 1,024 ft.), the highest point within 25 miles of the Atlantic coast south of Maine, may be accessed year-round by hiking trails. A scenic access road to the summits is open during daylight hours from April to October. Historic Fairview Pavilion (the halfway house) features excellent views and cool breezes. The spectacular alpine scenery at Merimere Reservoir inspired the 1896 play *The Sunken Bell*, adapted for opera by Ottorino Respighi in 1927.

WHERE: Mount Sanford/Naugatuck State Forest
North entrance: Bethany Mountain Road (Route 42), Cheshire, CT 06410. GPS coordinates: W72° 57.032', N41°28.042',
South entrance: Downes Road, Hamden, CT 06518. GPS coordinates: W72 56.803, N41 27.013

WEB: http://www.ct.gov/deep

FACILITIES: None, undeveloped state preserve. For parking, see trail map available online on the Connecticut DEEP website.

WHAT TO SEE: Mount Sanford (el. 890 ft.), a remote and unspoiled traprock summit on the western margin of the Connecticut Valley.

nature tours; seasonal programs. One of the best places in New England to observe the migration of large numbers of hawks in fall.

WHERE: Mount Holyoke/J. A. Skinner State Park
10 Skinner State Park Rd.
Hadley, MA 01035
PHONE: (413) 586-0350
WEB: http://www.mass.gov/eea/agencies/dcr/massparks
/region-west/skinner-state-park-generic.html
ENTRANCE FEE: Daily parking fee.
FACILITIES: Seasonal summit access road, historic summit house visitors' center and museum open seasonally, picnic grounds, interpretive signs, restrooms.
WHAT TO SEE: The heart of American landscape tourism, still one of the finest landscape views in the East. Restored Prospect House; historic summit tram powerhouse; view of the Connecticut River intervales and oxbow; B-24 crash monument; trails; seasonal programs and activities.

WHERE: Mount Holyoke Range State Park
The Notch
1500 West Street
Amherst, MA 01002
PHONE: (413) 253-2883
WEB: http://www.mass.gov/eea/agencies/dcr/massparks
/region-west/mount-holyoke-range-state-park.html
ENTRANCE FEE: Daily parking fee.
FACILITIES: The Notch visitors' center, open daily.
WHAT TO SEE: Scenic views of the traprock highlands; seasonal programs; trails. Visitors' center features exhibits on natural history, Connecticut Valley fossils and minerals, local history, along with guided hikes and interpretive programs.

NOTES

1. WELCOME TO TRAPROCK COUNTRY

1. Silliman 1820, 405.
2. Dwight 1821, 354.
3. Willis 1840, 1:10.

2. RISING IN SHAPES OF ENDLESS VARIETY

1. Jackson 1984, 59.
2. Hoadley 1868, 475.

3. BORN OF FIRE

1. Silliman 1822, 23–24.

4. SKY ISLANDS

1. Morse 1792, 225.
2. Silliman 1822, 174–77.
3. Hoadley 1868, 102.
4. Perkins 1849, 93.
5. Connecticut DEEP, "Black Bear Sightings."
6. Municipal Register of the City of Meriden 1889, 22.

5. A VALLEY OF EXTREME BEAUTY AND GREAT EXTENT

1. Silliman 1824, 2nd ed., 10–14.
2. Stevenson 1879, 21.
3. Morse and Parish 1808, 190.
4. Dwight 1829, 9–10; 1821, 2:377.
5. Coke's less than enthusiastic opinion of Mount Washington was certainly colored by the fact that he rose well before dawn, rode more than a dozen miles over rugged terrain and barely passable trails, was forced to ford the icy Ammonoosuc River several times, climbed at least 4,000 vertical feet, including a sheer cliff of more than 100 ft., had his water bottle freeze solid by the time he reached the summit, and then added a 30-mile carriage ride on his return to finally end his trip in wee hours of the following day. Sterner stuff, indeed.
6. Silliman 1812, 2nd ed., 2:280–81.
7. Hall 1829, 202. Hall's camera-lucida sketch of the Connecticut River oxbow not only set the standard for illustrating the view from Mount Holyoke, but also motivated Thomas Cole to paint his masterpiece landscape of the same view after he visited Hall in England in 1832.
8. Hitchcock 1841, 244
9. Dwight 1821, 1:355.
10. Myers 1993, 79.

11. As indicated by the widespread dissemination of geographic images in the 1800s, including viewbooks of landscape engravings (e.g., Barber, 1836; Hall, 1829; Hinton, 1832; Wm. H. Bartlett in Willis, 1840; Mayfield, 1852); magazines, gazettes, and newspaper illustrations; scenic lithographs (e.g., Sarony & Co., Currier & Ives, and N. & S. S. Jocelyn); the popularity of glass slide/magic lantern (stereopticon) shows; the rise of stereoscopic photographs and viewers for home entertainment and education; as well as scientific and travel literature (e.g., Silliman, 1820; Coke, 1833; Hitchcock, 1842; Lyell, 1845. See also Nancy Siegel (2003) for insights into the rising popularity of landscape and historic images in the early nineteenth century.

12. Camehl 1916, ix.
13. See Williams, http://englishpink.net.
14. Jackson 1984, 59

6. THESE MURAL CLIFFS

1. See Shepard 1895.
2. Barber 1836, 227–28.

7. SO FINE A PROSPECT

1. Pynchon 1896, 319.

REFERENCES

Adams, Charles, F., Jr., ed. 1883. *The New English Canaan of Thomas Morton*. Boston: The Prince Society. Hathi Trust, http://babel.hathitrust.org/cgi /pt?id=mdp.39015012085257;view=1up;seq=7.

Andrews, Charles, M. 1889. *The River Towns of Connecticut: A Study of Wethersfield, Hartford, and Windsor*. Baltimore, MD: Johns Hopkins University Press. Google Books, https://books.google.com /books?id=pZ14AAAAMAAJ.

Bain, G. W., and H. A. Meyerhoff. 1963. *The Flow of Time in the Connecticut Valley*. Springfield, MA: Springfield Library and Museums.

Barber, John W. 1836. *Connecticut Historical Collections*. New Haven, CT: J. W. Barber.

———. 1836. *Views in New Haven and Its Vicinity*. New Haven, CT: J. W. Barber.

Beach, J. C. 1933. "Mill Rock Reservoir." *Connecticut Society of Civil Engineers, 49th Annual Report*. 105–14.

Bedell, Rebecca. 2001. *The Anatomy of Nature: Geology and American Landscape Painting, 1825–1875*. Princeton, NJ: Princeton University Press.

Bell, Michael. 1985. *The Face of Connecticut*. Connecticut State Geological and Natural History Survey Bulletin 110.

Bickford, C. P., and J. B. McNulty, eds. 1990. *John Warner Barber's Views of Connecticut Towns, 1834–36*. Acorn Club/Connecticut Historical Society. Middletown, CT: Wesleyan University Press.

Bloemink, Barbara, et al. 2006. *Frederic Church, Winslow Homer, and Thomas Moran: Tourism and the American Landscape*. New York: Cooper-Hewitt National Design Museum.

Bureau of Outdoor Recreation. 1968. *New England Heritage: The Connecticut River National Recreation Area Study*. U.S. Department of the Interior.

Burt, Henry M. 1867. *Burt's Illustrated Guide of the Connecticut Valley*. Northampton, MA: New England Publishing Co. Google Books, https://books.google. com/books?id=648c7iY32HEC.

Camehl, Ada W. 1916. *The Blue-China Book*. New York: Halcyon House.

Carr, Ethan. 2002. "Preserving Mt. Holyoke." In *Changing Prospects: The View from Mount Holyoke*, edited by Marianne Doezema, 63–75. Mount Holyoke College Art Museum. Ithaca, NY: Cornell University Press.

Chapin, J. H. 1887. "The Hanging Hills." *Transactions of the Meriden Scientific Society* 2:23–28.

Charles, Eleanor. 1998. "In the Region/Connecticut, Towns Implementing Ridge Development Limits." *New York Times*, June 14.

Cleaveland, Parker. 1822. *An Elementary Treatise on Mineralogy and Geology*. Vol. 1. 2nd ed. Boston: Cummings and Hilliard.

Coke, E. T. 1833. *A Subaltern's Furlough*. Vol. 1. New York: J. & J. Harper. Google Books, https://books. google.com/books?id=bKLaA9o1w3gC.

Connecticut Department of Energy and Environmental Protection. "Black Bear Sightings." Accessed 2015. http://www.depdata.ct.gov/wildlife/sighting/bearsight.asp.

Cronon, William. 1983. *Changes in the Land: Indians, Colonists, and the Ecology of New England*. New York: Hill and Wang.

Curtis, G. M. 1906. "Meriden's Early History." In *A Century of Meriden: An Historic Record and Pictorial Description of the Town of Meriden, Connecticut*, edited by C. B. Gillespie, part 1, 1–400. Meriden, CT: Journal Publishing.

Cushman, R. V., D. Tanski, and M. P. Thomas. 1964. *Water Resources of the Hartford–New Britain Area, Connecticut*. U.S. Geological Survey Water-Supply Paper, no. 1499.

Dakin, W. S. 1926. *Geography of Connecticut*. Boston: Ginn and Co.

Dana, James. D. 1898. *On the Four Rocks of the New Haven Region*. New Haven, CT: Tuttle, Morehouse and Taylor.

Davis, William M. 1891. "The Lost Volcanoes of Connecticut." *Popular Science Monthly* (December): 221–35.

———. 1898. *The Triassic Formation of Connecticut*. U.S. Geological Survey Annual Report, no. 18, 2:1–192.

———. 1899. "The Physical Geography of New England." In *The Butterflies of Eastern United States and Canada*, by S. H. Scudder, 75–86. Cambridge, MA: W. H. Wheeler.

Doezema, Marianne, ed. 2002. *Changing Prospects: The View from Mount Holyoke*. Mount Holyoke College Art Museum. Ithaca, NY: Cornell University Press.

Donahue, Brian. 2004. *The Great Meadow: Farmers and the Land in Colonial Concord*. New Haven, CT: Yale University Press.

Dowhan, J. J., and R. J. Craig. 1976. *Rare and Endangered Species of Connecticut and their Habitats*. Connecticut State Geological and Natural History Survey, Report of Investigations, no. 6.

Dwight, Timothy. 1821. *Travels in New England and New York*. 4 vols. New Haven, CT: Timothy Dwight, S. Converse Printers. Hathi Trust, http://babel.hathitrust.org/cgi/pt?id=yale.39002002421833;view=1up;seq=14.

———. 1829. *Sketches of Scenery and Manners in the United States*. New York: A. T. Goodrich.

Farnsworth, Elizabeth. 2002. "New and Ancient Treasures: The Traprock Mountains of New England." In *Conservation Perspectives*. New England Society for Conservation Biology. www.nescb.org.

———. 2004. *Metacomet-Mattabesett Trail Natural Resource Assessment*. U.S. National Park Service.

Freeman, Stan. 1989. "Lost Airmen Get Final Tribute: Boyhood Discovery, Curiosity Led to Monument at Crash Site." *Springfield (MA) Sunday Republican*, May 28, 1989.

Genthe, Martha K. 1907. "Valley Towns of Connecticut." *Bulletin of the American Geographical Society* 39 (9): 513–44.

Goldberg, D. S., D. V. Kent, and P. E. Olsen. 2010. "Potential On-Shore and Off-Shore Reservoirs for CO_2 Sequestration in Central Atlantic Magmatic Province Basalts." *Proceedings of the National Academy of Sciences* 107 (4): 1327–32.

Graci, D. 1985. *Mt. Holyoke: An Enduring Prospect*. Holyoke, MA: Calem Publishing Co.

Guinness, Alison C. 2003. "Heart of Stone: The Brownstone Industry of Portland, Connecticut." In *Sedimentology, Stratigraphy, and Paleontology*, vol. 2 of *The Great Rift Valleys of Pangea in Eastern North America*, by P. M. LeTourneau and P. E. Olsen, 224–46. New York: Columbia University Press.

Hall, Basil. 1830. *Travels in North America in the Years 1827 and 1828*. 3rd ed. Edinburgh: Robert Cadwell. Google Books, https://books.google.com /books?isbn=1429001348.

Harte, Charles R. 1944. *Connecticut's Iron and Copper: Part 1*. 60th Annual Report of the Connecticut Society of Civil Engineers. The American Society of Civil Engineers.

Hauptmann, Gerhart. 1919. *The Sunken Bell: A Fairy Play in Five Acts*. Translated by Charles Henry Meltzer. Garden City, NY: Doubleday, Page & Co.

Hinton, John H. 1832. *The History and Topography of the United States*. Vol. 2. London, Jennings & Chaplin. Hathi Trust, http://catalog.hathitrust.org /Record/000332092.

Hitchcock, Edward. 1824. "A Sketch of the Geology, Mineralogy, and Scenery of the Region Contiguous to the River Connecticut: Part III, Scenery." *American Journal of Science* 7:1–30.

——. 1842. "Scenographical Geology." In *Final Report on the Geology of Massachusetts*, vol. 1, part 2, 227–97. Northampton, MA:, J. H. Butler.

——. 1842. *Sketch of the Scenery of Massachusetts*. Northampton, MA: J. H. Butler.

——. 1858. *Ichnology of New England: A Report on the Sandstone of the Connecticut Valley, Especially Its Fossil Footmarks*. Boston: Commonwealth of Massachusetts.

Hoadly, Charles, J. 1868. *The Public Records of the Colony of Connecticut: From August 1689 to May 1706*. Hartford, CT: Case, Lockwood and Brainard.

Hodnicki, Jill A. 1981. "The Connecticut Valley in Literature: A Delightful Excursion." In *Arcadian Vales: Views of the Connecticut River Valley*, edited by Martha J. Hoppin, 11–26. George Walter Vincent Smith Art Museum. Springfield, MA: Springfield Libraries and Museums Association.

Holyoke Water Power Company Collection. 1857–2001. *Historical Note on Collection Number HPLA2005.110*. Holyoke Public Library. Accessed 2009. http://www.holyokelibrary.org.

Hoppin, Martha J., ed. 1981. *Arcadian Vales: Views of the Connecticut River Valley*. George Walter Vincent Smith Art Museum. Springfield, MA: Springfield Libraries and Museums Association.

Hutson, Martha Y. 1977. *George Henry Durrie (1820–1863): American Winter Landscapist—Renowned through Currier and Ives*. Laguna Beach, CA: Santa Barbara Museum of Art and American Art Review Press.

Jackson, John Brinckerhoff. 1984. *Discovering the Vernacular Landscape*. New Haven, CT: Yale University Press.

Jorgensen, Neil. 1977. *A Guide to New England's Landscape*. Old Saybrook, CT: Globe Pequot Press.

——. 1978. *A Sierra Club Naturalist's Guide to Southern New England*. San Francisco: Sierra Club Books.

Kent, D. V., and P. E. Olsen. 2008. "Early Jurassic Magnetostratigraphy and Paleolatitudes from the Hartford Continental Rift Basin (Eastern North America): Test for Polarity Bias and Abrupt Polar Wander in Association with the Central Atlantic Magmatic Province." *Journal of Geophysical Research* 113, no. B6 (June): 1–24.

Kious, J. W., and R. I. Tilling. 1996. *This Dynamic Earth: The Story of Plate Tectonics*. Washington, DC: U.S. Government Printing Office. https://pubs.er.usgs.gov/publication/7000097].

Kirwan, Richard. 1799. *Geological Essays*. London: D. Bremner. Hathi Trust, http://catalog.hathitrust.org/Record/001519846.

Kornhauser, Elizabeth M. 2004. "Daniel Wadsworth and the Hudson River School." *Hog River Journal* 3, no. 1 (Winter): 18–23.

Kricher, J. C. 1998. *A Field Guide to Eastern Forests: North America*. Peterson Field Guides. New York: Houghton Mifflin Harcourt.

Kruska, E. J. 1996. "Mt. Tom Memorial Dedicated." *The Coast Guard Reservist* 18, no. 9 (September): 12. See also in same issue: "Mount Tom Monument Dedication a Success," Letters, 2.

Larsen, Ellouise B. 1975. *American Historical Views on Staffordshire China*. 3rd ed. New York: Dover Publications.

Lee, Cara. 1985. *West Rock to the Barndoor Hills: The Traprock Ridges of Connecticut*. Vegetation of Connecticut Natural Areas, no. 4. Hartford, CT: State Geological and Natural History Survey of Connecticut.

LeTourneau, P. M. 1985. "Alluvial Fan Development in the Lower Jurassic Portland Formation, Central Connecticut—Implications for Tectonics and Climate." In *Proceedings of the Second U.S. Geological Survey Workshop on the Early Mesozoic Basins of the Eastern United States*, edited by G. R. Robinson and A. J. Froelich, 17–26. U.S. Geological Survey Circular 946.

———. 2003. "Rift Basin Sedimentology and Stratigraphic Architecture." In *The Great Rift Valleys of Pangea in North America*. Vol. 2, *Sedimentology, Stratigraphy, and Paleontology*, 7–11. New York: Columbia University Press.

———. 2008. "Traprock Ridgelands: The Environmental Geography of Threatened Landscapes of the Connecticut Valley." In *Guidebook for Field Trips in Massachusetts and Adjacent Areas of Connecticut and New York*, edited by Mark Van Baalen, Trip C3. New England Intercollegiate Geological Conference, 100th Annual Meeting, Westfield State College.

———. 2010. "The Stone That Shaped America in the 19th Century: The Geology and History of the Portland Brownstone Quarries." In *Traprock, Tracks, and Brownstone: The Geology, Paleontology, and History of World-Class Sites in the Connecticut Valley*, edited by P. M. LeTourneau and M. A. Thomas, 17–30. Geological Society of Connecticut Field Trip Guidebook, no. 1. The Geological Society of Connecticut and Connecticut Department of Environmental Protection.

LeTourneau, P. M., and P. Huber. 2006. "Early Jurassic Eolian Dune Field, Pomperaug Basin, Connecticut, and Related Synrift Deposits: Stratigraphic Framework and Paleoclimatic Context." *Sedimentary Geology* 187:63–81.

LeTourneau, P. M., and N. G. McDonald. 1985. "The Sedimentology, Stratigraphy and Paleontology of the Lower Jurassic Portland Formation, Hartford Basin, Central Connecticut." In *Guidebook for Field Trips in Connecticut and Adjacent Areas of New York and Rhode Island*, edited by R. J. Tracey, 353–92. New England Intercollegiate Geological Conference, 77th Annual Meeting, Yale University. State Geological and Natural History Survey of Connecticut Guidebook, no. 6.

LeTourneau, P. M., N. G. McDonald, P. E. Olsen, T. C. Ku, and P. R. Getty. 2015. "Facies and Fossils: Depositional Environments and Ecosystem Dynamics along the Footwall Margin of an Actively Subsiding Rift." In *Guidebook for Field Trips in Connecticut and Massachusetts*, edited by M. Gilmore and P. Resor, Trip B-2, 107–51. New England Intercollegiate Geological Conference, 107th Annual Meeting, Wesleyan University.

LeTourneau, P. M., and P. E. Olsen. 1996. "Aspects of Triassic-Jurassic Rift Basin Geoscience—Abstracts." Hartford, CT: State Geological and Natural History Survey of Connecticut, Miscellaneous Reports 1.

———, eds. 2003a. *The Great Rift Valleys of Pangea in North America*. Vol. 1, *Tectonics, Structure, and Volcanism of Supercontinent Breakup*. New York: Columbia University Press.

———, eds. 2003b. *The Great Rift Valleys of Pangea in North America*. Vol. 2, *Sedimentology, Stratigraphy, and Paleontology*. New York: Columbia University Press.

LeTourneau, P. M., and M. A. Thomas, eds. 2010. *Traprock, Tracks, and Brownstone: The Geology, Paleontology, and History of World-Class Sites in the Connecticut Valley*. Geological Society of Connecticut Field Trip Guidebook, no. 1. The Geological Society of Connecticut and Connecticut Department of Environmental Protection.

Longwell, C. R., and E. S. Dana. 1932. *Walks and Rides in Central Connecticut and Massachusetts*. New Haven, CT: Tuttle, Morehouse and Taylor.

Ludlow, Roger. 1828. *Code of 1650: The Public Records of the Colony of Connecticut*. Connecticut State Library, 509–63. Accessed 2008. catalog.hathitrust.org /Record/002030288.

Lyell, Charles. 1845. *Travels in North America, in the Years 1841–2*. 2 vols. New York: Wiley and Putnam.

Marzoli, A., P. R. Renne, E. M. Piccirillo, M. Ernesto, G. Bellieni, and A. De Min. 1999. "Extensive 200-Million-Year-Old Continental Flood Basalts of the Central Atlantic Magmatic Province." *Science* 284, (5414): 616–18.

McDonald, N. G. 1996. *The Connecticut Valley in the Age of Dinosaurs: A Guide to the Geologic Literature, 1681–1995*. Connecticut State Geological and Natural History Survey Bulletin 116.

———. 2010. *Window into the Jurassic World: Dinosaur State Park, Rocky Hill, Connecticut*. Rocky Hill, CT: Friends of Dinosaur State Park and Arboretum.

McHone, J. G. 1996. "Broad-Terrane Jurassic Flood Basalts Across Northeastern North America." *Geology* 24 (4): 319–22.

McHone, G., and J. Puffer. 2003. "Flood Basalt Provinces of the Pangean Atlantic Rift: Regional Extent and Environmental Significance." In *Sedimentology, Stratigraphy, and Paleontology*, vol. 2 of *The Great Rift Valleys of Pangea in Eastern North America*, edited by P. M. LeTourneau and P. E. Olsen, 141–54. New York: Columbia University Press.

Meriden, City of. 1889. *Municipal Record for the City of Meriden for the Year 1889*. Meriden, CT: Journal Publishing Co.

Meyers, Kenneth 1993. "On the Cultural Construction of Landscape Experience: Contact to 1830." In *American Iconology*, edited by D. C. Miller. New Haven, CT: Yale University Press.

Morse, Jedidiah. 1792. *The American Geography*. London: John Stockwell. Google Books, https://books.google. com/books?id=PUcMAAAAYAAJ.

Morse, Jedidiah, and Elijah Parish. 1808. *A Compendious History of New England*. London: C. Taylor. Google Books, https://books.google.com/ books?id=f41KAAAAMAAJ.

Morton, Thomas. 1637. "New English Canaan." In *The New English Canaan of Thomas Morton*, edited by C. F. Adams Jr., 1883. Boston: The Prince Society. Hathi Trust, http://hdl.handle.net/2027/mdp.39015012085257.

Murphy, Kevin. 2010. *Water for Hartford*. Middletown, CT: Wesleyan University Press.

Nichols, George E. 1914. "The Vegetation of Connecticut III: Plant Societies on Uplands." *Torreya* 14 (10): 167–94.

Nichols, Ken. 1982. *Traprock: Connecticut Rock Climbs*. New York: American Alpine Club.

North, Catherine M. 1916. *History of Berlin, Connecticut*. New Haven, CT: Tuttle.

O'Gorman, James F. 2002. *Connecticut Valley Vernacular: The Vanishing Landscapes and Architecture of the New England Tobacco Fields*. Philadelphia: University of Pennsylvania Press.

O'Hara, Captain T. J. 1996. "Mount Tom Monument, Holyoke, Massachusetts." *The Coast Guard Reservist* 18, no. 5 (May): 11.

Olsen, P. E. 1986. "A 40-Million-Year Lake Record of Early Mesozoic Orbital Climatic Forcing." *Science* 234:842–48.

———. 1999. "Giant Lava Flows, Mass Extinctions, and Mantle Plumes." *Science* 284:604–5.

Olsen, P. E., J. Whiteside, P. M. LeTourneau, P. Huber. 2005. "Jurassic Cyclostratigraphy and Paleontology of the Hartford Basin." In *Guidebook for Field Trips in Connecticut*, edited by N. W. McHone and M. J. Peterson, Trip A-4, 55–106. New England Intercollegiate Geologic Conference. State Geological and Natural History Survey of Connecticut Guidebook, no. 8.

Palmer, H. S. 1921. *Ground Water in the Southington-Granby Area, Connecticut*. U.S. Geological Survey Water-Supply Paper, no. 466. Washington, DC: Government Printing Office.

Percival, James G. 1842. *Report on the Geology of the State of Connecticut*. New Haven, CT: Osborn & Baldwin.

Perkins, G. W. 1849. *Historical Sketches of Meriden*. West Meriden, CT: Franklin E. Hinman.

Philpotts, A. R., and A. Martello. 1986. "Diabase Feeder Dikes for the Mesozoic Basalts in Southern New England." *American Journal of Science* 286:105–26.

Platt, Franklin. 1887. "A List of the Birds of Meriden, Connecticut." *Transactions of the Meriden Scientific Society* 2:30–53.

Pynchon, William, H. C. 1896. "Ancient Lavas of Connecticut." *Connecticut Quarterly* 2:309–19.

Roberts, E. A. 1914. "Plant Successions of the Holyoke Range." *Botanical Gazette* 58 (5): 432–44.

Roberts, G. S. 1906. *Historic Towns of the Connecticut River Valley*. Schenectady, NY: Robson and Adee.

Roberts, Strother E. 2011. "The Commodities of the Country: An Environmental Biography of the Colonial Connecticut Valley." Ph.D. diss., Northwestern University.

Robinson, Ruth. 1992. "The View From: Ragged Mountain; Rock Climbers Band Together to Protect a Chunk of Nature." *New York Times*, March 22.

Rodgers, John. 1985. *Bedrock Geological Map of Connecticut*. Hartford, CT: Connecticut Geological and Natural History Survey.

Roque, O. R. 1982. "*The Oxbow* by Thomas Cole: Iconography of an American Landscape Painting." *Metropolitan Museum Journal* 17:63–73.

Russell, Gloria. 1981. "History of the Connecticut Valley." In *Arcadian Vales: Views of the Connecticut River Valley*, edited by Martha J. Hoppin, 7–10. George Walter Vincent Smith Art Museum. Springfield, MA: Springfield Libraries and Museums Association.

Russell, Howard S. 1982. *A Long Deep Furrow: Three Centuries of Farming in New England*. Hanover, NH: University Press of New England.

Sachse, Nancy D. 2009. *Born Among the Hills: The Sleeping Giant Story*. 4th ed. Hamden, CT: The Sleeping Giant Park Association. First published 1982.

Sears, J. F. 1989. *Sacred Places: American Tourist*

Attractions in the Nineteenth Century. New York: Oxford University Press.

Shepard, J. 1895. "The Small-Pox Hospital Rock at Farmington, Connecticut." *Connecticut Quarterly* 1:50–55.

Shumway, F. M., and R. Hegel. 1988. "New Haven: A Topographical History." *Journal of the New Haven Colony Historical Society* 34 (2): 1–64.

Siegel, N. 2003. *Along the Juniata: Thomas Cole and the Dissemination of American Landscape Imagery*. Juniata College Museum of Art. Seattle: University of Washington Press.

Silliman, Benjamin. 1812. *Journal of Travels in England, Holland, and Scotland*. Vol. 2. New York: E. Sargeant.

———. 1810. "Sketch of Mineralogy of the Town of New Haven." *Memoirs of the Connecticut Academy of Arts and Sciences* 1 (4): 83–96.

———. 1824. *Remarks Made on a Short Tour between Hartford and Quebec in the Autumn of 1819*. 2nd ed. New Haven: S. Converse.

———. 1822. "Natural Ice Houses." *American Journal of Science*, series 1, vol. 4: 174–77.

Sleeping Giant Park Association. Undated web site: www.sgpa.org.

Stevenson, Robert Louis. 1879. *Picturesque Notes on Edinburgh*. London: Seeley, Jackson & Hallidays.

Stier, M., and R. McAdow. 1995. *Into the Mountains: Stories of New England's Most Celebrated Peaks*. Boston: Appalachian Mountain Club Books.

Wadsworth, S. C. 1895. "The Towers of Talcott Mountain." *Connecticut Quarterly* 1:180–87.

Wallach, Alan. 1996. "Wadsworth's Tower: An Episode in the History of American Landscape Vision." *American Art* 10 (3): 9–27.

Waring, G. A. 1920. *Ground Water in the Meriden Area, Connecticut*. U.S. Geological Survey Water-Supply Paper, no. 449. Washington, DC: Government Printing Office.

Water Board of Holyoke, Massachusetts. 1902. *30th Annual Report*. Holyoke, MA.

Waterman, L., and G. Waterman. 2002. *Yankee Rock and Ice: A History of Climbing in the Northeastern United States*. Mechanicsburg, PA: Stackpole Books.

Wessel, Tom. 1997. *Reading the Forested Landscape: A Natural History of New England*. Woodstock, VT: Countryman Press.

Wetherill, Diana V. 1997. *Traprock Ridges of Connecticut: A Naturalist's Guide*. Connecticut Department of Environmental Protection Bulletin 25.

Whiteside, J. H., P. E. Olsen, D. V. Kent, S. J. Fowell, and M. Et-Touhami. 2007. "Synchrony between the CAMP and the Triassic-Jurassic Mass-Extinction Event?" *Palaeogeography, Palaeoclimatology, and Palaeoecology* 244 (1–4): 345–67.

Whiteside, J. H., P. E. Olsen, T. I. Eglinton, M. E. Brookfield, and R. N. Sambrotto. 2010. "Compound-Specific Carbon Isotopes from Earth's Largest Flood Basalt Province Directly Link Eruptions to the End-Triassic Mass Extinction." *Proceedings of the National Academy of Sciences* 107:6721–25.

Williams, Margie J., *English Pink*. Undated web site: http://englishpink.net

Willis, Nathaniel P. 1840. *American Scenery*. London: George Virtue. Google Books, https://books.google.com/books?id=xOMg-B1-dJEC.

Wood, William. 1634. *New England's Prospect*. London: Thomas Cotes. Google Books, https://books.google.com/books?id=ZW0FAAAAQAAJ.

INDEX

Italic is used to indicate an illustration or figure; page numbers
followed by *n* and a number refer to endnotes.

agriculture: corn, 20, 22, 25, 33; hay, 22, 33; onions, 22;
 soils, xiii, 20–21, 25, 30; wheat, 20–21. *See also* dairy
 farms; intervales; orchards; tobacco
alpenglow, 37, *107*, 158, *163–165*, 170
amphibians, 96–97, 98, 206; habitat, 96, 206; vernal pools
 and, 96, 98, 106. *See also* frogs; salamanders; toads,
 American
artists and illustrators. *See* Barber, John Warner; Church,
 Frederic E.; Cole, Thomas; Durrie, George H.; Hall,
 Basil

Barber, John Warner, 132, 220n2; *Connecticut Historical
 Collections* engravings, 67, 135, *182*, *194*; stone face at
 Cathole, 186
basalt, *42–43*, *44–45*, 52; colors of, 6, 7, 9, 52, *50*, 176;
 varieties, 52–56, 60. *See also* central Atlantic magmatic
 province (CAMP); minerals; traprock
Beacon Hill: East Haven, Conn., 182, *183*; Branford,
 Conn., visitors' information, 213
bears, black: historical occurrence, 87, 93; range
 expansion, 93
Berlin, Conn. *See* Lamentation, Mount; South
 Mountain
Beseck Mountain (Middlefield, Conn.), *x*, 8, 19, *70–71*,
 156–157, *159*, *165*, *171*; map, *40*; ski area, 31, 214; talus,
 79, *81*; visitors' information, 213–214
birds, 10, 98–99, *100*, *101*; eagles, bald, 99; falcons,

peregrine, 99, *101*; habitat, 72, 102, 158, 206;
 woodpeckers, pileated, 99
Black Pond (Middlefield, Conn.), *x*, 8, *108–109*, *165*;
 visitors' information, 213–214
Black Rock Fort (New Haven, Conn.), *182*
Blackstone River Valley National Heritage Corridor
 (Mass.–R.I.), 204–205; model for regional
 management, 205, 209; national park, 205
blue-blazed trail system, *199*, 200
Blue Hills Orchards (Wallingford, Conn.), 25, 29, 213
Bradley Hubbard Reservoir (Crescent Lake), *107*, *113*
brownstone: building stone, 46, 48; geology, 46; quarries,
 47
butterflies: great spangled fritillary, 89; monarch larvae,
 88; spicebush swallowtail larvae, 89

cactus, prickly pear (*Opuntia humifusa*), 72, 75
Carex pensylvanica. See sedge, Pennsylvania
Carmel, Mount (Hamden, Conn.). *See* Sleeping Giant
Castle Craig (Meriden, Conn.), *viii–ix*, 34, *147*, *148*, 160,
 179, 215
Cathole Peak (Meriden, Conn.), *vi–vii*, 6, 160, *172*, *188*;
 impacts, 78, 202; map, *40*; stone faces, 186, *191*, *194*
cedars, eastern red (*Juniperus virginiana*), 14, 81, 83; fire
 ecology of, 83
central Atlantic magmatic province (CAMP), *42–43*, *44*,
 45, 61–62

ceramics: East Rock, 184; English, 131–132, 133; imported, 145; Monte Video, 133; Mount Tom, 145

Chauncey Peak (Meriden, Conn.), 11, 107, 215; alpenglow, 164; map, 21; quarry, 63; views from, 19, 32–34, 39, 167, 211; water resources, 106, 107, 113

Chester, Leonard: gravestone and legend, 23

Church, Frederic E., 134, 137, 152; *West Rock*, 141

climate: and agriculture, 25, 30–31; Connecticut Valley, 20, 25, 30, 33; and ski areas, 30, 31; traprock hills, 72, 75, 86

Coke, Edward T., 9, 22, 155; ascent of Mount Washington, 126, 219n5; on the view from Mount Holyoke, 1, 5, 126

Cold Spring (Meriden, Conn.), 80

Cole, Thomas, 132, 134, 137; Monte Video ceramic plate, 133; *Monte Video, Seat of Daniel Wadsworth, Esq.*, 134; *View from Mount Holyoke after a Thunderstorm — The Oxbow*, 123, 141, 219n7

Connecticut Forest and Park Association, 199, 200

Connecticut River, 16–17, 124–125; geography, xiv, 18, 24, 118, 129; map, 21, 40; national recreation area proposal, 204; oxbow, 123

Connecticut River Valley, xiv, 118; early towns, 23; map 21; national recreation area study, 204. *See also* intervales

Connecticut Valley: agriculture, 22, 23, 25, 33; climate, 31; European settlement, 20, 23; defined xiv; geography, xiii, xiv, xv, 2, 18; maps, 21, 46; national heritage corridor proposal, 205–209; role in American culture, 9, 26, 132; soils, xiii, 18, 20; views of, 19, 26–27, 38–39, 123, 129, 134, 196, 208. *See also* dinosaur tracks; geology

copperheads, northern, 94, 98

coyotes, eastern, 92

cuesta landforms, 18, 34, 35, 137, 141

dairy farms, 25, 32, 33

Dana, Arnold G., 179; fall from cliffs, 179; plaque, 179, 180

Dana, Edward S.: on traprock summits, 71

Dana, James D., 62, 179, 180; quoted, 43

De Boer, Jelle Zeilinga, 30

deer, white-tailed, 92

Deerfield basin, 14, 46

Deerfield Valley: defined, 14, 18; map 21; tobacco, xiv

diabase (dolerite), 40, 52, 182; dikes, 61; landforms, xiii, xv, 41, 40, 57, 119; Western Range, 38, 40

Dinosaur State Park (Rocky Hill, Conn.), 48, 49; visitors' information, 216–217

dinosaur tracks, 48–49, 216–217. *See also* Dinosaur State Park; Hitchcock, Edward S.

drumlins: dairy farms, 25, 33; landforms, 25, 30; orchards, 25, 28, 29

Durrie, George H., 25, 136, 137, 141, 194

Dwight, Timothy, 185; quotations, 5, 87, 122, 127

eagles, bald, 99

East Rock, xviii, 6, 35, 60, 126, 153, 170; map, 21, 40. *See also* Salisbury Crags, Edinburgh

East Peak (Meriden, Conn.), 29, 34, 35, 54, 147, 149, 160, 163, 183; map, 40; visitors' information, 215

East Rock (lithograph), 136

East Rock Park (New Haven, Conn.), 198, 203; English bridge, 9, 153; Giant Steps, 155; Soldiers' and Sailors' monument, 183, 184, 185; visitors' information, 212

ecology, 72, 73; animals, 87–102; fire, 83; microclimates, 2, 72, 75; plants, 82, 84, 85, 86; soils, 73, 78; talus, 78–81, 93, 95; summit, 82, 84, 86. *See also* wetlands; vernal pools

Eli Whitney Museum (New Haven, Conn.), 26, 176

environmental impacts, 86, 200, 201, 202

falcons, peregrine (*Falco perigrinus*), 99, 101

Farnsworth, Elizabeth, 200

Fort Hale, New Haven, *182, 212*
foxes, red, 93, *92*
frogs, 97, 98, 158

geography: climate, 23, 25, 30, 31, 33; landforms, xiii–xx, 34, 41, 118; watercourses, 112, *114–117,*
geology, 44–62
Giuffrida Park (Meriden, Conn.), *11*; Crescent Lake (Bradley Hubbard reservoir), 112, *107, 113*; visitors' information, 215

Hall, Basil, 132, 155; on East Rock, 126; *View from Mount Holyoke in Massachusetts, 123*
Hampden Basalt: 13, 56, 57, 60; map, *40*
Hanging Hills (Meriden, Conn.), 9, 19, 57, *29, 34, 36, 147, 160*; elevations, 35; landscape painting of, *149*; map, *21*; reservoirs, 107, *111*; watersheds 107
Hanging Hills, The (unknown; c. 1855), *149*
Hartford, Conn., 27
Hartford basin: cross-section, 57; defined, 46; geology, 46, 48, maps, *21, 40*
Hauptmann, Gerhart, in Meriden, 195; *The Sunken Bell, 195, 215*
Higby, Mount, 30, *4–5, 19, 70–71, 161 189*; alpenglow, *164*; plane crashes, 186; stone face, *192–193*; summit meadows, *84, 166; 199* visitors' information 214–215
Hitchcock, Edward S., 49, 126; quotations, 15, 121, 209
Holyoke, Mount, 123, 126, 180; Prospect House, *140–143, 198*; Titan's piazza, 126, *140*; view, *16–17, 124–125, 129*; visitors' information, 218. *See also* Coke, Edward T.; Dwight, Timothy; monuments and plaques; Skinner State Park; tourism
Holyoke Basalt, 56, 57, 60; landforms, xx, xviii, *4, 36, 37, 42–43, 137, 141*; map, *40*; rock climbing, *4,* 61; quarries, 57, 63, 64
Hubbard Park (Meriden, Conn.), *150*; Fairview pavilion, *148*; Olmstead landscape design, 148; visitors' information, 215. *See also* Castle Craig; East Peak; Merimere Reservoir; West Peak
Hublein tower (Talcott Mountain), *128*; visitors' information, 217. *See also* Talcott Mountain State Park

inscriptions, traprock, 170, *178, 179*
insects, 88–91
intervales, 13, *24; 16–17, 18, 123, 124–125, 129*; agriculture and soils, 13, 20, 22, 23

juniper, common (*Juniperus communis*), 81, *83*

Lamentation, Mount, 30; legend, 23; map, *21, 40*; watershed, *107*; woodcut, *135*
landforms: traprock, xviii, *19, 41, 126, 132, 141*; stone faces, *190–194*. *See also* cuesta landforms; drumlins; intervales; talus (scree)
lichens, 77–79, 81, *82*
Lyell, Charles, 155
Lyman's Orchards (Middlefield, Conn.), 25, 28, 214

mammals, 87, 92–94
Manitook Mountain (Granby, Conn.), 41, 44, 60; map, *40*
Meriden, Conn.: Bilger farm, 32; views of, *120–121, 149. See also* Castle Craig; Giufridda Park; Hanging Hills; Hauptmann, Gerhart; Hubbard Park
Meriden Land Trust, 33, 203
Merimere Reservoir (Meriden, Conn.), *xxii,* 2, 12, 106, 107, 111, *160, 171*; talus, 54, 58, *59, 177*; visitors' information, 215
Metacomet Mountains, xv, 15, 19, 41; map, *40*
Metacomet-Monadnock-Mattabesett trail, 203, *204*
Middlefield, Conn. *See* Beseck Mountain; Black Pond; Wadsworth Falls State Park

Middletown, Conn. *See* Westfield Falls; Higby, Mount

minerals: 50, 66, 69, 163, 170; copper, 66–69; Old New-Gate mines, 68, 67

Monte Video, Seat of Daniel Wadsworth, Esq. (Thomas Cole, 1828), 134

Monte Video (Talcott Mountain), 133–135, 137

monuments and plaques, 170, 179, 180–185, 186

Motorcycle Chums in New England, 195

mountain lions, 87

Mountain Park (Mount Tom, Mass.), 146, 198

Mount Tom Ski Area, 30, 31

National Park Service, 15, 200, 204, 205, 209

newts, red-spotted, 97, 98

Northampton, Mass., 92, 123; intervales, 129; map, 21

Old New-Gate Prison (East Granby, Conn.), 67, 68; visitors' information, 217

Opuntia humifusa. See cactus, prickly pear

orchards, 25, 28, 29; 213, 214

Pangaea, 44–46; map, 45; rift valleys, 45–49

Peak House (West Peak, Meriden, Conn.), 149, 151

Peter's Rock (Rabbit Rock), North Haven, Conn.: columnar basalt, 55; Peter's Rock Association, 203; prickly pear cactus, 75; visitors' information, 213

Portland, Conn. *See* brownstone

Powder Ridge Ski Area, 31; visitors' information, 214

Prospect House (Mount Holyoke), 140–141, 198, 202; brochure, 143; interior, 142; visitors' information, 218

Pynchon, William (Trinity College, Hartford): quotation, 209

quarries: brownstone, 46, 47, 48, 216; traprock, 62, 63–64, 65, 217

Rabbit Rock (North Haven, Conn.). *See* Peter's Rock

Ragged Mountain (Southington, Conn.), *xvii*, 51, 117; map, 40; rock climbing, 4, 60, 61, 203; visitors' information, 216

Ragged Mountain Foundation, 203

rattlesnakes, eastern timber, 94, 98

reservoirs, 106, 107, 108, 110, 111, 112, 113. *See also* Bradley Hubbard Reservoir (Crescent Lake); Merimere Reservoir; Wassel Reservoir; water resources

Respighi, Ottorino: opera, source material for, 195, 215

rifts (rift basins), 44–46; map 46

Rocky Hill, Conn. *See* Dinosaur State Park

salamanders, 96, 98

Salisbury Crags, Edinburgh: comparison to East Rock, xviii, 122, 126; Robert Lewis Stevenson on, 122

sedge, Pennsylvania (*Carex pensylvanica*), 73; summit meadows, 73, 84, 86, 199

Silliman, Benjamin: natural ice houses, 80; talus, 53, 62, 170; traprock landscapes described, 5, 17, 41, 122, 126, 157

ski areas, 30–31; visitors' information, 214

Skinner State Park (Mount Holyoke): B-24 monument, 185; plaque, 180; visitors' information, 218

Sleeping Giant (Mount Carmel), Hamden, Conn.: geology, 40, 41, 57; landform, 25, 41, 38, 186, 188, 190; legend, 38, 186; map, 21, 40; quarry, 63

Sleeping Giant State Park (Hamden, Conn.), 36, 179, 198; visitors' information, 213; WPA tower, 154, 176, 183. *See also* Dana, Arnold G.

snakes, 94, 95, 98. *See also* copperheads, northern; rattlesnakes, eastern timber

soils, xiii, 18, 20, 83, 86; cryptogamic, 73, 78

Soldiers' and Sailors' Monument (East Rock, New Haven), 183, 184, 185, 212

South Mountain (Berlin-Meriden, Conn.), 3, 34, 80, 164, 169, 187; map, 40

Stevenson, Robert Lewis, xviii, 122

Summit House (Mount Tom), 144, 145, 198; brochure, 143. *See also* Tom, Mount; Mountain Park (Mount Tom, Mass.)

Sunken Bell, The. See Hauptmann, Gerhart

Talcott Basalt, 52, 56–57; map, 40

Talcott Mountain, 56, 122, 132; map, 40; Monte Video, 106, 133–135. *See also* Cole, Thomas; Hublein tower (Talcott Mountain)

Talcott Mountain State Park, 198, visitors' information, 217

talus (scree), 3, 9, 30, 53, 54, 58–59, 62, 95, 170; lichens, 79; microclimate, 80

Titan's Piazza (Mount Holyoke), 126–127, 140

toads, American, 97, 98

tobacco: cultivation, xiii, xiv; 23; material culture, 25.

Tom, Mount, 9, 198; B-17 crash, 185–186; cable railway, 9, 145; map, 40; Mountain Park, 144; ski area, 30–31; Summit House (Mount Tom Hotel), 145; visitors' information, 217–218

Town, Ithiel: lattice truss bridge, 26

traprock: defined, xii, 50–51, 52; building stone, 9, 151, 154, 170, 176, 179. *See also* basalt; quarries; talus (scree)

vernal pools, 96, 98, 106

View from Mount Holyoke after a Thunderstorm (The Oxbow), The (Thomas Cole, 1836), 123, 134, 137, 141

View from Mount Holyoke in Massachusetts (Basil Hall, 1831), 123, 219n7

View of Meriden with Hanging Hills (unknown, c. 1855), 149

View of Monte Video (John Warner Barber, 1836), 135

View of Monte Video, Seat of Daniel Wadsworth, Esq. (Thomas Cole, 1828), 134

Wadsworth Falls State Park (Conn.), 114–115; visitors' information, 214

Wainwright, Alfred, xix

Washington, Mount: E. T. Coke ascent of, 219n5; compared to Mount Holyoke, 126

Wassel Reservoir, 106, 108

waterfalls, 13, 60, 114–117, 119, 212, 214, 215

water resources, 12, 30, 104–105, 106, 112. *See also* reservoirs; vernal pools; wetlands

Western Range, 15, 38–39, 40, 41, 116

Westfield Falls (Middletown, Conn.), 13, 116–117, 119

West Peak (Meriden, Conn.), xix, 29, 34, 35, 36, 37, 82, 134; map, 40; Peak House, 149; summer colony, 151; tele-communications towers, 201; visitors' information, 215

West Rock, 35, 135, 152, 170, 212; Church, Frederic E., 137, 141; Judge's Cave, 25, 182; maps, 21, 40

West Rock State Park (Conn.): visitors' information, 212

Wethersfield, Conn., 22, 23

wetlands, 103, 104–105, 158. *See also* vernal pools

Whitney, Eli: museum, 26, 176

Will Warren's Den (Rattlesnake Mountain), 179, 182, 180

Winter-Time: Sunday Callers (George H. Durrie, c. 1860), 136

wolves, eastern timber, 87, 92; bounties, 92; extirpation of, 92

woodpeckers, pileated, 99

Garnet Books

Titles with asterisks () are also in the Driftless Connecticut Series*

Garnet Poems: An Anthology
*of Connecticut Poetry Since 1776**
Dennis Barone, editor

The Connecticut Prison Association
*and the Search for Reformative Justice**
Gordon Bates

Food for the Dead: On the Trail
of New England's Vampires
Michael E. Bell

The Case of the Piglet's Paternity:
*Trials from the New Haven Colony, 1639–1663**
Jon C. Blue

Early Connecticut Silver, 1700–1840
Peter Bohan and Philip Hammerslough

The Connecticut River: A Photographic Journey through
the Heart of New England
Al Braden

Tempest-Tossed: The Spirit of Isabella Beecher Hooker
Susan Campbell

*Connecticut's Fife & Drum Tradition**
James Clark

Sunken Garden Poetry, 1992–2011
Brad Davis, editor

Rare Light: J. Alden Weir in
*Windham, Connecticut, 1882–1919**
Anne E. Dawson, editor

The Old Leather Man: Historical Accounts
of a Connecticut and New York Legend
Dan W. DeLuca, editor

Post Roads & Iron Horses: Transportation in
*Connecticut from Colonial Times to the Age of Steam**
Richard DeLuca

The Log Books: Connecticut's Slave Trade
*and Human Memory**
Anne Farrow

Dr. Mel's Connecticut Climate Book
Dr. Mel Goldstein

Hidden in Plain Sight:
A Deep Traveler Explores Connecticut
David K. Leff

Maple Sugaring: Keeping It Real in New England
David K. Leff

Becoming Tom Thumb:
Charles Stratton, P. T. Barnum,
*and the Dawn of American Celebrity**
Eric D. Lehman

Homegrown Terror: Benedict Arnold
*and the Burning of New London**
Eric D. Lehman

The Traprock Landscapes
of New England: Environment,
*History, and Culture**
Peter M. LeTourneau and Robert Pagini

Westover School: Giving Girls
a Place of Their Own
Laurie Lisle

Heroes for All Time:
Connecticut's Civil War Soldiers
*Tell Their Stories**
Dione Longley and Buck Zaidel

Crowbar Governor: The Life and Times
*of Morgan Gardner Bulkeley**
Kevin Murphy

Fly Fishing in Connecticut:
A Guide for Beginners
Kevin Murphy

Water for Hartford: The Story of
the Hartford Water Works and the
Metropolitan District Commission
Kevin Murphy

African American Connecticut Explored
Elizabeth J. Normen, editor

Henry Austin: In Every Variety of
Architectural Style
James F. O'Gorman

Breakfast at O'Rourke's: New Cuisine
from a Classic American Diner
Brian O'Rourke

Ella Grasso: Connecticut's Pioneering
*Governor**
Jon E. Purmont

The British Raid on Essex: The Forgotten
*Battle of the War of 1812**
Jerry Roberts

Making Freedom: The Extraordinary
Life of Venture Smith
Chandler B. Saint and George Krimsky

Welcome to Wesleyan: Campus
Buildings
Leslie Starr

Barns of Connecticut
Markham Starr

Gervase Wheeler: A British Architect
*in America, 1847–1860**
Renée Tribert and James F. O'Gorman

Connecticut in the American Civil War: Slavery, Sacrifice, and Survival
Matthew Warshauer

*Inside Connecticut and the Civil War: One State's Struggles**
Matthew Warshauer, editor

Prudence Crandall's Legacy: The Fight for Equality in the 1830s, Dred Scott, *and* Brown v. Board of Education*
Donald E. Williams Jr.

*Riverview Hospital for Children and Youth: A Culture of Promise**
Richard Wiseman

Stories in Stone: How Geology Influenced Connecticut History and Culture
Jelle Zeilinga de Boer

*New Haven's Sentinels: The Art and Science of East Rock and West Rock**
Jelle Zeilinga de Boer and John Wareham

PETER M. LETOURNEAU is an environmental science educator, and a research affiliate of the Lamont-Doherty Earth Observatory of Columbia University, with degrees in earth and environmental science from Wesleyan University (MA) and Columbia University (PhD). He has lectured widely on the topic of Connecticut Valley traprock ridges, including as a keynote speaker in the Connecticut Landmarks Speakers Series in 2009 at the Connecticut Historical Society and the Florence Griswold Museum.

ROBERT PAGINI is an award-winning photographer. A member of the Meriden Land Trust, Bob has worked tirelessly to preserve, protect, and promote Meriden's traprock landscapes, and his work has been featured in publications by the Connecticut Forest and Park Association, Diane Smith's *Seasons of Connecticut*, and the National Park Service M-M-M trail study. He has presented many lectures about his photography for the Meriden Land Trust and the Quinnipiac River Watershed Association and had a collection of his traprock landscape photographs on exhibit at the Portland Library.

ABOUT THE DRIFTLESS CONNECTICUT SERIES

The Driftless Connecticut Series is a publication award program established in 2010 to recognize excellent books with a Connecticut focus or written by a Connecticut author. To be eligible, the book must have a Connecticut topic or setting or an author must have been born in Connecticut or have been a legal resident of Connecticut for at least three years.

The Driftless Connecticut Series is funded by the
Beatrice Fox Auerbach Foundation Fund
at the Hartford Foundation for Public Giving.
For more information and a complete list
of books in the Driftless Connecticut Series,
please visit us online at
http://www.wesleyan.edu/wespress/driftless.